Art & Language
Phyllida Barlow
David Batchelor
Martin Boyce
Glenn Brown
Billy Childish
Martin Creed
Jeremy Deller & Karl Holmqvist
Tracey Emin
Graham Fagen
Laura Ford
Liam Gillick
Paul Graham
Lucy Gunning
Graham Gussin
Susan Hiller
David Hockney
Dean Hughes
Anna Hunt
Runa Islam
Emma Kay
Joan Key
Jim Lambie
Michael Landy
Hilary Lloyd
Rachel Lowe
Sarah Lucas
Kenny Macleod
Chad McCail
Conor McFeely
Lucy McKenzie
David Musgrave
Mike Nelson
Paul Noble
Jonathan Parsons
Grayson Perry
Kathy Prendergast
Michael Raedecker
Paula Rego
Carol Rhodes
Donald Rodney
Paul Seawright
David Shrigley
Johnny Spencer
Simon Starling
John Stezaker
Wolfgang Tillmans
Padraig Timoney
Amikam Toren
Keith Tyson
John Wood & Paul Harrison
Richard Wright
Cerith Wyn Evans

Edinburgh
8 April – 4 June 2000

City Art Centre
Collective Gallery
Dean Gallery
Fruitmarket Gallery
Inverleith House – Royal Botanic Garden
Scottish National Gallery of Modern Art
Stills
Talbot Rice Gallery

Southampton
23 June – 20 August 2000

John Hansard Gallery
Millais Gallery – Southampton Institute
Southampton City Art Gallery

Cardiff
8 September – 5 November 2000

Centre for Visual Arts
Chapter Arts Centre
Ffotogallery
National Museum & Gallery

Birmingham
25 November 2000 – 28 January 2001

Birmingham Museum and Art Gallery
Ikon Gallery

The British Art Show 5

Exhibition curated by

Pippa Coles

Matthew Higgs

Jacqui Poncelet

sbc

Published on the occasion of the exhibition **The British Art Show 5**,
a National Touring Exhibition organised by the Hayward Gallery, London,
for the Arts Council of England

Presented in association with participating venues in the cities of
Edinburgh, Southampton, Cardiff and Birmingham

The British Art Show 5 is sponsored nationally by habitat

Edinburgh showing: Bloomberg faulds THE SCOTTISH ARTS COUNCIL ·EDINBVRGH· THE CITY OF EDINBURGH COUNCIL Lothian and Edinburgh Enterprise Limited

Southampton showing: SOUTHAMPTON CITY COUNCIL SOUTHAMPTON INSTITUTE University of Southampton

Birmingham showing: Birmingham City Council Birmingham

Exhibition curated by Pippa Coles, Matthew Higgs and Jacqui Poncelet

Exhibition organised by Susan May and Lucy Till, assisted by
Elena Lukaszewicz

Catalogue designed by Herman Lelie
Typeset by Stefania Bonelli
Printed in England by P.J. Print

Front cover: Kenny Macleod, *Twin Sisters*, 1999 (detail), photograph: Richard Haughton
Back cover: David Shrigley, *Drink Me*, 1998, photograph courtesy the artist and
Stephen Friedman Gallery, London

Published by Hayward Gallery Publishing, London SE1 8XX
© The South Bank Centre 2000
Texts © the authors 2000
Interview © Judith Bumpus, Pippa Coles, Matthew Higgs and Jacqui Poncelet 2000
Artworks © the artists 2000, unless stated otherwise

ISBN 1 85332 204 0

This publication is distributed in North and South America and Canada by the University
of California Press, 2120 Berkeley Way, Berkeley, California 94720, and elsewhere by
Cornerhouse Publications.

Hayward Gallery Publishing titles are distributed outside North and South America
and Canada by Cornerhouse Publications, 70 Oxford Street, Manchester M1 5NH
(tel 0161 200 1503; fax 0161 200 1504; email: publications@cornerhouse.org).

Contents

Preface

Organised by the Hayward Gallery as part of its National Touring Exhibitions programme, *The British Art Show* is the most ambitious exhibition in that programme and, on a consistent basis, nationally. Over the twenty-five years of its history, it has been unrivalled in its scope and unprecedented in its outreach, occupying, especially in its recent manifestations, galleries and other spaces across each city on its tour, and reaching hundreds of thousands of people.

The first *British Art Show* was mounted in 1979/80, and the series has continued every five years since, each exhibition surveying British art produced in the preceding five years and providing an important barometer, capturing and reflecting particular moments in British art. It is inevitable that this exhibition, the fifth, will also be considered in the context of the millennium, and perhaps now, more than ever, visitors to the exhibition will seek to identify through it the state of British art and an indication of the direction in which it is going.

If the work included in this exhibition does indeed anticipate future directions, the outlook is promising. The selection of artists is not restricted by age or geography, and while the exhibition cannot hope to be, nor has ever purported to be, a representative survey of every aspect of contemporary British art, the range, variety and, above all, the freshness of the work gathered here, by established figures and recent graduates alike, is notable. While many of the works are modest – in actual size, in their means of presentation or in the nature of their subject – there is also a strong thread of sheer visual exuberance. A pervasive theme of displacement is tempered by utopian visions. Some of the works have a fretful obsessiveness, but throughout the exhibition there is also a great deal of optimism and humour. One of the benefits of touring this exhibition to four different cities and several venues within them is that at each showing it will change shape and have a different impact; new characteristics, themes and relationships will surface as works are exhibited before new audiences in different sites and combinations.

Curatorial practice, like artistic practice, has changed in the last twenty-five years. The three curators of *The British Art Show 5*, Pippa Coles, Matthew Higgs and Jacqui Poncelet, each have their own passionately held positions and views as curators and/or artists, but collectively they approached the selection with remarkably open minds and without a pre-conceived thesis. They have spent over eighteen months making extensive visits to studios and exhibitions across the country, and the development of the show has been a process of exploration and evolution. We are immensely grateful to them for the dedication and thoughtfulness they have brought to the task, and for the commitment they have shown. Every aspect of the exhibition has benefitted from their engagement, from the selection of works, to the exhibition's presentation in each city, to this publication itself.

Britain has also changed in the twenty-five years of *The British Art Show*'s history, markedly with political devolution in the past year. The very nature of a 'British' art show may indeed be questioned in the future. However, we are delighted that the present exhibition is being presented in the capitals of both Scotland and Wales, as well as in two major cities in England, Southampton and Birmingham. This has been a collaborative project which has depended upon the hard work, advice and expertise of the curators and staff at the participating galleries in each of the cities, and we are indebted to them for their enthusiasm and commitment to this undertaking from its very inception. In particular, we extend our thanks to: in Edinburgh – Pat Fisher, Keith Hartley, Sarah Munro, Graeme Murray, Paul Nesbitt, Iain O'Riordan, Kate Tregaskis, Jane Warrilow and to Andrew Patrizio at the Edinburgh College of Art as well as to The City of Edinburgh Council and the Scottish Arts Council; in Southampton – Bridget Davies, Stephen Foster and Godfrey Worsdale, and Southampton City Council; in Cardiff – Christopher Coppock, Oliver Fairclough, Alex Farquharson, Bruce Haines, Karen MacKinnon and Mike Toobey, and also John Hambley and the Arts Council of Wales; and in Birmingham – Claire Doherty, Brendan Flynn and Jonathan Watkins.

Many individuals and organisations have advised and assisted us at every stage of the project, and we are particularly grateful to the following:

Emma Anderson; The Annual Programme, Manchester; Ian Barker, Annely Juda Gallery, London; Irene Bradbury, White Cube, London; Catalyst Arts, Belfast; Susan Daniel; Sarah den Dikken and Robin Klassnik, Matt's Gallery, London; Willie Doherty; Gregory Evans; Flaxart Studios, Belfast; David Graves; Isabel Hitchman; Callum Innes; Tessa Jackson; James Kerr, Context Gallery, Derry; Karen Kuhlman; Locus +; Elizabeth A. MacGregor; Carol Maund, Site Gallery, Sheffield; Nóirin McKinney, Arts Council of Northern Ireland; Alastair

McLennan; Brendan McMenamin, Orchard Gallery, Derry; Jeremy Millar; Becki Pope, Spike Island, Bristol; Anthony Reynolds; Richard Riley; Bill Seaman, formerly of Birmingham Museums and Art Gallery; Waygood Gallery, Newcastle; Clarrie Wallis; and Anthony Wilkinson.

Given the numbers of artists in the exhibition and the variety of work, we have been especially dependent on the expertise of many technical advisers and art handlers. We particularly thank Tom Cullen, Adrian Fogarty, Andy Golding, Jem Legh, David Leister and Arnold Robinson, as well as the Hayward's transport and installation crew. We would also like to thank staff and students at art schools and colleges in the four cities for their assistance.

For this catalogue, we are indebted to Tony Godfrey for his observant essay about the history of The British Art Show, and also to Judith Bumpus for her interview with its three curators; the resulting text provides illuminating insights into the process of making the exhibition and the thinking and discoveries which underpinned the selection. We thank Matthew Higgs for his essay, in which he gives his personal view of developments in British art during the 1990s. Marcelo Spinelli has written brief texts on each of the artists and we also extend our thanks to him. We are similarly grateful to Herman Lelie, who has designed this catalogue with customary flair, to Stefania Bonelli for typesetting the text, and to Kate Bell, the Hayward's Art Publisher, for skilfully and sensitively seeing it through all stages of production.

Other colleagues at the Hayward have also played an essential role in bringing the exhibition to fruition. Helen Luckett, who has had a long acquaintance with numerous British Art Shows, has, as ever, illuminated the works in the exhibition, both by compiling the chronology in this catalogue and, most particularly, by developing an innovative educational programme. We are also grateful to Elizabeth Manchester for her work in preparing interpretative material. The British Art Show is an important vehicle for local educational activity, and the staff at the venues have devised superb accompanying events.

The exhibition has also depended on the collective efforts of numerous members of Hayward staff in Exhibitions, Marketing, Press, Development, and SBC Design departments. I would like to thank Pamela Griffin for her help with research, Lise Connellan for overseeing the guide, Alex Hinton and Alison Wright for organising the marketing and press campaigns, Karen Whitehouse and Maggie Prendergast for their work with our sponsors and John Pasche for the design of publicity materials. Very special mention, and enormous thanks, on the Hayward's behalf as well as on that of the curators and our partners at the venues, must be made to Susan May, the Hayward Exhibitions Curator initially responsible for the exhibition, who so superbly launched the project, and to Lucy Till, who so ably and energetically took over from her. Elena Lukaszewicz has been a constant source of support to them and has administrated the project from the start, latterly assisted by Heather Caven. I am also grateful to Roger Malbert, the Hayward's Senior Curator NTE, and Martin Caiger-Smith, Head of Exhibitions, for the guidance they have provided throughout.

The British Art Show 5 has received valuable sponsorship from Habitat for the tour of the UK, and we are enormously grateful to the company for their continued support of the Hayward's work.

Many of the works in the exhibition have very particular requirements in terms of equipment, and we have received support in kind from Unicol and Augustus Martin to whom we also offer our thanks.

Above all, and certainly not least, our profound gratitude goes to the artists themselves; we are indebted to them all, as well as to their dealers and the owners of their works, for their immense generosity and collaborative spirit. They have enabled us to present a most challenging and engaging exhibition to what will, we anticipate, be a wide and appreciative public, whether based in Britain or visiting from abroad.

Susan Ferleger Brades
Director, Hayward Gallery

Pippa Coles, Matthew Higgs and Jacqui Poncelet Interviewed by Judith Bumpus

Judith Bumpus For the fourth time *The British Art Show* has been selected by a team of three people from very different professional backgrounds. By way of introduction I should like to ask each of you why you think you were chosen for this task. Jacqui Poncelet?

Jacqui Poncelet It's such a particular task, I would say that I've grown into the job. Professionally, I'm an artist, originally a ceramic artist, now a fine artist, which gives me a specific qualification. I've taught for many years and have only a small experience of curating. I always keep an open mind. I think it's important when you're doing a job like this, to be able to go in with an opinion, but be willing to change your mind.

JB Pippa Coles, why you think you were chosen?

Pippa Coles Unlike Jacqui and Matthew I'm not an artist. I've been working as a curator for seven years, having previously spent a lot of time looking at work and being involved with the arts in marketing and fundraising. I've also viewed British art and culture from a different perspective, having spent a year in Berlin working with DAAD (German Academic Exchange Service). Part of my time there involved organizing a conference, 'Splendid Isolation', which was concerned with British art and national identity.

My first degree was in archaeology, and I've never abandoned this interest. I draw on it when considering the ways in which context informs the development of an artist's ideas. It's certainly reflected in my work commissioning site-specific projects for public places.

JB Matthew Higgs?

Matthew Higgs I was trained as a fine artist in the painting department of Newcastle Polytechnic in the late 1980s. But I think one of the reasons I may have been considered for this project is that I operate between many different disciplines. Throughout the 1990s my work has developed as a curator, writer, publisher, artist and teacher. It's the overlaps and the relationships between these various activities that have always interested me and which inform my thinking and writing.

JB You've hinted at a certain ideology. In what way did it inform your selection?

MH I certainly hoped that the exhibition would reflect a broader constituency, a more plural idea of contemporary art practice than the last *British Art Show* in 1995. On that occasion the selectors chose to show a restricted group of twenty-six artists, all under the age of thirty-five with the exception of Lucia Nogueira. But earlier *British Art Shows* proposed a much broader idea of potential practice and, whether as a viewer one agreed with the selections or not, one was allowed to consider a wide range of approaches to making art. I wanted this show to be inclusive and to reflect, both geographically and in terms of cultural practice, a spread of interests. Although we know that artists gravitate towards the metropolitan centres for many obvious reasons, the idea was to reflect a more complex and less centrally-located story. This is especially important at the end of the 1990s, following the phenomenal interest throughout the earlier part of the decade in young British art. There's definitely a different kind of approach to thinking about and making art that this *British Art Show* has to reflect. It's about plurality.

JB Pippa, what interests, and perhaps biases, did you bring to the project?

PC From the beginning and throughout the process I've tried to be as unbiased as possible. I wanted particularly to focus on the unfamiliar. It was very important to keep the memory of less familiar work clearly in my mind. Living in Northumberland, one becomes aware of how London-centric the art world is. So, I suppose I brought a geographical bias to the project and a determination to do as much research as possible in Scotland and the North East. Scottish artists are better represented than they have been in past *British Art Shows*.

I was interested in what it means to present work made in the last five years. It seems to be such a precise, yet arbitrary, parameter. What particularly concerned me was the idea of work being 'born of the moment', and reflecting a *Zeitgeist* – not in terms of defining a movement, but understood as fresh and pertinent work.

JB Jacqui, are you as broad in your interests as the other two?

JP I think I'm broad, but in a very different way. Where Pippa and Matthew come primarily from an interest in fine art, my background began with design, and not only ceramic design.

I was very interested in architecture and town planning as well. I learned to look at painting very late on. I love looking at sculpture because I've been very interested in three dimensions from the beginning. When I look at things and when I feel passionate about them it's because they are very generous in their nature. And part of my idea of generosity might be the extent to which things are embroiled in ordinary people's everyday experience of their lives.

JB You've come closest to giving me some clue as to the kind of art you yourself like. Pippa and Matthew, can I push you a bit, or would you rather not identify your likes and dislikes?

MH Well I would hope that my use of the term plurality doesn't suggest a kind of benign liberalism, or a kind of capture-all relationship. If I were to polarize the range of my personal interests, on the one hand you might have an artist such as Billy Childish, and on the other, Stephen Willats. Billy Childish is an outsider in almost the classic sense. He's an independent musician, poet and painter who works in Kent and has done for twenty odd years, and he exists entirely outside the mainstream modes of discussion. Stephen Willats is a conceptual artist based in London, who, since the early 1960s, has been investigating the social context and the social relationships for art. And it's in the disparity between two such artists and their respective motivations that my curiosity lies. My only engagement with curatorial practice is to satisfy my own curiosity and to understand why people make things.

JB What was your brief for the exhibition?

PC The Hayward gave us two parameters. It was to be cross-generational, and to focus on work created in the last five years.

JB Were you asked to select 'the best', or how was it defined?

JP I read the contract again and it didn't say 'the best'. I was pleased about that. It said: 'The work of living artists who've made an original and important artistic contribution and whose work in the exhibition has been made within the five years previous to the opening of the show.'

PC It was to be a thorough review and was to reflect a wide range of practice. And they suggested a selection of thirty to fifty artists.

JB Matthew, how did you each, or collectively, deal with the exhibition brief? Did you have a model in mind?

MH I think it threw into clear focus the problem, which has become more acute through the 1990s, primarily because of the sheer number of large-scale biennials, triennials and so forth, of authorship in relationship to curatorial practice. On the one hand, there is the model of an exhibition which is the vision of a single individual, and on the other hand, there's a more collaborative or collective approach to making exhibitions. Both models have their problems, but in some respects the visionary model created by a single curator often produces the most engaging exhibitions because the viewer is forced to confront and to deal with a particular take on things. Where the viewer has to deal with a group of individuals with different values and strategies, he or she has a much more complex relationship with the underlying intention of the exhibition.

The team is, perhaps, the most useful model in relation to the ambition of *The British Art Show*. But it raises the question of whether the final exhibition becomes a compromised, rather than a forceful, dynamic, proposal. Certainly in its last three incarnations, and in this one, *The British Art Show* hasn't attempted a forceful, authorial proposition. This show's aimed as best it can to reflect the practice of the last five years in Britain, and, in order to get that atmosphere of reflection, you need safety valves. Counter-positions are useful in making a survey exhibition.

In selecting a list of fifty-seven artists there are bound to be moments of compromise. We only agreed unanimously on fifty per cent of the artists. The other fifty per cent were selected by a two-thirds majority.

JB Pippa, did you have a model in mind?

PC No, I didn't have a model in mind at the outset. I think this was something that was developed and defined over time. At the beginning we had a number of discussions to try and define overlapping areas of interest, of which there were several, but we did not formalize these as a model.

MH Something that came up and is very present in the current exhibition is practice that involves, or emerges from, an engagement with social and political ideas in the very broadest sense.

JB Like *Documenta X*, the international contemporary art exhibition held in Kassel in Germany in 1998.

MH Yes, certainly *Documenta X* was influential even if it was never specifically proposed as a model, because it reflected the way artists internationally are working, including many in this country. *Documenta X* was heavily criticized, but the way that the curator, Catherine David, brought out the relationships between generations, calling them retro-perspectives instead of retrospectives, suggested ways in which we, too, might put earlier practices in perspective, rather than seeing them

as dusty, museological stuff. She highlighted the idea of a slippage backwards and forwards, and the earlier work that she chose to include dealt strongly with social enquiry, institutional critique and the kind of issues and agendas that came from the 1970s. These ideas are present in the current move away from the spectacular nature of the yBas – the young British artists – and it was therefore something that we had to deal with.

JP I want to point out that in the show we haven't totally abandoned spectacle. For instance we have a multi-screen installation by Susan Hiller. What I'm really excited about in this exhibition is that we're not closing doors, but we're welcoming in. We're not saying don't be loud, don't be spectacular, don't be forceful. We're saying you're allowed, but you can also be as loud being Dean Hughes as you can be being Susan Hiller. I always say that you can whisper loudly with the same impact. One minute you'll have something that's surrounding you, literally physically surrounding you, and then the next minute you'll have something that's surrounding you because you'll have to look at it so intensely that it fills your head in another way. So if you're looking at a Kathy Prendergast map there won't be any escape. It'll envelop you, but it's a discreet thing. It just says, spend a little time with me. You won't look at a map again without relishing the thought that this map is sprinkled with words that are about people travelling and spaces and places and moments and longings.

JB Pippa, in an age in which there is no shared aesthetic yardstick, what made you say about the selection of a work, this is it?

PC Work that really excites me is work that arouses my curiosity and gives me a sense of anticipation. I suppose it's work that sustains a continual interest. It's work that I can return to again and again, that can be read in different ways. Artists can reveal something very personal about their own experience, but also make it resonate for a much wider audience, perhaps by touching a chord at a deeper, psychological level. For example Wood & Harrison video each other undertaking a highly formalized play within large-scale geometric formations. Its meaning is obscure. It suggests to me freedom and boundaries in a political sense, as well as social and personal liberty. But it's also very funny. I can't help looking at it and laughing at the futility of the actions. It's pure slapstick.

MH I want to make two points about our selection. One is that I'm surprised that we've ended up with a very traditional exhibition of objects, whether they're sculpture, painting, photography or video work. We haven't really considered other possibilities, works that operate digitally or use new

media, works that are based in performance, and artists who operate entirely through interventionist activity or processes. It's a very difficult thing for a touring exhibition to frame an artist such as Tim Brennan, who makes guided walks. And, apart from Art & Language, we haven't included the idea of collaborative or collective practice, nor have we reflected the decision of a lot of artists to return to publishing. The exhibition represents a particular approach to making things.

I guess all curators of previous *British Art Shows* must have addressed the title '*The British Art Show*'. The idea is now a very interesting one to consider because we have a shifting social and political geography in Wales, Scotland and the North of Ireland, which didn't exist in the past history of *The British Art Show*. So as we find ourselves in this unstable stability, if you can put it that way, with a more fluid idea of what British identity means, we can reflect on it without becoming dogmatic.

JB That brings me to another aspect of British identity. Here we have a team, made up for the very first time of two women and one man, and there is an imbalance of women artists selected. It doesn't reflect a British profile. Why is this?

JP I haven't found an answer to it. What I find interesting is that actually the women artists who are in the show represent a huge range of practice. The show includes Susan Hiller and Paula Rego, both making very bold statements; Anna Hunt doing embroideries; and also Tracey Emin, who's gained a certain notoriety, but actually the works of hers that we've chosen are fairly discreet, small drawings and her blankets, which are crafted and intimate. Rachel Lowe is making drawings, trying to draw a landscape on a car window in a wonderful demonstration of an ambition to master the impossible. So while I'm sad that there aren't more women, I'm very pleased with the variety of work we've included. It's sad if people choose to pick up on numbers, rather than considering what is interesting about the work of the women we've chosen in this context. It suggests a personal anxiety that I wish women would leave behind. We don't have to tell ourselves that we're inadequate. We're not inadequate and the work in this show demonstrates that very clearly.

JB Does it show, Pippa, that male art today is the more dominant voice?

PC I think there are several male artists who seem to be addressing something to do with their own identity, that seems to be fresher and more pertinent and I think more revealing, less rehearsed, rawer and more vulnerable. Kenny Macleod, for example, has produced a video called *Robbie Fraser* where the eponymous character tries to develop his own sense of

identity through a series of short statements. The identity is extremely confused, implausible as a whole, but believable in a fragmented way as a series of 'possible outcomes' or 'lifestyle options'. Wolfgang Tillmans seems to describe a kind of levity or state of bliss in the everyday, but what appears to be a documentation of an almost perpetual euphoria is undermined by *Soldiers*, a work in which media images of peacekeepers suggest that appearances can be deceptive. There are also artists in the show who expose high levels of insularity and anxiety. For instance, Dean Hughes or Paul Noble with his infinitely detailed obsessive large-scale pencil plans of *Nobson Newtown*. This doodling turned megalomania is a six-year-project in which he is developing an extraordinary urban utopia, or distopia.

JB I think, Matthew, Pippa's made an interesting point. I don't know whether you agree with her. She has found male consciousness in the art that you've looked at, a male sensitivity, particularly interesting. Have you anything to say about that and why there should be so many more men than women in this exhibition?

MH I think there's one argument that should definitely be thought about. The last *British Art Show*, in giving almost equal representation to men and women, was a unique moment in post-war British art history, maybe in the entire British art history. There the visibility of female artists was really unprecedented. One of the curious things that has occurred, perhaps as a result of that, is that various institutions and organizations have a kind of feel-good factor that the work has been done. What we've started to see towards the end of the 1990s is a drift, and maybe it's an insidious drift, back towards a dominance of male artists. In Britain we still have a very influential group of artists, a lot of whose work is associated with first-person narrative or autobiography, and I think it's harder for younger female artists to find a place for themselves in relation to works as strong as, say, Sarah Lucas's representations of herself, or Tracey Emin's quite phenomenal ability to make her own history public. It's actually closed down the possibility of finding nuances within it.

JB Now that you've selected your fifty-seven artists, I'd like to ask each of you how you see the show.

JP I always talk in terms of story-telling. Stories aren't about closing down the possibilities, they're about opening up the possibilities. A story allows you to enter it imaginatively and to join in a conversation with it. I think of the show in this way. Is this the story you would want to engage with now, about art? It's about art which is outward-looking, which is inviting you in. It's not only for artists, but for all kinds of

people. Other people with histories, with their own lives, with their own feelings and their own passions can come and get something from it. That's the kind of show I hope this is.

JB What is the story you're telling, Jacqui?

JP A very complicated one, I hope. It leads you down all kinds of routes, some cul-de-sacs, some openings. You pick up a thread of a theme, you carry it on for a bit, then you lose it. It seems to go off another way. It's mostly a visual story, although sometimes it's also verbal and uses a written language, as with Emma Kay. The pleasure of Emma Kay's work is thinking about your own past, thinking about memory, thinking about experience.

JB What identifies it as a story of this moment?

JP The artists are exploring and investigating, not only their own lives, but aspects of life around them. So you sit on one of the chairs in Graham Fagen's installation and you're confronted immediately with a visual story about a kind of ordering and manipulation of today's society. The environment isn't the most fabulous environment you've ever sat in, but that environment underpins the way that we manipulate each other and the way that we order spaces in order to take control of people and to keep them in their place and make them know their place. Once you've worked this out, you sit down and watch the video and you begin to think about the way that the manipulation moves on outside the building. I've picked on a particular aspect of the show, but there's lots of work that suggests endless nuances that spill over into our lives.

JB Pippa, this is the twenty-fifth anniversary of *The British Art Show*. It's the show for the new millennium. Does it look forward, or back?

PC I'm anxious not to talk about it as a millennial show but I think inevitably artists are working within this context. The work we've selected looks back, but it also appears to look forward in quite an optimistic way. There seems to be a sense of disillusionment with the twentieth century in much of the work. A lot of artists are addressing the collapse of modernism and its ideologies. Martin Boyce, for example, takes a modernist utopian grid which he associates with high-rise living and turns it into a spider's web. And there are others, like Graham Fagen, who reflect a similar sense of anxiety. Jim Lambie's floor-piece provides a total immersion into colour and form, but this suggests to me a kind of diversion from the problems of life, like taking a drug. Chad McCail, with his sad, dark, child-like images, is central to this show in the way he exposes injustice

and proposes a simple equality. Wolfgang Tillmans's own photographs seem to me to offer pleasures of a more spiritual life.

Many of the artists turn inwards, using their own experiences to try and explore wider issues. And I think something else that is apparent in the work is sincerity. There isn't much of the tongue-in-cheek irony which came to characterize British art at the beginning of the 1990s.

JB Matthew, what story does the show tell for you?

MH For me the show actually reflects a crisis. I think one of the advantages of the first three *British Art Shows* is that they took place throughout the late 1970s up to 1990 when there was no international curiosity about British art. *The British Art Show 4* took place at the absolute epicentre, the fever-pitch moment, of interest in young British art, so its impact, both locally and internationally was very different and it reflected a kind of euphoria. Now there is a genuine international suspicion in relation to British art. *The British Art Show 5* takes place at the height of this moment, when it's possible for overseas curators to make an international exhibition and virtually by-pass Britain and British art. So collectively we need to address critically the reasons why we should find ourselves in this situation.

Paradoxically, I think this *British Art Show* takes place at a curious, but positive, moment in British art. We haven't had long enough yet to consider our position now, and the representation of artists in the show to some degree reflects this uncertainty. The move away from spectacle, the tendency for artists to internalize, is a critical and questioning process for artists and it's a self-reflective process for all of us. Now that the international spotlight has shifted it's a really great time to be thinking about things, and a good time to be making work. And I hope that *The British Art Show 5* reflects that optimism and potential without trying to speculate on the condition of the next five years. The idea that the exhibition represents significant contributions made in the previous five years implies a backward-looking approach. So to make an exhibition which is relevant for the moment it occurs in is the highest ambition we could have had.

JB How will the show work when it's installed?

MH It's significant that in this show a number of the artists are represented by a single work. It's about moments in an artist's practice that seemed relevant and in which the artist's intention seemed fully resolved. I think in many ways the works will operate as lures, or leads. We hope they will arouse curiosity and be a stimulus to independent research, or just stay in the memory so that when you see a subsequent work you can make a kind of dialogue for yourself. This will become very important when the work is installed, because rather than offering the artists a separate, privileged space, we will, to the best of our capabilities, be offering them a conversation. The work will be seen in dialogue, or a relationship, with other works.

It seems to me that the only practical way that you can make visual the kind of conversation that's had to take place between the three of us, is to make the work operate in a conversational manner. That conversation will take place across the venues, so that it reflects the everyday pleasure of having a conversation, a kind of game of Chinese whispers, that everyone can join in.

Ars Brevis, Vita Longa / Success Can Be Overcome

Matthew Higgs

This is not an attempt to re-write the tale of British art in the 1990s. Rather it is a highly subjective consideration of some of the issues and concerns that have impacted upon British art and its reception throughout the 1990s. For those with the wherewithal and patience to construct their own spin on the phenomenon that came to be represented via the acronym 'yBa' (young British art/artists), I would refer you instead to some of the more considered – and, it should be said, more reliable – accounts published elsewhere.[1]

If we accept the commonly held, and not altogether unreasonable, assumption that the yBa phenomenon found its initial momentum through the agency of the now 'legendary' exhibition *Freeze*,[2] curated by the artist Damien Hirst in 1988, then one would have thought that it shouldn't be so difficult to negotiate the labyrinthine twists and turns that charted the development of British art throughout the ensuing decade. Yet even now, despite the voluminous literature that surrounds it, there is a striking lack of consensus as to exactly what the legacy of British art's national and international prominence throughout the 1990s is. For those of us who have subsequently become both implicated in and conditioned by its development, the story remains murky, inevitably subject to our own experience of it, and consequently bears little resemblance to its mediation in the press – both popular and otherwise. However, one thing that appears to be generally agreed is that British art is currently in a state of flux.

Writing in a recent issue of the American art magazine *Artforum* dedicated to the 'Best of the '90s', the critic David Rimanelli observed that, '*Freeze*, the exhibition that Hirst curated in a forlorn London docklands site in 1988, sent his career and those of his friends into international orbit and created the mythos of Young British Art, which has sustained many often slender talents right up through the latest "scandal" at the Brooklyn Museum. Only the wilfully ignorant would deny the significance'.[3] Restricted to a single paragraph, Rimanelli's commentary could never hope to articulate fully the complex sequence of events that led to British art's sustained international position throughout the 1990s, yet even in its condensed form it is not so far off the mark. Whilst we might readily agree with Rimanelli that only the 'wilfully ignorant' would deny the short-term significance of both Hirst's gesture and of what followed, we ignore at our peril the divisive long-term consequences of its subsequent dissemination.

For many of those 'fortunate' enough to have been at its initial private view the abiding memory of *Freeze*, apart from the fact that most of the works presented were little more than reconfigurations of earlier modernist strategies (with the notable exception of those by Mat Collishaw, Simon Patterson and Angela Bulloch), was witnessing the glorious spectacle of a neighbouring office development catching fire. This poignant image – a real-life take on Ed Ruscha's painting of the Los Angeles County Museum aflame[4] – simultaneously signalled the end of the 1980s and anticipated the eventual demise of the Thatcher administration that the Docklands re-development had come, so powerfully, to symbolize. However, Rimanelli's most telling observation – with regard to our current predicament – concerns not so much Hirst's role within the story of recent British art as the acknowledgement of the 'slender talents' that have been encouraged and nourished in the euphoria that followed.

We are currently witnessing the inevitable break-up of the grouping of some twenty or so artists associated with the formulation of the yBa: a process that probably began in the mid-1990s – around the time of *The British Art Show 4* – but which gained momentum in *Sensation*, the display of Charles Saatchi's collection of recent British art at the Royal Academy in 1997. Clearly the financial success and critical acclaim accorded to some could not be afforded to all. One result of this process has been the emergence of an elite group of some half-a-dozen or so artists – including Hirst, Rachel Whiteread, Sarah Lucas, Douglas Gordon and Gary Hume[5] – who have, by whatever means, found themselves in a position socially, economically and culturally far removed from the apparently egalitarian nature of the nascent scene with which they have traditionally been associated. (Those heady days in the early 1990s when artist-run spaces such as City Racing in London and Transmission in Glasgow seemed to provide a genuine sense of community and commonality). In their shadow lie many artists, too numerous to list here, who must now confront the – very personal – reality of being consigned to second, or worse, third division status as the international opportunities to exhibit and, more significantly, to be collected, dry up.

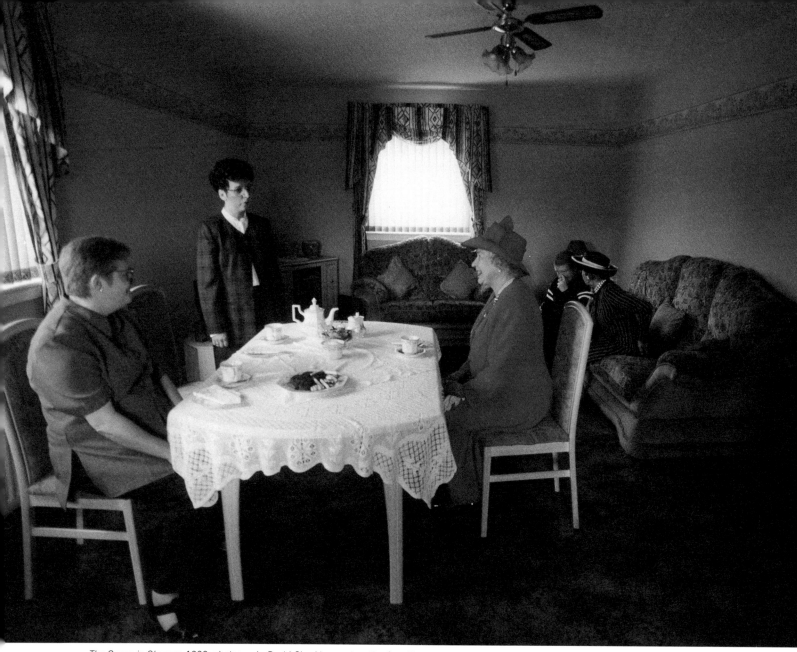

The Queen in Glasgow 1999, photograph: David Cheskin, courtesy the *Guardian*

What an extraordinary image by David Cheskin this is, an image to dwell on and to return to. It isn't simply that it shows the Queen, sharing elevenses in a Scottish council bungalow. There is something else going on here.

The room looks bigger than it is, opened-out like a kipper by the wide-angled lens. The camera affects a disinterested gaze, taking everything in equally. It shows a room almost without character, tidied and arranged like a furniture-shop display, not a cushion out of place. The distances between the objects in the room, like the apparent distances and separation of the people who inhabit it, are accentuated by the camera. The wide angle makes it difficult to tell quite how near or far from one another the people are. There seem to be huge distances, both physical and psychological, between them.

The camera points straight down the room, dividing the image in two and separating the Queen from the two women at the other side of the table. The white tablecloth and the white light at the far window also keep them apart, just as the end of the table nearest us forms a kind of barrier, keeping us, and the photographer, on the threshold of the scene. Even the dismal symmetry of the objects on the tablecloth – the untouched plate of biscuits, the paraphernalia of a very British tea ceremony – fixes the mood. The Queen looks across the table, her eye-level at the midpoint of the image, looking directly ahead across this central, pictorial gulf.

If this scene were really pictorially contrived, with a painter's guile, with rulers and a set square, it could not look more rigid, more composed. The Queen, in perfect profile and dressed in a symphony of fuchsia, stares directly ahead, as though through the window that faces her. What is unnerving is not just her unnatural profile, nor her formal posture, but her fixed smile, the Regal rictus. The Queen and her lady in waiting appear not so much dressed for the occasion as costumed. The shell-suited boy in the corner wears the uniform of youth.

The boy is being kept quiet, neutralised as a presence both in the photo and in the room itself. What might the lad say, should he be allowed to the table? One is drawn to this far corner of the image, because it provides a moment of constrained liveliness, of the possibility of things going wrong. The boy's finger is at his nose. He looks down at the mud-coloured carpet. The lady in waiting adjusts her clothing. Perhaps it has snagged on the sofa's pile.

The most unsettling thing about the scene is that all five people are having trouble looking one another in the eye. The seated tenant mirrors the Queen's pose. Both sit slightly forward on their chairs. The Queen holds her gloves, while the other probably only feels the sweat on her palms. The woman standing, hands to her sides, wears a name-tag. She's a housing officer. Standing, she appears proprietorial.

The image is stilled and stilted. It has no real human warmth, only social unease. It reminds me of one of those moralising 19th-century narrative paintings (*When Did You Last See Your Father?*, perhaps, or *What Is The Purpose Of Your Visit To Germany?*).

But I think even more of one of Sam Taylor-Wood's choreographed photos, which were in last year's Turner Prize. In them, we see contemporary loft-dwellers at home, posing in their groovy apartments for the camera and each other. This picture, however, has no spontaneity; it has the quality of a tableau. They could be stuck like that, in that room, forever. It is a terrific photograph.[6]

© Adrian Searle, 1999
Courtesy the *Guardian*

This Darwinian struggle – a gladiatorial survival of the fittest, ultimately played out in the auction houses of London and New York – is of course not a new concept, and certainly not one unfamiliar to the art world. Yet its relative novelty – in Britain at least – and its knock-on effects will have serious implications for contemporary art in Britain. Observers and commentators both at home and abroad tend to agree that the initial generous reception afforded to British art at the outset of the 1990s was incrementally eroded as the decade rolled on, to be replaced by a deeply-entrenched scepticism. The seemingly endless succession of group shows dedicated solely to British art that circumnavigated the globe throughout the 1990s[7] has, paradoxically, had a counter-productive effect, engendering a kind of 'art-lag', a collective weariness with British art that has accelerated its marginalized presence internationally. Whilst the rationale for the exclusion of significant numbers of British artists from recent large-scale international exhibitions such as *Manifesta 2*, *Documenta X* and the 1999 Venice Biennale[8] is no doubt complex, one can't help feeling that British art has perhaps had its day.

Admittedly this is a fairly bleak picture and I accept that I could be accused of being unduly pessimistic. For it is certainly true that contemporary art's mediation, in Britain at least – via the twin agencies of the popular press and television and their various satellites – continues apace. Likewise British artists continue to figure as permanent fixtures in the lifestyle supplements alongside celebrities drawn from the more traditionally fame-fixated worlds of pop, fashion and sport. It is also true – and the statistics exist to prove it – that more people are visiting contemporary art exhibitions in Britain than ever before: the annual *Turner Prize* exhibition at London's Tate Gallery posts ever higher attendance figures, the audience for *The British Art Show* grows with each five year instalment and the income for the Royal Academy's display of *Sensation* broke box-office records for an exhibition dedicated solely to British contemporary art. In 2000 Britain will witness the continued growth in new Lottery-supported institutions dedicated to the visual arts.[9] So on the one hand we could be forgiven for thinking that everything is going to be alright; that the drive – both socially and politically – towards increased accessibility and awareness for the visual arts in Britain is becoming a reality. Yet beyond the media gloss and statistics one can't help feeling that little consideration (or support) has been given to developing and sustaining a culture that questions both the nature and intention of these institutions and of the art they will display – or indeed where the money will come from to ensure their survival.

Writing in the *Guardian* about David Cheskin's photograph of the Queen's visit to the Glasgow home of Susan McCarron,

Amanda Foreman stated categorically that it represents '… one of the most important artefacts of the Elizabethan reign. It will reveal more to historians in the next century than any number of articles and newsreels.'[10] Foreman – it could be argued – might have added artworks to her list of possible historical referents, inasmuch as we continue to interpret history through its cultural by-products, whether they be novels, plays, music, paintings, sculptures or video installations. However, Foreman is probably right in suggesting that Cheskin's extraordinary image reveals more about the disparity and discrepancies existing within British culture at the end of the twentieth century than any number of newsreels, articles – or, for that matter, pickled sharks, bloodied heads and dishevelled beds[11] – could ever hope to. Adrian Searle's brief dissection of this image (printed in full on page 14) was one of the most acute pieces of 'art' writing of the late 1990s. His response reveals a desperate attempt to reconcile an increasingly out-moded monarchy (and all it stands for) with its increasingly disenfranchised subjects. Cheskin's image graphically illustrates the irreconcilable economic and cultural divide that persists at the heart of British society, despite what the incumbent government and its agents would like us to believe.

We could have been forgiven for thinking, throughout the 1990s, that it was enough that British artists were – like Susan McCarron's son in Cheskin's photograph – best 'seen and not heard'. Critical dissent – whether by action or by words – was for most of the decade a deeply unfashionable position to avow. Voices of dissent – whether oriented by gender, race, sexual preference, intention or political allegiances – were silenced by their marginalization. To be actively critical of British art during the decade was to be associated with either the 'Emperor's New Clothes' brigade led by the *Evening Standard*'s Brian Sewell and *Art Review*'s David Lee or worse, to be ostracized from the party, as can be witnessed by the largely dismissive response to an organization such as BANK which has challenged head-on – and with some wit – the pomposity of almost every British art institution. This absence of critical engagement and dissent from within is perhaps the most significant legacy of the yBa phenomenon. Curiously, and with no sense of irony – post-*Sensation* – to be actively critical of the current condition of British art, or at least to distance oneself from the very phenomenon that provided so many opportunities for so many 'slender talents' (artists, critics and curators alike) is now potentially the only reasonable position to adopt.

As we have seen, British art was largely exported throughout the 1990s. At home the field was – somewhat inevitably – left open for one man to attempt to establish the branding

of British art. The title of the recently published tome *Young British Art: The Saatchi Decade*[12] accurately reflects the collective inability of British institutions to come to terms with the art produced in its own backyard in the 1990s. It is significant that even now we have yet to see substantial exhibitions in British institutions by artists such as Sarah Lucas, Liam Gillick, Douglas Gordon, Angela Bulloch, Gillian Wearing, Cerith Wyn Evans, or BANK, for that matter, That most of these artists, and others like them, elected instead to establish their reputations elsewhere should come as no surprise. That Charles Saatchi could go on record as saying that '90% of the work I buy could be worthless in ten years time to anyone but me',[13] should not be read as disingenuous. I think he really believes it. His suggestion that a significant proportion of the British art contained within his collection might be simply of – and only of – its time, of interest only to him, signalled not only the overall diminished durability of British art but our limited expectations of it.

Of course not all art produced in Britain during the 1990s could be ascribed to this condition of temporality. Yet for a significant part of the decade an art based on novelty, an art that relied upon both the spectre and spectacle of theatricality, became the dominant form, the common currency of British art that ultimately contaminated the wider perception of all art produced in Britain throughout the 1990s. As the market and the media's thirst for ever more novel commodities grew, many artists increasingly found themselves trapped and undermined by the very novelty that had allowed them their fifteen minutes in the limelight. Living in fear of sacrificing its short-term benefits – a few pounds in the bank, the odd article in a respectable journal, a part-time teaching position, invitations to the better parties – notions of development and progress, the very idea of radical shifts or, for that matter, protracted self-reflexive periods of non-production, became anathema for most practitioners. In a reversal of the age-old adage that *ars longa, vita brevis* (art is long, life is short) we might reasonably propose that its antithesis, *ars brevis, vita longa* (art is short, life is long) was more appropriate to much of the art produced in Britain during the 1990s – inasmuch as art's residual effect, its ability to transcend its moment, was seriously compromised – and that life, despite art's temporary physical presence within it, would continue regardless. Likewise theory, the once dominant discourse that underpinned art's developments during the 1970s, '80s and early '90s, found itself hopelessly adrift, unable adequately to reflect upon an art that no longer sought its comforting intellectual reassurances.

I can't remember which poet it was, but when he said that 'Success can be overcome', I think he was making the fairly straightforward observation that success is a double-edged sword. Success needs to be monitored, its excesses kept in check, if we are to benefit from its attention and lead productive, meaningful lives. In 2000 *The British Art Show 5* finds itself in a quandary, its very rationale questioned by the recent social and political upheavals in Britain. The title of the exhibition – *The British Art Show* – is now more problematic, and paradoxically more pertinent, than at any previous time in the exhibition's history. The very idea of attempting to present a coherent national display of cultural artefacts appears increasingly untenable, increasingly anachronistic. The last *British Art Show* in 1995/96 took place in a very different social climate. It elected to present the work of only twenty-six artists, consolidating the careers of a generation of artists – mostly under the age of thirty-five and mostly based in London – who for the most part continue to dominate the broader reception of British art to this day. In the ensuing five years it has become clear that we can no longer be so confident about this process of consolidation. The effects of the relatively recent change in government and the shifting social and political geographies in England, Scotland, Wales and Northern Ireland have yet to impact tangibly upon cultural life in Britain. Yet it is already apparent that the initial optimism that accompanied Tony Blair's rise to power is increasingly tempered by the mundane reality of New Labour and its often simplistic ambitions for a Creative Britain – a scenario neatly illustrated by the current fiasco that is the Millennium Dome. For better or worse Britain – and *The British Art Show* – find themselves in a fragile state of flux.

Yet perhaps this moment of flux, a moment that coincides with the diminished international profile for British art generally, provides us with a useful breathing space, an opportunity to reflect upon and re-evaluate the current status and future potential of British art, a process that *The British Art Show 5* is undoubtedly engaged upon. Perhaps the ultimate legacy of *Freeze* is that it graphically illustrated that artists should never rely upon or trust an institutional culture to accommodate and filter their ambitions and desires. The sense of shared responsibilities, the collective desire to make something happen, that fuelled so many artist-led initiatives at the turn of the decade was the determining factor that allowed British art to re-establish itself both nationally and internationally in the 1990s. That this culture allowed itself both to capitulate to, and to be compromised by, the very orthodoxy it set out to challenge, was its greatest failing. Yet 2000 bears witness to a renewed sense of urgency within the artist-led sector. In the face of the new, benign, state and lottery-funded institutions – with their misplaced emphasis on accessibility and education – the *raison d'être* for artist-led initiatives has never been greater. Recent models, whose founders are all

Handwritten annotations throughout:

(top) oh great! thanks! Radio 4

Michael Raedecker's new works are a departure from the suburban bungalows depicted in his recent solo show in London. Here Raedecker creates brooding landscapes, still using his signature delicate threads combined with thickly caked paint. These landscapes are still, sad and full of longing. *Michael Raedecker (b. Amsterdam, 1963) had a solo exhibition at The Approach Gallery earlier this year.*

Handwritten: lose the comma for more accuracy. Good perfume ad. feel tho:

Handwritten: PATRONISING - Good! Good old David!

David Thorpe's collages of delicately cut-out sugar paper create romantic dreamscapes from the urban grit of South East London. Paeans to traditionally despised modernist architecture, Thorpe rescues council flats and Thames estuary bleakness and turns them into a contemporary sublime: thrilling sites for beauty and the adventure of the possible. *David Thorpe (b. London 1972) graduated from Goldsmiths College MA this September. He exhibited in the Post-Neo Amateurism exhibition at the Chisenhale Gallery, London earlier this year.*

Handwritten: "traditionally despised modernism"? WHAT IS WRONG WITH YOU? Not really - Indian miniatures are good, though - these are crap. Meaningless - Good!

Jane Brennan's paintings of flowers and birds and jewels are small and perfectly formed, reminiscent of Indian miniatures. Modestly requesting our attention, they are not ironic, they are heartfelt and honest. There is something Victorian in their delicacy and simplicity. *Jane Brennan was born in London 1966.*

Handwritten: I'm going to be sick - good. Ahhh! Very good. You said it! What about Peter Blake?

Steven Gontarski's plastic sewn sculptures fuse high renaissance marble sculpture and sci-fi fantasy forms. Hybridised sexuality mixes easily with dance aerobics to create works of great energy and grace. His *Lying Active* which greets visitors in the Lower Gallery is a homage or 'cover version' of Michelangelo's most profoundly homoerotic work *The Dying Slave. Steven Gontarski was born in Philadelphia 1972.*

Handwritten: Incredibly pretentious - GOOD! This sentence doesn't make sense - you're combining reality and metaphor.

Shaun Roberts and Gilbert McCarragher's film combines the art house style of Gus Van Sant's *My Private Idaho* with the easy seductions of the music video to describe the body image pressures of a young gay male Londoner. The softness and style of the film echoes the fetishising of pain and problems that have become the staple of day time TV. *Shaun Roberts was born in Leeds 1958, and Gilbert McCarragher was born in Armagh, Northern Ireland in 1970.*

Handwritten: This doesn't make logical sense -

Martin Maloney has developed an informal style of painting which sometimes uses exaggeration or ugliness to tell a story or depict a character. His painting in the Upper Gallery is based upon Poussin's *The Choice of Hercules*. Updating a narrative tradition he has revamped the image into a 90s world of single mothers, friendly Sloanes and over-tanned male narcissists. In the past Maloney has revisited many forms of genre painting such as flower painting, portraits and 'conversation pieces'. *Martin Maloney was born in London in 1961. He participated in the Sensation exhibition at the Royal Academy in 1997.*

Handwritten: Err... 'revisited' is only accurate if he used to do this crap before; which isn't clear. Meaningless - Good.

Caroline Warde's cast painted resin animals provide an eery presence within the gallery. Seamless, luscious and suffocating these creatures create a gothic aesthetic from nature. *Peach Branch* offers forbidden fruit: frozen and blackened, while *Deer* arches its back dangerously on the brink of disaster. *Caroline Warde was born in London in 1973. She was selected for this year's New Contemporaries.*

For more information please consult the exhibition catalogue (available at the ICA Bookshop, priced £9.99) and the exhibition website at http://www.pinkink.net/gallerychannel/dysp. (website curated by Pink)

Handwritten: Generally good sick-making slippers-and-Horlicks 'call to order' advertisement, which is all the more alarming because these "young" fogeys mean to be limp, dried up and middle-aged. SCARY!

Handwritten: 5/8 / 10 'Young' fogey art, good!

Logos: ICA SUPPORTED BY Sun microsystems — Institute of Contemporary Arts

THE BANK FAX-BAK SERVICE Help Yourselves!

Martin Creed
Work No. 203 1999
Commissioned by Ingrid Svenson
Photograph: Hugo Glendinning

too aware of the sequence of events that undermined their predecessors' efforts, provide us with a blueprint for a renewed sense of locality and community, which might in turn present a revitalized challenge to the orthodoxy and complacency so symptomatic of British art's passage through the 1990s.

Organizations as diverse – in both their intention and administration – as Locus+ in Newcastle, the All Horizon's Club in Liverpool and Glasgow, The Annual Programme in Manchester, Catalyst Arts in Belfast, The Modern Institute in Glasgow, the Proto Academy in Edinburgh, Salon 3, SaliGia, The Pier Trust, BANK (persistently), Arthur R. Rose, dot, Deutsch Britische Freundschaft and the late (and lamented) Info Centre in London, and publications such as *British Mythic*, *Stop Stop*, *Inventory*, *break/flow*, *Variant*, *everything*, *CRASH!* and *mute*, provide us with a degree of optimism for British art's development in the forthcoming decade. These organizations, and others like them, address the desires of artists – and the desires of the communities in which they choose to operate

– in a manner that suggests a more critical engagement with their participants and audiences alike. Often eschewing accepted means of production and distribution, often operating on shoe-string budgets outside the state-supported funding system, they are engaged in the consideration and promotion of an art that no longer subscribes to the indecent haste and short-termism that determined and overshadowed so much of the art produced in Britain throughout the 1990s.

In some respects, *The British Art Show 5* reflects some of these tendencies, in other ways it probably cannot and probably should not attempt to frame practices whose very rationale, whose modus operandi almost denies the possibility of their inclusion in such a survey. Yet a great deal of the art in the current exhibition shares concerns with the intentions of the art promoted by these various agencies – and in many cases is the art that has been persistently supported by them. It could be argued that British art is increasingly conditioned by a more reflexive, more internalized response to current social, economic and political realities. This condition – which

might (inadequately) be categorized by the term 'informalism' – is present in the activities of artists as distinct as Chad McCail, Lea Andrews, Jeremy Deller, Lucy McKenzie, Paul Seawright, Kenny Macleod, Runa Islam, Graham Fagen, Martin Creed, Grayson Perry, Hilary Lloyd, Liam Gillick, Jim Lambie, Paul Noble and Wolfgang Tillmans; artists whose works deal, variously, with issues of gender, race, class, sexuality, politics, idealism, boredom and pleasure. As yet, this informal grouping – and others like them – does not provide us with coherent strategies for the future unfolding of visual cultural practice. This is, of course, as it should be. *The British Art Show* should never be thought of as a debutante's ball or passing out parade. Rather it should be celebrated as a transitional moment around which we can consider and speculate upon the current rationale and future implications for British art. If it is about anything at all, *The British Art Show* is about potential, and it perhaps offers us a renewed sense of optimism for British art, a new sense of engagement that reinforces the hope that success might, indeed, be overcome.

Notes

1
The best of which include: Matthew Collings's urbane and criminally under-rated *Blimey! From Bohemia to Britpop: The London Artworld from Francis Bacon to Damien Hirst*, 21, Cambridge 1997; Julian Stallabrass's pointed *High Art Lite*, Verso, London/New York, 1999; Patricia Bickers's valuable and early account of the international reception of British art, *The Brit Pack: Contemporary British Art, the View From Abroad*, Cornerhouse, Manchester, 1995; David Burrows's edited collection *Who's Afraid of Red White & Blue: Attitudes to Popular and Mass Culture, Celebrity, Alternative & Critical Practice & Identity Politics in Recent British Art*, University of Central England/ARTicle Press, 1998; and *Occupational Hazard: Critical Writing on Recent British Art*, Black Dog Publishing, London, 1998, edited by Duncan McCorquodale, Naomi Siderfin and Julian Stallabrass.

2
Conceived and curated by Damien Hirst in 1988, *Freeze* presented works by Steven Adamson, Angela Bulloch, Mat Collishaw, Ian Davenport, Dominic Denis, Angus Fairhurst, Anya Gallacio, Damien Hirst, Gary Hume, Michael Landy, Abigail Lane, Sarah Lucas, Lala Meredith-Vula, Richard Patterson, Simon Patterson, Stephen Park and Fiona Rae.

3
David Rimanelli, *Artforum*, December 1999, p. 122. The 'scandal' to which Rimanelli refers was the furore surrounding the inclusion of Chris Ofili's 1996 painting *The Holy Virgin Mary* at the Brooklyn Museum's display of *Sensation* and New York's Mayor Giuliani's subsequent attempts to withdraw funding from the museum on the grounds that Ofili's work was offensive to the Catholic faith.

4
Ed Ruscha, *Los Angeles County Museum on Fire*, 1965–68. Collection Hirschhorn Museum and Sculpture Garden, Smithsonian Institution, Washington DC.

5
Others such as Peter Doig and Jenny Saville have largely avoided being associated with the yBa phenomenon.

6
Adrian Searle, *Guardian*, 9 July 1999, p. 3.

7
The most significant of which include: *General Release: Young British Artists at Scuola di Pasquale*, Venice, 1995, *Brilliant!: New Art From London*, Walker Art Center, Minneapolis, 1996, *Live/Life: La scène artistique au Royaume-Uni en 1996 de nouvelles aventures*, Musée d'art moderne de la ville de Paris, 1996, *Pictura Britannica: Art From Britain*, Museum of Contemporary Art, Sydney, 1997 and *Real/Life: New British Art*, Tochigi Prefectural Museum of Fine Arts, Japan, 1998/99.

8
Manifesta 2 included amongst its 40 plus European artists only two British artists, Richard Wright and Christine Borland, both Glasgow-based. *Documenta X*, Kassel, 1997 included a number of senior British practitioners, including Richard Hamilton, Art & Language, Alison and Peter Smithson, and Archigram. The younger British artists represented there did not conform to received notions surrounding the yBa: they included Liam Gillick, Heath Bunting, Steve McQueen and Adam Page. Harald Szeemann's 1999 Venice exhibition *APERTO over ALL* included work by only two British amongst its 100 plus artists; Douglas Gordon and Roderick Buchanan, again both Glasgow-based.

9
Recently opened or about to open venues include: the re-built Ikon Gallery in Birmingham; Cardiff's Centre for Visual Arts; Dundee Contemporary Arts; the Milton Keynes Gallery; Baltic, Gateshead; the New Art Gallery, Walsall; The Dean Gallery, Edinburgh; and Tate Modern, London.

10
Amanda Foreman, 'Uncommon Touch', *Guardian*, 9 July 1999, p. 2.

11
The works referred to are: Damien Hirst, *The Physical Impossibility of Death in the Mind of Someone Living*, 1991; Marc Quinn, *Self*, 1991; and Tracey Emin, *My Bed*, 1999.

12
Young British Art: The Saatchi Decade, Booth-Clibborn Editions, London, 1999.

13
Quoted in Matthew Slotover's review of *Young British Art: The Saatchi Decade*, *frieze*, issue 47, June–July–August 1999, p. 112.

British Art and The British Art Show 1976–2000

Tony Godfrey

For those of us who went to the fourth *British Art Show* in 1995 and who could remember the first *British Art Show* in 1979 it was extraordinary to think not only how much the art had changed, but how differently the exhibition was organized, and how dissimilar the artists seemed to be. Five years on and the fifth *British Art Show* reveals still further changes. There were no balloons or videos in 1979: almost every work was a painting or sculpture. By 1995 it was difficult to define the majority of works as either painting or sculpture. Of course, this reflected international changes. If in the 1970s the world's most revered artist was Jasper Johns, whose work, however experimental, was always within a tradition of painting, in the 1990s it was Bruce Nauman, who made videos, installations and text pieces, but never paintings. Johns's work was concerned with quality, Nauman's with problems. Broadly speaking, since 1979 it seems that the art world has changed from something like a gentleman's club to a website and that the large group show has been transformed from an anthology to an argument. Most generally, we see a shift from patronage to curatorship – symptomatically the selectors of *The British Art Show 5* are for the first time called, by their preference, curators.[1]

Every five years the creation and reception of *The British Art Show* acts as an indicator of what has happened and will happen – indeed it has been a significant agent in fostering change. *The British Art Show* has always been contentious, in its very nature as well as its execution. Or, put another way, *The British Art Show* has always mattered: for what it did, what it failed to do and how it did or did not do it.[2]

To understand how much the profile of the artist has changed we should go back to the photographs in the catalogue of *The British Art Show 1*. We see a crew of somewhat dowdy and unsmiling art school teachers, invariably dressed in unbuttoned shirts and/or jumpers. Compare this to photographs of the artists who appeared in *The British Art Show 4*. They are more glamorous, younger, more knowing, more ironic. Look, for example at Jane and Louise Wilson in 1995 when, just before they showed in *The British Art Show 4*, they posed for *Time Out* as fashion models: Louise wears a snakeskin-look Joseph suit (£595), Jane a Paul Smith jacket (£309). They seem simultaneously to parody the images of artist and model: Jane has a Q-tip in her ear, Louise examines

another. In the accompanying blurb they jest: 'Have you ever bought a bespoke suit?' 'Never,' replies Louise, 'but I wore a giant chicken for the school play.' They are at ease with the camera and the media, able to spoof it. Indeed such a spoof could be seen as part of their work.

The artists in *The British Art Show 1* belonged to the generation that had grown up during and just after the Second World War and had emerged from art schools when the influence of American-style modernism was at its peak. To be an artist was a vocation, a serious, po-faced business. Jane and Louise Wilson and their contemporaries grew up in the 1970s and 1980s when modernist notions of progress faded, when all forms of representation, not just painting and sculpture, came to be widely recognized within the remit of art.[3] We are looking at a shift from art as a worthy thing in itself to art as something more dependent on everyday personal life.

Arte Inglese Oggi at Milan in 1976, organized by the British Council, was perhaps the most substantial exhibition of 'contemporary' British art ever and to some extent acted as a model for all subsequent such survey exhibitions.[4] The artists were drawn almost exclusively from British Pop, American-style abstract painting, New Generation Sculpture or Conceptual Art.[5] Most of them were aged between thirty and forty-five: it was, therefore, a generational show that excluded an earlier generation of artists, including the two most famous names of all, Francis Bacon and Henry Moore.[6] Also, crucially, the exhibition was the exact opposite of the salon or Royal Academy-type show where works are hung cheek-to-cheek and stacked above each other: instead, forty-seven of the artists were given a room each, so that the show seemed like a succession of one-man shows. The post-war artist, it was argued, thought in terms of the room,[7] and also you needed a body of work to understand his or her personal language.

The artists of *Arte Inglese Oggi* had posed together in Trafalgar Square for the photograph in the catalogue, but despite their fur, leather and Afghan coats and their wind-tousled hair they were clearly 'the establishment': most of these were artists who had teaching jobs, who had contracts with commercial galleries, who were the chosen ambassadors of British

The British Art Show 1 1979 – 80
Installation shot: Graves Art Gallery, Sheffield

culture. Yet some of the artists included neither felt part of a like-minded community, nor felt comfortable with the principles of selection: Victor Burgin used his catalogue text to attack the art world's resistance to theory, its escapist acceptance of art for art's sake, the bankruptcy of abstract painting, the 'blind anti-intellectualism in the art schools';[8] R. B. Kitaj, from a very different viewpoint, warned the Italians to treat the exhibition with caution because it was filled with 'every aspect of modernist fragmentation … a new academy, a new establishment disguised as an avant-garde'.[9] He especially decried the absence of such artists as Lucian Freud and Frank Auerbach whom in the same year he had made central figures in the exhibition *The Human Clay*, which he had organized for the Hayward Gallery, and which proposed life drawing as the panacea for the ills of late modernism. Whether exhibitions should refer to radical theory or artistic tradition was to be an ongoing question.

The late 1970s was a time rich in contentious exhibitions that proposed different solutions to what was being described as 'the crisis in British art'.[10] In 1977, *Towards Another Picture* combined high with 'low' art such as popular paintings by David Shepherd and art from working class clubs, to act as

a critique of what the curators Andrew Brighton and Lynda Morris termed the 'official orthodoxy of the Tate *et al.*'; in *Narrative Paintings*, a selection of confessional paintings shown at the Arnolfini in 1979, Timothy Hyman called, as Kitaj had done, for a return to the figure; *Art for Whom?*, selected by Richard Cork in 1978, and *Art for Society*, at the Whitechapel Art Gallery in 1978, both emphasized the social role of art and the sort of art a leftist position seemed to require; *Lives*, selected by Derek Boshier in 1979, proposed, prophetically, a turn to the everyday. It seemed that critics and artists were like rutting deer, each standing on a hillock proclaiming the unique potency and validity of the art he championed.

Where was British art going? What was the point of it? For whom was it intended?

It was in this fissiparous situation that the Arts Council initiated a series of survey exhibitions at the Hayward: the first *Hayward Annual* opened in 1977. There was a feeling that modernism had run its course or at least that its future was uncertain. It was a broad river that had dominated a valley but had now dried up or split into a hundred meandering rivulets.[11] A survey could show that the centre would hold,

The British Art Show 1 1979 – 80
Installation shot: Graves Art Gallery, Sheffield

that there was a sense of community: like the *Whitney Biennial* in New York it would also be democratic, allowing all artists a chance to be seen.[12] As always with a survey show, it revealed two often contradictory roles: to show what was happening and to indicate what was worthwhile, that is, in effect, what should be happening. The first *Hayward Annual* was selected by Michael Compton, a curator from the Tate, and two artists, William Turnbull and Howard Hodgkin. It followed the precedent of *Arte Inglese Oggi* in giving each of the thirty artists an entire room,[13] but as so many of the artists were represented by one commercial dealer (Waddington and Tooths) this made it seem like a sequence of commercial exhibitions and it was denounced as such by critics.

The critic Richard Cork spoke for many in denouncing it as a 'back-slapping old boys' reunion', redolent of Buggins' turn, and claimed that most of the work was fifteen years out of date.[14] Even William Packer of the *Financial Times*, a cautious rather than radical critic, remarked that he thought it would be an opportunity to show 'the new and unfamiliar, work that was radical or experimental … but in fact the same old names surface, the safe establishment'.[15] But the *Hayward Annual* was following a shift from surveys showing the great and the good to those showing a specific generation – almost all of the artists here being aged between thirty-two and forty-seven.

It was in this atmosphere that the first *British Art Show* was commissioned and organized. It was intended to present the 'state of the nation', to review the best or most original art made in the previous five years. It was also intended to take art to the regions: it had been a long-standing complaint that too great a proportion of art events happened in London only. Moreover, the exhibition was not to be just crumbs from the rich man's table, but a veritable feast. This decentralizing tendency was also seen in the recurrent ambition to include artists from outside London – an intent that rarely brought as much reward as was hoped. The exhibition was not meant to promote an agenda for future art but, inevitably, all survey shows are read as doing just that.

William Packer, respected as a 'safe pair of hands', was chosen to select the show and he dutifully spent eighteen months going to studios around Britain. If the model for *The British Art Show* was the salon, then this first exhibition, including 283 works by 112 artists, was the closest of all five to that model.[16] With so many artists represented by only one or two, often small, works, it was difficult for anyone to stand out. This tendency was accentuated by the installation. There was a plethora of screens, and works were hung within inches of each other so that it seemed just like an academy salon, or a trade fair, or the reserve collection of a museum. The vast majority of the artists shown in *The British Art*

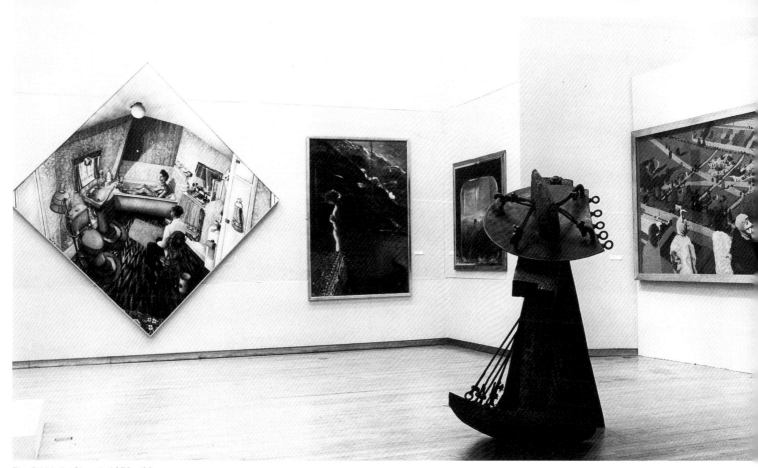

The British Art Show 1 1979 – 80
Installation shot: Graves Art Gallery, Sheffield

Show 1 were also art school teachers, and one would characterize their work as competent rather than innovative. This was *The British Art Show* where formal, academic criteria dominated the selection. Most of the paintings and sculptures were abstract (prime exemplars being John Hoyland and Anthony Caro) though there was a hearty sprinkling of rather wacky figurative work. Despite the number of artists the work looked strangely similar. Like porridge with all the lumps carefully stirred out, it was well done, but rather dull.

The omission of any conceptual or confrontational work ensured the selection was partial and apolitical. Packer's defence was that it was a personal selection – which is what he had been asked to produce. Also, no doubt, he wanted to be emollient, to pour oil on troubled waters, to show the inherent unity of the art world: he had written as the *Hayward Annual* brouhaha spilled into the public arena that 'the controversy is mistimed and the energy is misdirected. We are all embattled and should know that our right place is together, on the same side.'[17] But, given that this was a time when the art world was so highly politicized, such apoliticism was itself political.

Although everyone agreed that Packer had done an hon-ourable job – it was an accurate survey of what was happening – that accuracy did not make for either high quality or excitement. This was never the best of British art, rather the best of particular types of art, mainly by one generation: arguably, this was an exhibition dominated neither by the first eleven nor the youth team, but by the second eleven. The exclusion of such big names as Bacon and Moore set a precedent that could not be rescinded. However, the competence of the artists selected spoke much of the serious-ness and calibre of British art schools. If the artists who were to dominate the subsequent *British Art Shows* were more spectacular and daring, it was undeniable that they owed a good deal to the teaching of this preceding generation.

In 1979, Packer had felt able to say that modernism had slowed down, allowing a 'period of reflection and consolida-tion',[18] but it was clear by the mid-1980s that a storm of activity from unexpected areas, expressive figurative painting and image-orientated sculpture, had swept across the land-scape. The ideas and attitudes of conceptual art were also reappearing. British art, in line with that elsewhere, looked diverse, energetic and indecorous.

If the late 1970s had seemed a time of crisis, with much pious beating of the breast, the early 1980s was a far more dynamic period when art was not a matter of mutually exclusive posi-tions, but was marked by a blurring of distinctions. In 1981 the exhibition *A New Spirit in Painting* at the Royal Academy

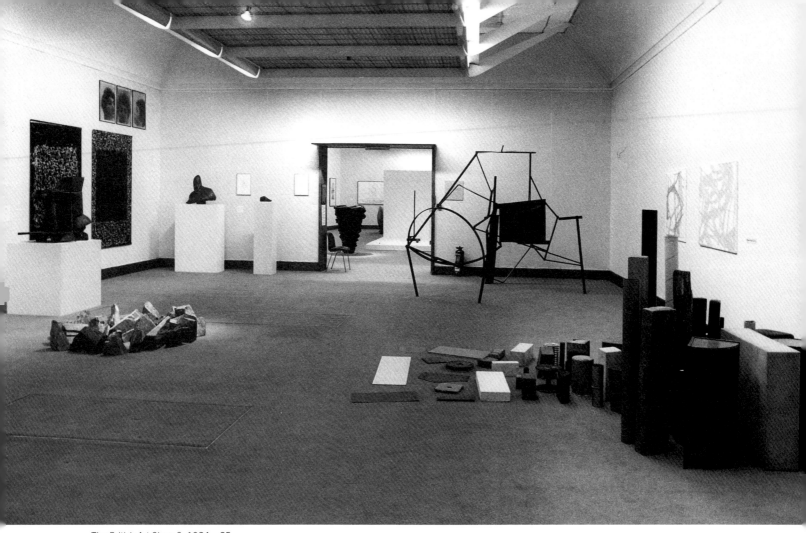

The British Art Show 2 1984 – 85
Installation shot: City Art Gallery, Birmingham

had introduced the work of Georg Baselitz, Francesco Clemente and Anselm Kiefer to England, whilst a whole stream of sculpture exhibitions, beginning with *Objects and Sculpture* at the Arnolfini and the ICA in 1982, had heralded a new generation of image-inspired sculptors. Just before *The British Art Show 2* opened, Malcolm Morley had been awarded the first Turner Prize, to general scandal: he lived in America not England; conservative critics protested that he could not paint. Had the rule of fashionability replaced that of Buggins' turn? What it certainly proved was that the canon of major British artists as presented in *Arte Inglese Oggi* or the first *Hayward Annual* was no longer set in tablets of stone. Historical importance, a place in the Tate and sales were up for grabs – whereas the art market had been in the doldrums through the 1970s it was now relatively healthy.

For *The British Art Show 2* in 1984, rather than reflecting a single man's taste, three people (Jon Thompson, then teaching at Goldsmiths College, the Scottish figure painter Sandy Moffat and the young curator Marjorie Allthorpe-Guyton) sought to make an exhibition that would be both survey and argument. Andrew Brighton astutely remarked in *Art Monthly*

that 'virtually all the work in the 1979 show could have been made as if Duchamp had never lived. The 1984 catalogue starts with a quote from him.'[19] Of the first *Hayward Annual* Caroline Tisdall had written that 'playing safe makes for smooth careers and kills cultural life. Controversies, question-ing, pushing things a bit further should all be part and parcel of a dialogue with the public. Why shouldn't there be out-rages occasionally, rather than drifting in and out of soporific shows with never a question asked?'[20] Jon Thompson, in his catalogue essay, actively sought such a dialogue, berating the influence of American culture and claiming the way forward was through a more poetic, European tradition. Several artists also sought argument and controversy, notably, Alastair MacLennan from Ulster with his endurance performances that involved pigs' heads and entrails, and dead fish, with him wearing tights over his head.[21]

Both catalogue and exhibition were divided into seven thematic sub-sections such as 'Reinventing the Real World', 'Critical Attitudes' and 'Visual Poetry'. This had the salutary effect of making one think in terms of ideas rather than media or styles. There were several other ploys to escape the look

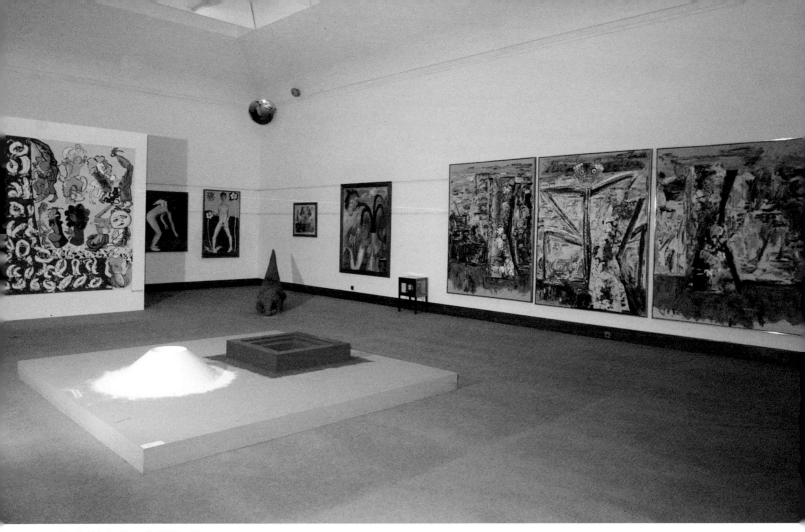

The British Art Show 2 1984 – 85
Installation shot: City Art Gallery, Birmingham

of the salon and the feel of patronage. Compared to the two-and-a-half-page foreword in the catalogue of *The British Art Show 1* there were ten essays filling thirty-nine pages of the catalogue. These were argumentative, questioning what should happen after the 1970s and the collapse of modernism. There were thirty fewer artists than in *The British Art Show 1* and their works were often far larger, brighter, more aggressive.

But despite this, it looked a bit episodic – like a sampler album where too many songs are in different keys. It was not clear why certain artists were in some categories rather than others: why were Ian Hamilton Finlay's elegiac texts in stone in 'Critical Attitudes' rather than 'Visual Poetry'? To have both Caro's abstract sculptures and Susan Hiller's photographs covered with automatic writing in 'Signs of Language' required special pleading.

The selectors had again scoured England, visiting, it is claimed, 1,000 artists: 'Moffat recalls gruelling long wet winter days in deepest Wales or foggy Yorkshire where a Regional Arts Officer, determined to push his local artists, would conduct them via Land Rover and cart track to the back room of a

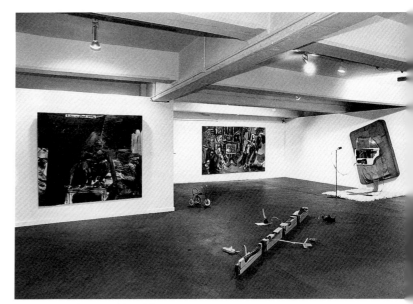

The British Art Show 2 1984 – 85
Installation shot: City Art Gallery, Birmingham

painter's cottage where, confronted with mediocre work, their one reaction was "How fast can we get out of here?"'[22] Their visits confirmed, as expected, that too many of the best British artists end up in London.

Despite having a core of artists being aged between thirty-four and forty-five, *The British Art Show 2* in fact had a somewhat more diverse range of ages and gender than The *British Art Show 1*.[23] More importantly the range of work was far wider and the individual artworks competed with each other for the viewer's attention: Paula Rego's paintings of girls and animals, vividly coloured, ebullient and witty, were unmissable, as was the performance by Stephen Taylor Woodrow, where three men shared a suit and acted like automatons, encapsulating the fear of identity loss that underpinned the exhibition. Equally outrageous was Tim Head's *State of the Art*, a large colour photograph of massed vibrators, sci-fi videos and plastic skulls all in the shape of the New York skyline. But there was great power to several quiet, unobtrusive works: the small models by Bob Law, the grey monochromes of Alan Charlton, the delicate drawing of rock and waves by Leonard McComb. McComb also made a bowl-shaped sculpture especially for the tour. It acted as a counterpoint to his large drawing and prefigured a future tendency for artists to make works especially for the show.

William Packer, in a positive and generous review, remarked: 'The world has moved on considerably, of course, in these five years past, our art world with it, and change itself can be no surprise … a younger generation has declared itself … a coherent and intelligent exhibition.'[24]

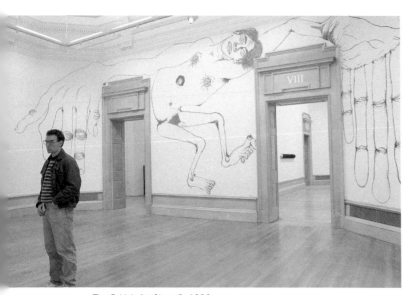

The British Art Show 3 1990
Installation shot: McLellan Galleries, Glasgow

Intellectually, this was the most ambitious and generous of all the *British Art Shows*, even if it was not the most visually coherent. Despite its messiness it had a true sense of carnival to it. It was a virtue that it elicited such varying responses. 'The blossoming of creativity in the UK has proved a delightful surprise for some,' Clare Henry remarked, 'a worrying threat to others and a puzzle to many of the general public. One of the reasons this second *British Art Show* has been so universally well received (the other reason is that it's fun!) is that it explains, guides, compares, in other words, throws light on what can be very puzzling and problematic areas.' But, in her review, Caroline Collier contrariwise concluded: 'One of the indisputable weaknesses of the British art world is its insularity, its parochialism.' (Others had suggested the time had come to include artists from overseas.) 'Another is that it somehow succeeds, despite the artists, in making an event of this kind a wholesome bore.'[25]

Five years later Collier, who was then working at the Hayward Gallery, along with David Ward, an artist who also taught at Goldsmiths, and Andrew Nairne, curator of the Third Eye Centre, Glasgow, were the selectors of *The British Art Show 3*. They set out to make an exhibition that was more coherent than *The British Art Show 2* and that was avowedly generational. Asked to select artists aged thirty-five or below,[26] they chose only forty-two artists, who thus were each able to show a more substantial amount of work. Half the artists were female and six were from ethnic minorities. This may have been a response to an Arts Council agenda for positive discrimination, but more importantly it was belated recognition that much of the best work was being done by women and artists of colour. Importantly, six artists were Scottish, two artists were from Ulster and one from Welsh-speaking Wales.[27] This truly was a *British* show. The selectors denied, somewhat speciously, that the exhibition was a survey, claiming it was only a 'glimpse' of 'what is happening', that it was 'forward looking' and 'speculative'.[28] In short they set out not only to present the new chickens, but also to read the entrails.

If the two earlier *British Art Shows* had met with a varied response, the third attracted a good deal of sheer vituperation. As the exhibition was a far more coherent one than those preceding, and included artists such as Ian Davenport, Gary Hume and Rachel Whiteread who were clearly going to be dominant figures in the forthcoming decade, one must ask why it was so hated. Was there a sense that it was a *putsch*? Compared to the bric-à-brac of *The British Art Show 1* and the disjointedness of *The British Art Show 2* this was a trim, tight, even tight-lipped show. Packer saw the show as beautifully installed but too particular, not a true survey.[29] In its selection of the young and hopeful, its failure to provide

The British Art Show 3 1990
Installation shot: McLellan Galleries, Glasgow

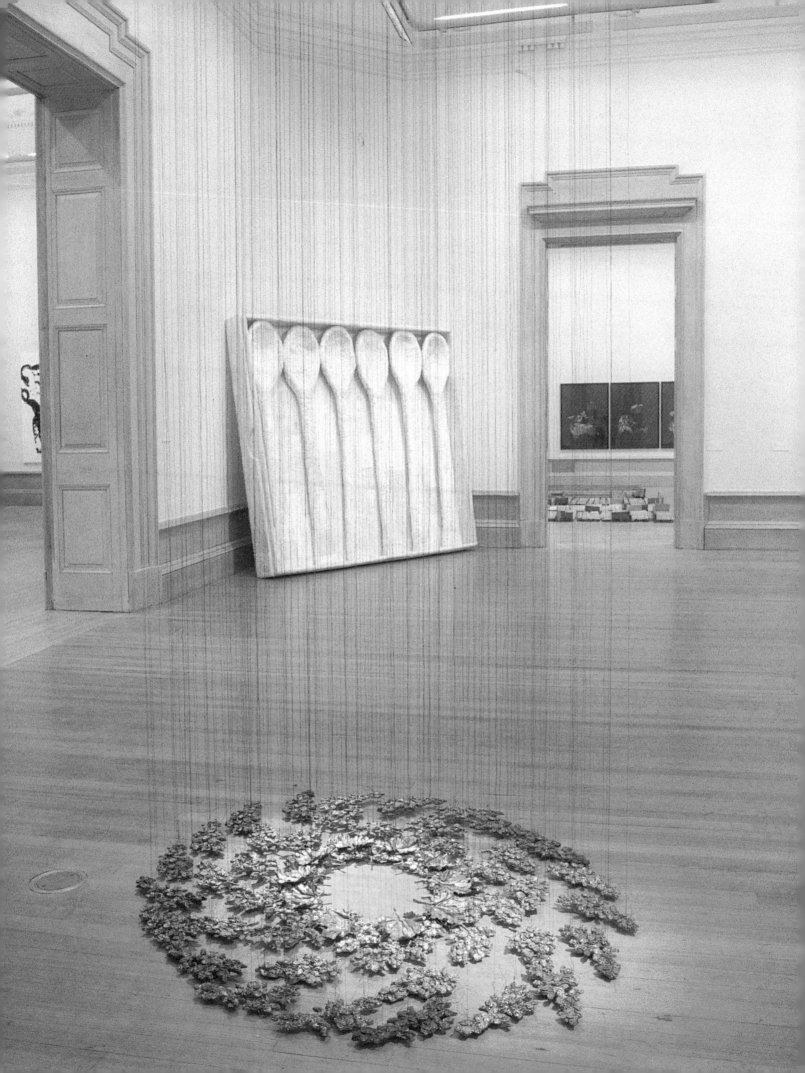

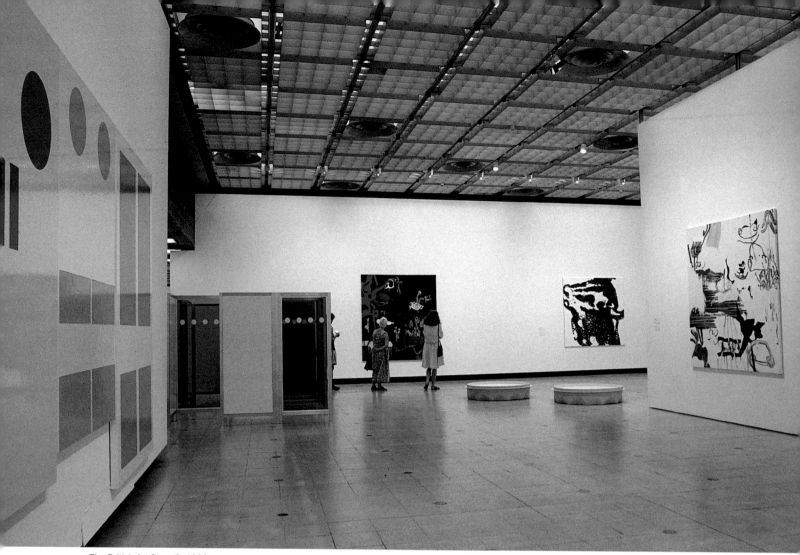

The British Art Show 3 1990
Installation shot: Hayward Gallery, London

explanatory groupings, it arguably looked like a jazzed-up, cleaned-up version of the annual *New Contemporaries*.[30] These were artists still establishing their careers – it was noticeable that the show improved for its final showing at the Hayward Gallery, as artists made new, more sophisticated work to replace original selections.[31]

When the exhibition began in Glasgow, Scottish commentators – whose first question was, as always, 'how many Scots are here?' – were shocked by the absence of Peter Howson, Ken Currie and other young, exuberant Scottish figurative painters then being much touted as successors to Baselitz *et al*. The three selectors were interested in a cooler, more dispassionate art, though one that, as Collier remarked, was often to do with private life and the everyday rather than the cynical consumerism of Jeff Koons who, with his inflatable bunny and kitsch confections, had been the cult artist of the late 1980s.[32] Scottish painting was represented instead by Callum Innes, who showed his near monochromes with areas washed away by turps. These process-orientated works echoed those by Ian Davenport: large canvases with house

paint methodically dripped down them. There were also striking but melancholy installations by Mona Hatoum and Vong Phaophanit, Lebanese and Laotian exiles respectively. The first was of elements from an electric fire barring a corner, the second a bank of spinning electric fans with images of Phaophanit's native, distant Laos projected on them.

The theme of the body appeared in many works, most especially in the drawing made directly on the wall by Brian Jenkins, exploring how he related to the world as a disabled man. Another recurrent theme was that of alienation, most clearly encapsulated by Julian Opie's maze of anonymous, but designer-elegant, partitions – as though someone had transformed a DHSS office into minimal art.

The 'scandalous' work of *The British Art Show 2* had been the excessiveness of MacLennan, and that of *The British Art Show 1* its lack of scandal; the most controversial work of this show was arguably Bethan Huws's three small reeds twisted and tied into boat shapes and placed on a plinth. This may have seemed very Duchampian – could you call that art? – but

was in fact a highly personal gesture: a way for the artist to connect back to nature, childhood and make a metaphor for life. Despite the hype that was attached to the show as being young and trail-blazing, the art was generally understated.[33]

Some commentators had noted how many of the artists in *The British Art Show 2* had taught at Goldsmiths, now they noted how many of the chosen artists had been students there. More importantly this was a generation of artists that had been taught more about semiotics and theory than American formalism: emerging at a time when the art market was in free fall and when there were few jobs left in the art schools. These artists were astute at dealing with the art world. Several of the artists in *The British Art Show 3* were from that generation of Goldsmiths students associated with the 1988 exhibition *Freeze*, who were to dominate the ensuing decade: Fiona Rae as well as Davenport and Hume.[34] It was queried why other bright sparks, Damien Hirst especially, were not included. But generally, as this exhibition demonstrated, it was probably two years too early for this generation of artists to present work in such a high-profile situation. Nevertheless the decision to choose a smaller group of young artists was perspicacious: these artists were to produce the most outstanding work of the 1990s, just as the artists in *The British Art Show 2* had shown the issues that dominated the late 1980s. It should never be forgotten that in touring through Britain, accompanied by press and education events, the *British Art Shows* are uniquely accessible to art students, the vast majority of whom do not study in London: perhaps none of the shows had so great an impact as *The British Art Show 3*.

Dismayed at what he saw as elitist art for elite audiences, Julian Spalding, director of the McLellan Galleries, where *The British Art Show 3* opened, felt the necessity of a popular show (the McLellan had just been renovated at major cost) and mounted immediately afterwards as his riposte, *Glasgow's Great British Art Exhibition* – an exhibition of fifty famous British artists from Hockney to Caro. In a plethora of interviews and articles at the time, Spalding berated the arrogance of the selectors and the 'cool pop and abstract expressionism' they had selected. Even if he could be mistaken for a bore sounding forth in the golf club, his intervention, it must be admitted, raised questions about the role of this survey and its attitude to its intended audience. What do we want and/or need to see: the great and the good or the up-and-coming?[35] Do we go to contemporary exhibitions to admire artists or to have a profitable argument with them?

The last word on *The British Art Show 3* should belong to Stuart Morgan who after a blistering attack on the newspaper critics of the show as 'reactionary, ill-informed, sloppy and uncreative … the maunderings of a bunch of bitter, ignorant hacks,' and a gripe about the blandness of the catalogue essays noted that, 'it has shown what we all knew before: that 'British' means not only white but also black, yellow and brown and 'Britain' means not only London. For the first time, perhaps, the work on show is powerful and sensitive enough to drive the point home. Shaffique Uddin, Vong Phaophanit, Sonia Boyce and in particular Mona Hatoum testified to the loneliness, anger and separation of outsiders in Britain.'[36]

The British Art Show 4 was strangely beautiful, I believe by far the most successful of the four as an exhibition. In part this was because it was a more coherent group of artists, several of whom had been shown together in group shows throughout Britain and abroad, and because there were only twenty-six of them.[37] These artists were of the same generation as Davenport, Hume or Rae, but five years more mature. In part, because the works were given more space, for the first time many artists had a room to themselves and thus were allowed to reveal their lyricism – Mat Collishaw's snow-shaker containing a miniature video projection of a sleeping girl, his birdcage with the projection of a canary in it, Steve McQueen's films or Hirst's paintings with butterflies stuck in the paint are examples. One was seduced or enveloped by the large video installations of Georgina Starr and Sam Taylor-Wood. For some the paintings of Chris Ofili were the stand-outs, but for most this was an exhibition dominated by video projections: Douglas Gordon and Jane and Louise Wilson. The medium seemed most appropriate for a generation fascinated by the pictorial spectacle, but whose work was not in the painting tradition.

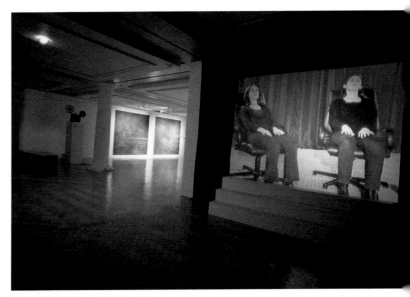

The British Art Show 4 1995 – 96
Installation shot: City Art Centre, Edinburgh

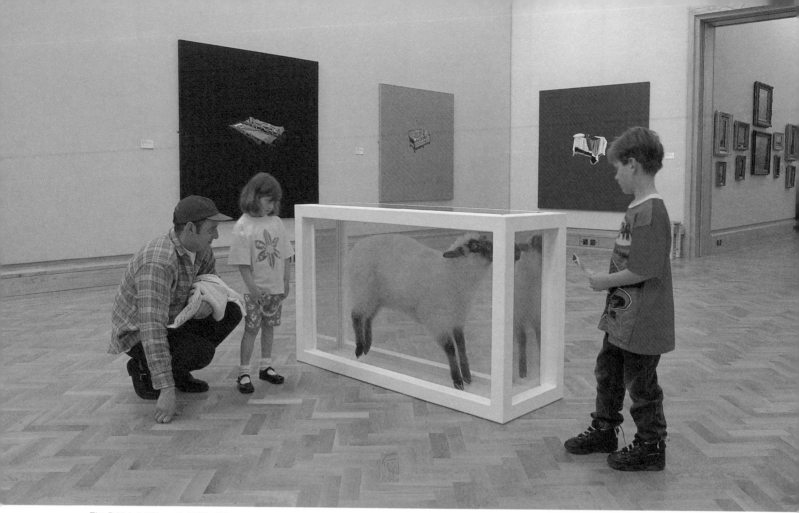

The British Art Show 4 1995–96
Installation shot: National Museum of Wales, Cardiff

Spread across seven sites in Manchester in its initial showing, the walk from one to another became part of the exhibition: there was a discourse between art and everyday, urban life. As visitors went from venue to venue they became intrigued by Manchester, its architecture and street life. It was not just a matter of taking the exhibition to Manchester, but of integrating the art with the city.[38]

Nevertheless the exhibition, selected by Richard Cork, artist Rose Finn-Kelcey and the Los Angeles-based artist and critic[39] Tom Lawson, was panned by the newspaper critics. Even the generally even-handed William Packer despaired of this 'truly dreadful show … the only challenge in any of such pseudo-profundity is to our patience.'[40] Of course the critics knew what they were getting: these artists were well known, the preview clichés predictable: 'this event champions the vitality and originality of contemporary British art and attempts to present a showcase of those artists who continually experiment beyond the bounds of the traditional.' No other *British Art Show* included so few unknown artists. Most of them had had one-person exhibitions already, most had shown in major public spaces in London, most of them were showing abroad – some were downright famous. By now Damien Hirst was the

Jeff Koons of his generation: witty, spectacular and gutsy.

It may seem ironic to recall Richard Cork's protestation in 1977 that 'in the unlikely event I were to select an annual, extra-dealer developments would play a large part in my final choice. I would certainly consider it a prime responsibility to look around for some at least of those artists who have never been given the chance to exhibit in such a context before.'[41] But, of course, the art world had changed unbelievably since then: for one thing, there were by now so many more private galleries. It was an active, lively, highly social scene. Where once the meeting places of artists had been the art schools, they were increasingly private views and art world parties with a predominantly young clientele.[42]

There was much greater emphasis in the press on interviews: *Tatler* had Georgina Starr, *Dazed and Confused* did Sam Taylor-Wood, *Elle* did Jane and Louise Wilson, *Observer Life* did Gillian Wearing, the *Telegraph Magazine* did Wallinger – though he did not look so glamorous as the others. Likewise when *Tate* magazine, purportedly a serious art magazine, did a profile of Georgina Starr, it included nine photographs of her looking pretty.

But beauty was a serious theme here, the artists finding it in unlikely places – decaying flowers (Anya Gallaccio), spooky interiors (Jane and Louise Wilson), cinema curtains (Bridget Smith), or elephant dung (Ofili). This was a world of surfaces, hence the prevalence of video projections, and the artists were living it – to their credit, not at a banal level, but always with suggestions of crime, disease, mortality, mourning or sexuality. The scandalous work, as far as the popular press was concerned, was to do with sexuality: Hermione Wiltshire's images of erect penises in glass drops scattered on the floor and entitled *Seamen*. But the reaction was nothing compared to the scandal the work would have created in 1979 – if, indeed, it could have been shown at all. Despite the predominately negative newspaper press the general audience was increasingly open to this art. Attendance figures have risen for each *British Art Show*, as they have for the Turner Prize exhibition. The average interested person no longer believed art had to be drawn or carved; most were ready to think about art objects as queries and problems. Perhaps they saw the world they lived in, with all its fascinations and contradictions, presented here. Perhaps they were beguiled by the personalities of these artists.[43] Perhaps they happily participate in the scandal too?

Arguably *The British Art Show 4* was the best exhibition but the worst survey. Simon Morrisey was not alone in arguing that the selectors had 'culled their contributors from too limited a clique of only the most fashionable young artists. The selectors seem to have been a little over eager to prove their hipness and in so doing neglected artists who could have made their selection richer and, ultimately, more daring.'[44] It would not have been difficult for anyone involved in the art world to have found four times twenty-six artists making original and interesting work in 1995. It seems absolutely correct that *The British Art Show 5*, is a much more expansive exhibition: this is not a moment dominated by 'star artists'. It also seems correct that the exhibition, like *The British Art Show 4*, is in several venues: urbanism and the *dérive* is as much an issue of art today as it was five years ago – if not more so.

It is not the job of this essay to respond to or comment on *The British Art Show 5*.[45] That is the job of the person now reading this essay when he or she goes around the actual exhibition. How does it fit into the history of *The British Art Show*?[46] In what ways is it different? How different is the world it comes from and alludes to? Is it a survey or an argument? Elitist or everyday? Fair or partisan? If the key themes of *The British Art Show 1* were formal competence and the belief in art as a decent thing in itself; if those of *The British Art Show 2* were anti-Americanism, social engagement and the poetic; those of *The British Art Show 3* private life, reverie, exile and the body; and those of *The British Art Show 4* beauty and death, the city, spectacle and surface; what are the key themes of *The British Art Show 5*? Does it return us to the world outside, if not better and wiser people, at least more alert, with a keener sense of delight, with better questions to ask?

Notes

1
The rise of the curator, someone who organizes exhibitions as their profession, is a key development in the last twenty-five years. It is symptomatic that the selector of *The British Art Show 1* was a critic and that two of the three 'selectors' of *The British Art Show 5* should describe themselves, wholly or in part, as freelance curators. A defining moment in the professionalization of the curator in Britain was the founding in 1992 of the Royal College of Art MA in Visual Arts Administration: Curating and Commissioning Contemporary Art. As of this year, a new curating course – specifically for digital art – has been established in Bristol.

2
I first became involved in the art world in 1977 when the *The British Art Show 1* was in preparation: though I have made every attempt to be fair, this essay inevitably shows my personal viewpoint.

3
Crudely speaking, we see a shift from artists as middle-class professionals (bohemian by self-proclamation) committed to art as an activity that seems self-justificatory, to artists happier in their marginality and who used such a position to research and comment on their world and lives.

4
The exhibition contained about 340 works by fifty-five artists plus films and performances.

5
All ten artists selected as 'Alternative Developments' had been included in 1972 in *The New Art* at the Hayward Gallery, selected by Anne Seymour.

6
Of the fifty-five artists scattered through the forty-nine rooms of the Palazzo Reale in Milan only two (Bridget Riley and Rita Donagh) were women; of the nineteen artists in the accompanying avant-garde film and performance section, predictably exiled to the education room and another building, five were women. All the artists were white.

7
There is a sense in which the Abstract Expressionist painters in this way prefigure installation artists – both wished to enclose the viewer in their universe.

8
Arte Inglese Oggi 1960–1976, p. 366

9
Op cit., vol. 1, p. 128

10
The climax to this proclaimed 'crisis' was a series of discussions at the ICA, eventually published in *Studio International*, issue 990, 1979

11
William Packer used a similar metaphor in his preface to *The British Art Show 1*, but he saw no decadence in this slowing down into the delta: 'before it reaches the sea its [the river's] wandering course divides into many channels. All of them equally useful to the navigator.' Exhibition catalogue *The British Art Show 1*, p.15

12
Whether the *Whitney Biennial* does this is a matter for debate: certainly, it is always controversial, the exhibition everybody loves to hate.

13
To fit this number of artists into the Hayward the exhibition had to be in two parts. Richard Cork remarked in the *Evening Standard* of 26 May 1977 that, 'The handsome white compartments which give each participant plenty of space to show an adequate body of work, tend at the same time to neutralize the exhibits and make them appear unhealthily concerned with stylishness for its own sake.'

14
Ibid.

15
The *Hayward Annuals* petered out as an institution. In a sense the first one was the only true survey and subsequent shows concentrated on particular types of art or constituencies: drawing, sculpture, women, artists under thirty-five. The last one, an exhibition of European art selected by Jon Thompson and Barry Barker, entitled *Falls the Shadow*, was in 1986, but as the format was so different few realized it was a *Hayward Annual*.

16
Of these 112 eleven were women (compared to one in the first *Hayward Annual*), the core being male artists aged thirty-three to forty-seven with a fair number of older artists, sixteen aged over fifty, forty-three in their forties, forty-seven in their thirties, seven in their twenties. Only three were technically Scottish, only one Welsh. So, like *Arte Inglese Oggi*, it was in effect a generational show and not truly 'British'.

17
Financial Times, 1 August 1977

18
Preface to exhibition catalogue *The British Art Show 1*, p.15

19
Art Monthly, December 1984

20
Guardian, 1 June 1977

21
In the first venue this lasted twenty-four hours non-stop, in the second forty-eight hours, in the third seventy-two, in the fourth ninety-six. Predictably this was the 'favourite' piece of reviewers in the local papers.

22
Quoted in Clare Henry, *Glasgow Herald*, 19 January 1985

23
Fifteen aged over fifty, twenty-two in their forties, thirty-three in their thirties, nine in their twenties.

24
Financial Times, 6 November 1984

25
Studio International, March 1985

26
In fact, six were slightly older than that: the average age was thirty. Nevertheless, one effect of this cut-off age and emphasis on one generation (compounded by a similar concentration on one generation in *The British Art Show 4* and, in effect, an equivalent policy decision by the British Council) is that the generation of artists born in the early 1950s has never been anthologized by a *British Art Show* or equivalent exhibitions. This is the forgotten generation. Furthermore, not including any artists from the previous shows also became self-denying and emphasized still further their generational nature. The more cross-generational look of *The British Art Show 5* seems healthier.

27
Despite one of the selectors being Scottish only four artists in *The British Art Show 2* had been Scottish.

28
Quoted in the *Christian Science Monitor*, 9 February 1990. The actual brief from the Hayward Gallery was that the show should be 'exploratory – not a historical summing up of a period but a forward-looking exhibition which would suggest emerging possibilities by focusing on new developments.' Foreword to exhibition catalogue *The British Art Show 3*, p.12

29
Financial Times, 27 January 1990

30
The annual touring exhibition of work by art students.

31
The third *British Art Show* was the only one to be shown in London.

32
'The show is about human things, the intimate relationships between art and life, and its concern with feelings, ideas and attitudes.' Collier quoted in *Scotland on Sunday*, 3 December 1989. Ward also remarked that 'one of the themes which emerged during the selection process was the importance of reverie, of dreams and nostalgia, of the consciousness of passing time'. (Quoted by Edward Lucie Smith, *Modern Painters*, January 1990)

33
Edward Lucie Smith cruelly remarked it was like meeting a mouse who thought he was Mussolini. *Op cit*.

34
If correct guessing of future successes is a token of correct selections it should be noted that eleven of these artists were subsequently shortlisted for the Turner Prize: Grenville Davey actually won it in 1992, and Rachel Whiteread in 1993.

35
By now G & G stood for both the great and the good and Gilbert & George – they too appeared in Spalding's show.

36
Stuart Morgan, 'Complaints Department', *Artscribe*, May 1990

37
Fifteen of the twenty-six were women, three from ethnic minorities, with an average age of thirty-one; most had studied at Goldsmiths.

38
This was also true of *The British Art Show 4* when it went to Cardiff. I did not see it in Edinburgh.

39
It is too wearisome to detail them but the number of factual mistakes in all these reviews is extraordinary.

40
Financial Times, 14 November 1995

41
Guardian, 20 July 1977

42
How often I hear people who entered the art world in the 1970s say that they used to feel like young men surrounded by middle-aged men, but that now they feel like middle-aged men surrounded by young men and women.

43
The responses of public interviewed were more in tune than before e.g. *Scotland on Sunday* 25 February 1996.

44
Creative Camera, February 1996

45
Only to say that, for the record, at twenty-three Lucy McKenzie is the youngest artist ever to show in *The British Art Show*; Kenneth Martin in *The British Art Show 2* at the age of seventy-nine was by far the oldest.

46
One could point out that this exhibition follows four controversial surveys of recent British art, and may, to some extent, be seen in relation to them. *Brilliant!* at Minneapolis in 1996 presented the Damien Hirst generation as super cool, hip successors to the Pop artists of the 1960s. (For a brilliant analysis of this see Patricia Bickers in the exhibition catalogue of *Pictura Britannica*). *Sensation*, selected from the collection of Charles Saatchi, shown at the Royal Academy in 1997, in Berlin in 1998 and in 1999 at the Brooklyn Museum, New York, to scandalous effect, can be seen as the apogee of the generation, but has also been seen by many as marking the end of that 'brilliant period'. *Life/Live* in Paris 1996 acted as a partial corrective to this lauding of one set of artists from one generation, adding a couple of much older artists and emphasizing instead the range of collaborative activity in England. *Pictura Britannica* in 1997, touring through Australasia, selected by the Australian Bernice Murphy and organized by the British Council was an attempt to show recent British art as various, argumentative and socially directed. (For the record it included forty-eight artists, twenty-three of whom were women, six from ethnic minorities. The average age was thirty-six, a figure distorted by the presence of two seventy-five-year-old artists, Richard Hamilton and John Latham. The catalogue with its collection of articles by various writers is perhaps the best analysis of recent British art.)

Lea Andrews
Art & Language
Phyllida Barlow
David Batchelor
Martin Boyce
Glenn Brown
Billy Childish
Martin Creed
Jeremy Deller & Karl Holmqvist
Tracey Emin
Graham Fagen
Laura Ford
Liam Gillick
Paul Graham
Lucy Gunning
Graham Gussin
Susan Hiller
David Hockney
Dean Hughes
Anna Hunt
Runa Islam
Emma Kay
Joan Key
Jim Lambie
Michael Landy
Hilary Lloyd
Rachel Lowe
Sarah Lucas
Kenny Macleod
Chad McCail
Conor McFeely
Lucy McKenzie
David Musgrave
Mike Nelson
Paul Noble
Jonathan Parsons
Grayson Perry
Kathy Prendergast
Michael Raedecker
Paula Rego
Carol Rhodes
Donald Rodney
Paul Seawright
David Shrigley
Johnny Spencer
Simon Starling
John Stezaker
Wolfgang Tillmans
Padraig Timoney
Amikam Toren
Keith Tyson
John Wood & Paul Harrison
Richard Wright
Cerith Wyn Evans

Lea Andrews

Lea Andrews was born in Sonning Common, Oxfordshire, in 1958. He studied at Brighton Polytechnic and the Slade School of Fine Art, London. His photographs have usually been the result of an investigation of specific sites and the communities living in and around them, with an emphasis on the artist's own personal context. He is currently teaching at Middlesex University. He has exhibited recently in *The British Art Show 3*, National Touring Exhibitions from the Hayward Gallery, London (1990), *Collected*, The Photographers' Gallery, London (1997), and *The Sunday Photographer*, Ashdown Forest (1999). Lea Andrews lives and works in London.

Made in Heaven 1990/1997
Tape/slide
Dimensions variable
Courtesy the artist

Art & Language

Founded in 1968 by Terry Atkinson, David Bainbridge, Michael Baldwin and Harold Hurrell as a collaborative group, Art & Language is now identified with the artistic work of Michael Baldwin and Mel Ramsden and the critical and literary work which they share with Charles Harrison. Baldwin was born in Chipping Norton, Oxfordshire, in 1945, and attended Coventry College of Art; Ramsden was born in Ilkeston, Derbyshire, in 1944, and studied at Nottingham School of Art. Art & Language was highly influential in the Conceptual art movement of the late 1960s and 1970s, and continues to produce work that is concerned with ideas and the language of art. Baldwin and Ramsden now live and work near Banbury, Oxfordshire. Recent exhibitions include *Documenta X*, Kassel (1997), *Then and Now*, Lisson Gallery, London (1998), *Art & Language in Practice*, Fundació Antoni Tàpies, Barcelona (1999) and *The Artist Out of Work: Art & Language 1972–1981*, PS1, New York (1999).

Sighs Trapped by Liars 510–602 1997
Alogram on canvas over plywood and mixed media
92 parts: each 29.5 x 42.5 cm
Courtesy Lisson Gallery, London
Photograph courtesy Lisson Gallery, London

Phyllida Barlow

Phyllida Barlow was born in Newcastle upon Tyne in 1944. She trained at Chelsea College of Art & Design and the Slade School of Fine Art, London. Her work consists predominantly of large, three-dimensional installations in which the use of space – and our relationship to it – plays an important role. As if watching a play unfold on stage, the viewer witnesses the work and its carefully constructed plot. Barlow is currently Head of Undergraduate Sculpture at the Slade School of Fine Art. Recent exhibitions include *EAST International*, Norwich (1997), *Out of Place*, Chapter, Cardiff (1998), *Not, Nothing, Nowhere*, Deptford, London (1998), *O Pas Là, Surprising Spaces*, Lieu d'Art Contemporain, Sigean (1999), *Furniture*, Richard Salmon, London (1999), and *Dumb-founded*, Battersea Arts Centre, London (1999). Phyllida Barlow lives and works in London.

illustrated below and opposite
(not in exhibition)

Far Away 1999
Site-specific installation; mixed media
7 x 7 x 4 m
Installation view,
O Pas Là, Surprising Spaces,
Lieu d'Art Contemporain,
Sigean, France, 1999
Photographs courtesy the artist

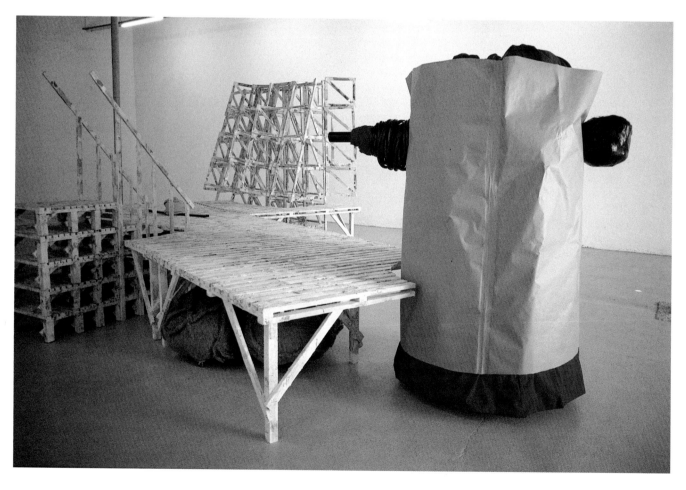

work not illustrated

after dark – into black 2000
Mixed media
Dimensions variable

Courtesy the artist

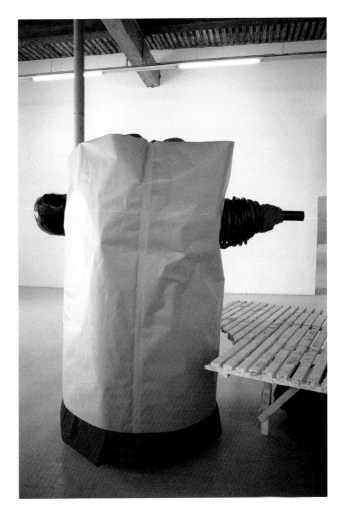
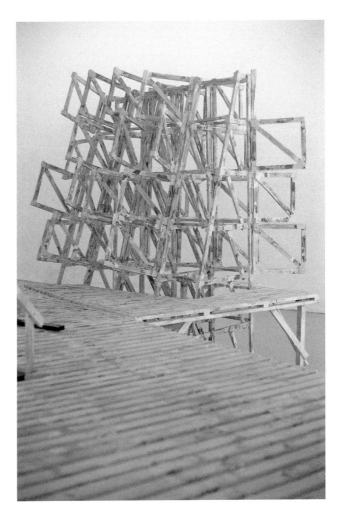

David Batchelor

David Batchelor was born in Dundee in 1955. He studied at Trent Polytechnic, Newcastle upon Tyne, and the Centre for Contemporary Cultural Studies, University of Birmingham. Batchelor's work is largely concerned with colour and urban experience. Most works combine intense monochromatic surfaces and found objects of one kind or another – from industrial trolleys and steel shelving to discarded road signs and commercial lightboxes. Batchelor is a tutor at the Royal College of Art, London, and his new book on colour and corruption, *Chromophobia*, will be published in autumn 2000. Recent exhibitions include *Polymonochromes*, Henry Moore Institute, Leeds (1997), *Postmark: An Abstract Effect*, SITE Santa Fe (1999), and *Fact and Value*, Charlottenberg Palace, Copenhagen (2000). David Batchelor lives and works in London.

work not illustrated

I Love King's Cross and King's Cross Loves Me, 3
1999–2000
Found objects, acrylic sheet and enamel paint
Dimensions variable: 13 parts
Courtesy Anthony Wilkinson Gallery, London

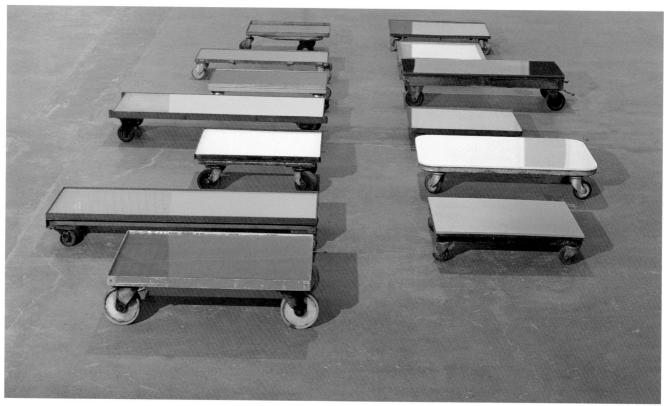

illustrated above (not in exhibition)

I Love King's Cross and King's Cross Loves Me, 2 1998–99
Found objects, acrylic sheet and enamel paint
650 x 235 x 23 cm
Courtesy Anthony Wilkinson Gallery, London
Installation view, SITE, Santa Fe, New Mexico

illustrated opposite (not in exhibition)

I Love King's Cross and King's Cross Loves Me 1997–98
Found objects, acrylic sheet and enamel paint
6 parts, overall installation 425 x 104 x 24 cm (variable)
Courtesy Anthony Wilkinson Gallery, London
Photograph: Dave Morgan

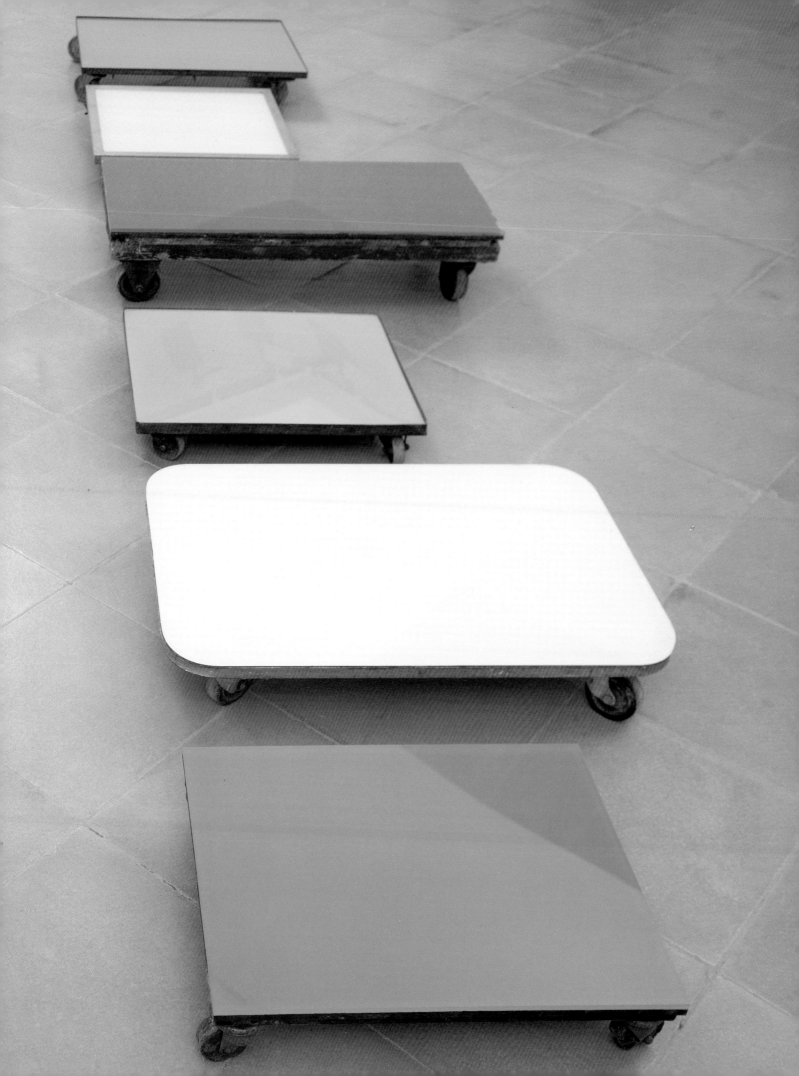

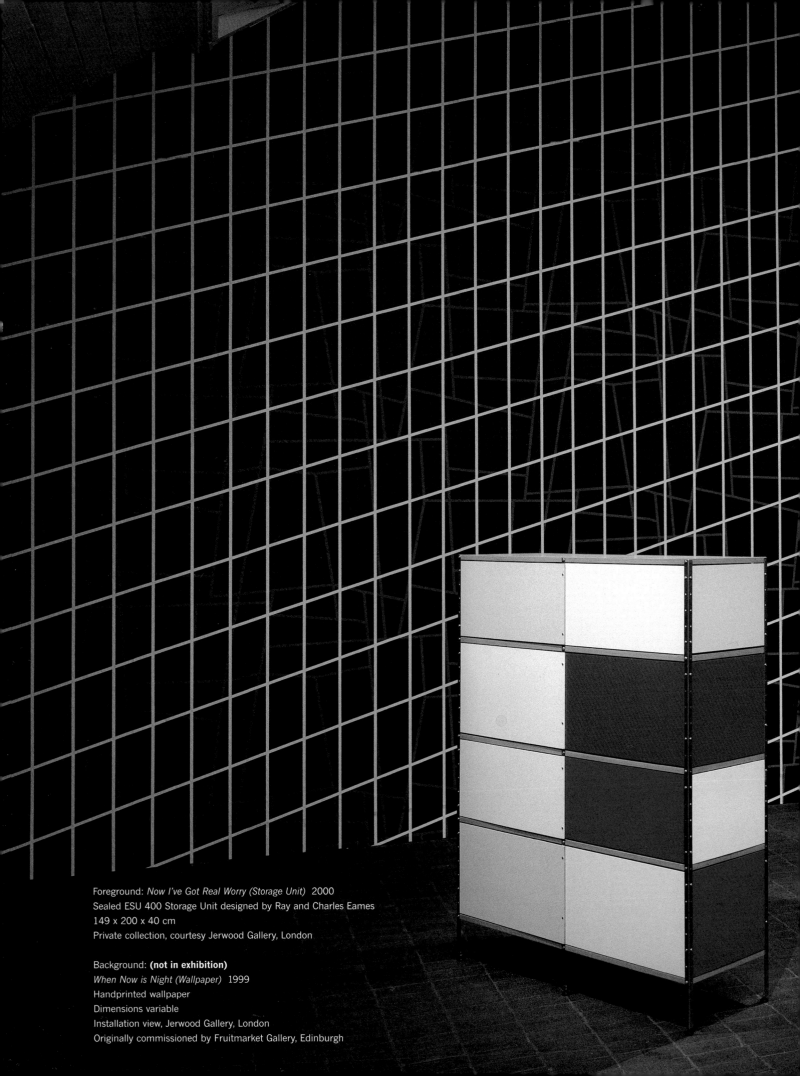

Foreground: *Now I've Got Real Worry (Storage Unit)* 2000
Sealed ESU 400 Storage Unit designed by Ray and Charles Eames
149 x 200 x 40 cm
Private collection, courtesy Jerwood Gallery, London

Background: **(not in exhibition)**
When Now is Night (Wallpaper) 1999
Handprinted wallpaper
Dimensions variable
Installation view, Jerwood Gallery, London
Originally commissioned by Fruitmarket Gallery, Edinburgh

Martin Boyce

Martin Boyce was born in Glasgow in 1967, and studied at Glasgow School of Art. Boyce's constructions are reminiscent of pieces of furniture and the urban lifestyle with which they are associated. The functionality of industrial design, with its promise of easy-living and squeaky-clean interiors, is disrupted and questioned when contrasted with the more uncomfortable aspects of contemporary life. Recent exhibitions include *Material Culture: The Object in British Art of the 1980s and '90s*, Hayward Gallery, London (1997), *Nettverk Glasgow*, Oslo (1998), *Visions of the Future*, Fruitmarket Gallery, Edinburgh (1999), and solo shows at Lotta Hammer Gallery, London (1999), and Jerwood Space, London (2000). Martin Boyce lives and works in Glasgow.

work not illustrated

The City is of Night (Wall Drawing) 2000
Emulsion paint on wall
Dimensions variable, in situ installation

Glenn Brown

Glenn Brown was born in Hexham, Northumberland, in 1966. He studied at Bath Academy of Art and Goldsmiths College, London. Brown's exact renderings of other artists' paintings are like a visual game of Chinese-whispers. Painted from photographs, they are at one remove from the original image. Through his smooth, flat representations of the emotionally-charged brush strokes and impasto of famous artists such as Frank Auerbach and Willem de Kooning, Brown's paintings question issues of authorship, authenticity, and originality, forcing us to look elsewhere for the intrinsic value in his own work. Recent exhibitions include *Sensation*, Royal Academy of Arts, London (1997), and *Glenn Brown*, Jerwood Gallery, London (1999). Glenn Brown lives and works in London.

illustrated (not in exhibition)

Breaking God's Heart 1999. Oil on wood. 77.9 x 67.3 cm. Private collection, London
Photograph courtesy Patrick Painter Inc., Santa Monica

illustrated (not in exhibition)

Beatification 1999
Oil on wood
60.7 x 58.1 cm
Collection Charles Asprey, London
Photograph courtesy Patrick Painter Inc., Santa Monica

45

Billy Childish

Billy Childish was born in Chatham, Kent, in 1959. He studied painting
at St Martin's School of Art, from which he was expelled in 1981.
Childish has published 30 collections of his poetry, recorded over 80
albums and produced over 2,000 paintings. He is the co-founder of the
anti-conceptualist group *The Stuckists*, which is 'against conceptualism,
hedonism and the cult of the ego-artist'. According to Childish, true art
is to be found in the 'depth of personal expression rather than in the
drive for fame and press cuttings'. Recent projects include *The Resignation
of Sir Nicholas Serota*, Gallery 108, London (1999), and *I'd rather you liead*,
selected poetry, woodcuts and drawings 1980–98, published in 1999.
Billy Childish lives and works in Chatham.

my paintings

one of my paintings
blocks up a hole in
the bathroom
another 3 or 4 make
a barrier to stop the
kittens falling down
stairs

one was once tared
to the roof of a
wearhouse in battersea
to keep the rain out

dont let anyone ever
say that
my art is not usefull

from Billy Childish, *The Unknown Stuff*,
Hangman Books, Chatham, 1983

still bashing that banjo

im a living anachronism
i still rite poems
i still paint pictures
and im still bashing that banjo

im out of date
and out of touch
my contempories have all
past me by
whilst im still here experimenting
with coloured crayons theyve
all gone out and discovered
'modernism'

they walk around the playground
arms linked swearing like
six year olds whove just
discovered the word 'fuck!'
no wonder i feel left out

but even this little plot
of land they wont leave me
these purveyors of 'art-fashion'

says billy
i will stay here and
werk with my tools
and wait for this
merry-go-round to stop

from Billy Childish, *Big Hart And Balls*,
Hangman Books, Chatham, 1994

dead funny

i am a thorn in the side
of the establishment

my success annoys everyone
to the extent that even i pretend
not to be successful

my adolescent concerns
are the bore of the town
my friends hiss at me
and ex-lovers wish me dead

honestly even my own mother
cant bear to read my texts

it seems ive painted a lot of shit
so much so that i meet complete strangers
who presume that i swim in it with glee

and with every poem i rite
my fame grows
another nail in my coffin
people feel embarrassed for me
everything i utter becomes a cliche

when oh when the people ask
will billy shut up?

from Billy Childish, *Big Hart And Balls*,
Hangman Books, Chatham, 1994

Martin Creed

Martin Creed was born in Wakefield, Yorkshire, in 1968. Creed has stated that his works are concerned with 'nothing in particular'. He deploys real objects – doorstops, metronomes, ceramic tiles and items of furniture – to create a frank picture of everyday life. His parsimonious use of materials such as masking tape, elastoplast, Blu-tack and balloons, combined with an almost puritanical simplicity, provide him with a potentially endless source of inspiration. This 'making do' aesthetic frequently produces sublime results. Recent exhibitions include solo shows at Cabinet Gallery, London (1999), Marc Foxx Gallery, Los Angeles (1999), Gavin Brown's Enterprise, corp, New York (2000), and *Martin Creed: Works*, Southampton City Art Gallery and tour (2000). Martin Creed lives and works in London.

Work No. 201
Half the Air in a Given Space 1998
Multi-coloured 11 inch balloons
Collection Jack and Nell Wendler
Installation view, Gavin Brown's
Enterprise, corp., New York
Courtesy Cabinet Gallery, London

Work No. 202
Half the Air in a Given Space 1998
Black 12 inch balloons
Collection Charles Asprey, London
Installation view, Titanik,
Turku, Finland
Courtesy Cabinet Gallery, London

Work No. 200
Half the Air in a Given Space 1998
White 12 inch balloons
Collection Pierre Huber, Geneva
Installation view, Analix Gallery, Geneva
Courtesy Cabinet Gallery, London

progress to the cult of
personal success. . .

AND DID this mean there
no longer no religion at
fear and a need to get a
Save oneself from worki
job for no pay.

Talk about being an a
Talk about being disco

(-JUST LIKE THAT! -IN A REC

AND THAT BEING just about
was able to construct ir
divine intervention.

THE WAY singing and dan
made to look so easy. E
for the first time.
MORE THAN ANYTHING; how
while being interviewed
(-WE WOULD NEVER HAVE GU
-It is everything we eve
hoped for. . . And more.

Talk about being an ama
Being a pro.
Like the difference betw
working for money and working for
free.

(HE LIKED THAT; Working f

Like the difference betw
say something and havin
to say.

Such a shy figure.
I lose myself sometimes

What's up? what's up?
Storm in a teacup with
made to watch the skies

(Fade to Grey.)

And No Mystery to Solve

ON SCREEN OR IN MAGAZINES

(BUT LOOK; just look at how their
faces glow!)

Pre-recorded prayer calls.

(And you can't help but wonder
sometimes about how much can
be said with a bomb?)

SELL-OUT LOVE
THE MME SO-SO-STRISSES
THE EASY WAY OUT
THE SHAGS
CARPET CLEANERS
NAILS IN SPACE
THE TUMMIE ACHES
O T O
INSIDE SWEEPERS
THE SWEET
DIAMOND TEAR
THE MAHARISHIS
SHIV PARVATI GANESH
RETURN TRIPPERS
THE COME BACKS
SISTER SATELLITES
HIRED UNCLE
ANNA SELF THIRD
THE CODE
THE LOST CONTROLS
blur-suede-pulp - oasis
CHIHUAHUA
CONSOUL
THE PASSION PILOTES
FANTASIES CARRIER
THE UNDYING NEVERENDS
KEEPER OF DREAMS
GREY FOG
BRASS KEY

'unhappy' life stories from Hollywood or other dream vistas Windsor, White House - as a kind of reversed satisfaction that things are not always what they seem!)

double of what most men made it to in his time) a lifetime during which he published thousands and thousands of pages of writing (the thick tomes of which were once said to have acted as heat resistant

L (1968)

With things con
just assumed th
areas where the
and produced et
big leisure zone
few being able t
there being fore
everyday strugg
An illusion as of
invested in by 'n
becoming maste
impression.

In line with this
we have the cle
spaces for exhib
dressing up to g
even how cultur
governments etc. will often be given
as status or a kind of reward rather
than with an ide
actually to be d

Having inside ar
guess, is a wor
whether it mear

Jeremy Deller & Karl Holmqvist

Jeremy Deller was born in London in 1966. 'Warhol said that pop art was about liking things, whereas for me Folk art is about loving things.' This statement by Jeremy Deller indicates the nature of his relationship to the various social groups with which he has collaborated, whether it be acting as the curator/facilitator of *The Uses of Literacy* (1997), an exhibition of art works produced by fans of the Manic Street Preachers, or as in his current work in progress – *Folk Archive* – collecting and documenting artefacts and events from around the country (with Alan Kane). Other projects include *Acid Brass* (performance and CD – 1997) and *Unconvention* (Centre for Visual Arts, Cardiff – 1999). He has collaborated with Karl Holmqvist on the work *Now it is Allowable*. Holmqvist was born in Västerås, Sweden, in 1964. His work deals mainly with the ambiguities of language and communication. Recent solo exhibitions include Galleri Larsen, Stockholm (1998), and Bildmuseet, UMEA (1999).

utting together
ndon for SWEDEN
al life - because
n at the time, ho
riting than that
ch brought him
to print. And
t due to the free
Englishmen as a
positioned group of people in the afterlife - with vision
spiritworld London and with in every smallest detail bu
being carried on as usual.
To think that one's surroundings are in this way repeat
outside of time would add even more urgency to what t
are in the here and now.
(Environmental awareness in a whole new light!)

But more than anywhere also with the actual weather
conditions, numerous history book and literary renditio
or even just as memories in the back of minds of visite
(coming back more or less frequently or else still hopin
how London as a city hovers between language and illus
and then different tenses and between reality and drea
With the streets to be followed more or less like the in
of someone's mind and with that which is usually taken
discrete, very different things experienced and unders
as one.

*** AGAIN AND AGAIN SWEDENBORG will stress the in
of Charity together with Christian faith; found it intere
how this word, charity almost exclusively it seems ha
to mean giving your money away to 'charitable' cause
centerstage in Christianity and for instance in relation
parts of the world or people who are poor how we will
help (I F we do. . .) out of pitying someone with built-i
hierarchy (how good we are for giving something away
how miserable they, us&them etc.) whereas charity
another sense and I think, the one SWEDENBORG intende
is about generosity of spirit - something part of how y
interact with other people, certainly give them money
wish, but also think of how you treat them or even hov
think of them - this would be a continuous work and in
not really at all about sentimentality in this sense.

Don't know if this re-defines what it means being a Ch
but it does slightly shift the focus for how one should
and go about it - in facing fears of the 'unknown' and s
step moving away from a kind of interior materialism.

Tracey Emin

illlustrated opposite

No Chance
Appliqué blanket
216 x 228 cm
Collection Mr and Mrs
Guy Kennaway

Tracey Emin was born in London in 1963. She trained at Maidstone School of Art and the Royal College of Art, London. Using her own life story as a plot in which she as artist is the main protagonist, Emin's work uses text, painting, drawings, embroidery, video and installations to expose her experiences in an unmediated manner. Often tragic, some-times funny, her confessional work inspires and engages some while exasperating others. Recent exhibitions include *I Need Art Like I Need God*, South London Gallery, London and Gesellschaft für Aktuelle Kunst, Bremen (1998–99), *Sobasex (My Cunt is Wet with Fear)*, Sagacho Exhibit Space, Tokyo (1998), *Here to Stay: Arts Council Collection purchases of the 1990s*, National Touring Exhibitions from the Hayward Gallery, London (1998), *Pandaemonium*, LEA Gallery and Lux Cinema, London (1998), *Tracey Emin: Every Part of Me is Bleeding*, Lehmann Maupin, New York (1999), and *Turner Prize*, Tate Gallery, London (1999). Tracey Emin lives and works in London.

Go on Shoot me 1997
Monoprint
58 x 81 cm

No-No-No-No No 1997
Monoprint
48 x 61 cm

Go Back Wear 1997
Monoprint
43 x 51 cm

Fucking down an Ally 1995
Monoprint
58 x 75 cm

works not illustrated

Fat Minge Thinking About it 1995
Monoprint
29 x 41 cm

The Lido 1995
Monoprint
58 x 65 cm

All the Girls 1997
Monoprint
51.5 x 61.5 cm (framed)

In you go 1997
Monoprint
51.5 x 61.5 cm (framed)

The Ability to Love 1997
Monoprint
51.5 x 61.5 cm (framed)

Bottled 1998
Monoprint
15 x 21 cm

All works courtesy Jay Jopling (London)
All photographs: Stephen White, courtesy Jay Jopling (London)

Graham Fagen

Graham Fagen was born in Glasgow in 1966. He studied at the Kent Institute of Art and Design, and Glasgow School of Art. Fagen works mainly with photographic or interactive installations, often including printed scripts and videos. His work, at first, may seem to be fictional but, on closer examination, actually deals with social, cultural and historical accuracies. Fagen currently lectures in Sculpture at the Duncan of Jordanstone College of Art, Dundee, and is a member of Transmission Gallery, Glasgow. Recent exhibitions include *Peek-A-Jobby*, Matt's Gallery, London (1998), *Subversive on the Side of a Lunatic*, Henry Moore Institute, Leeds (1999), and *Graham Fagen at the Botanics*, Inverleith House, Edinburgh (1999). Graham Fagen lives and works in Glasgow.

Nothank 1999
Installation and Documentary
Carpet, TV and Video, 5 chairs, 3 tables, plants, research material and refreshments
Dimensions variable: carpet approximately 396.3 x 584.8 cm
Courtesy the artist and Matt's Gallery, London
Installation commissioned by ICA for *The Golden Age* 1999
Photographs courtesy Matt's Gallery, London

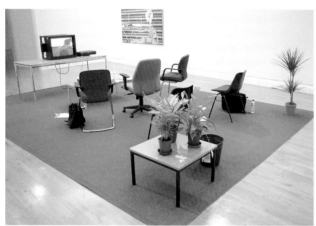

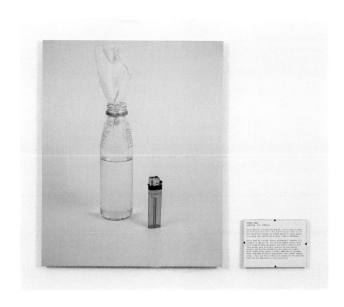

Weapons (series) 1998

Clockwise from right:
Weapons (Petrol Bomb)
Weapons (Flame Thrower)
Weapons (Crossbow)
Weapons (Pish Balloon)
Weapons (Finger Sling)
work not illustrated *Weapons (Blow Pipe)* 1998
Cibachrome print, text
each 61 x 50.8 cm
Courtesy the artist and Matt's Gallery, London
All photographs courtesy the artist

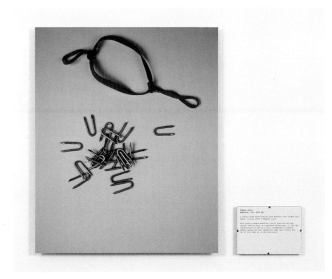

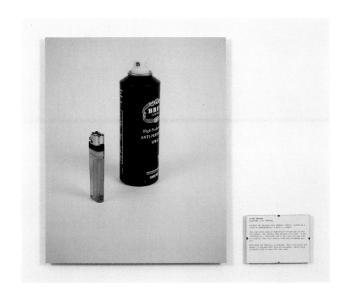

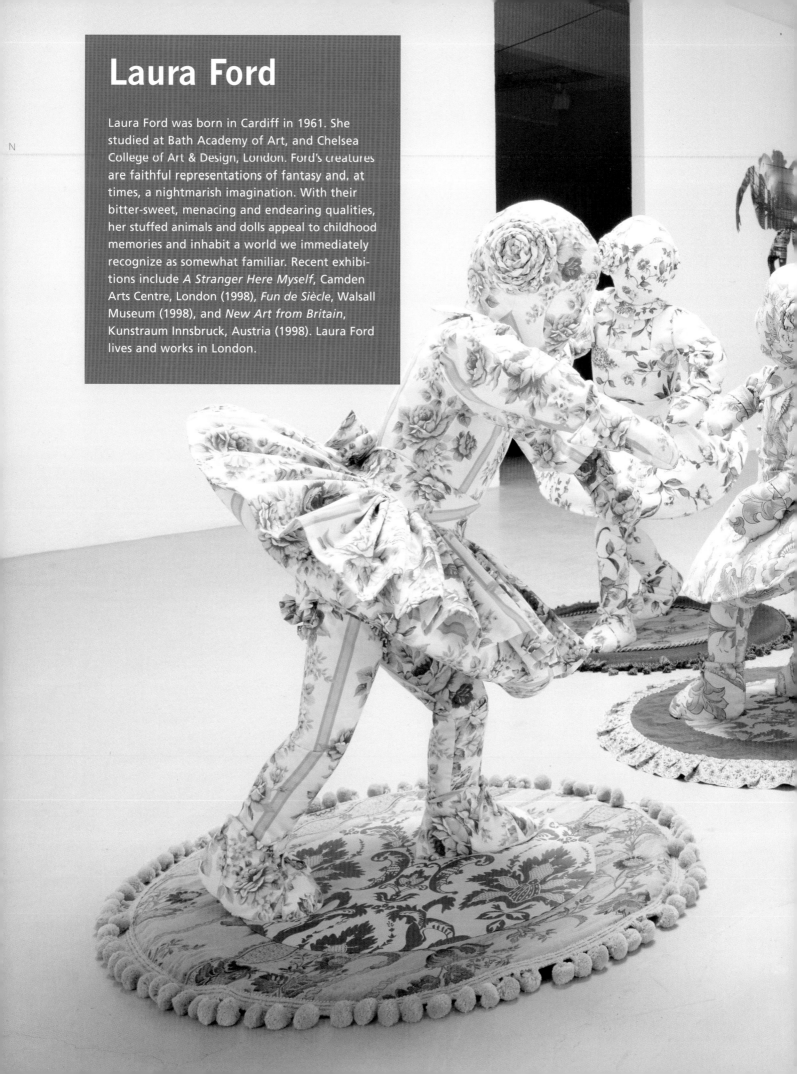

Laura Ford

Laura Ford was born in Cardiff in 1961. She studied at Bath Academy of Art, and Chelsea College of Art & Design, London. Ford's creatures are faithful representations of fantasy and, at times, a nightmarish imagination. With their bitter-sweet, menacing and endearing qualities, her stuffed animals and dolls appeal to childhood memories and inhabit a world we immediately recognize as somewhat familiar. Recent exhibitions include *A Stranger Here Myself*, Camden Arts Centre, London (1998), *Fun de Siècle*, Walsall Museum (1998), and *New Art from Britain*, Kunstraum Innsbruck, Austria (1998). Laura Ford lives and works in London.

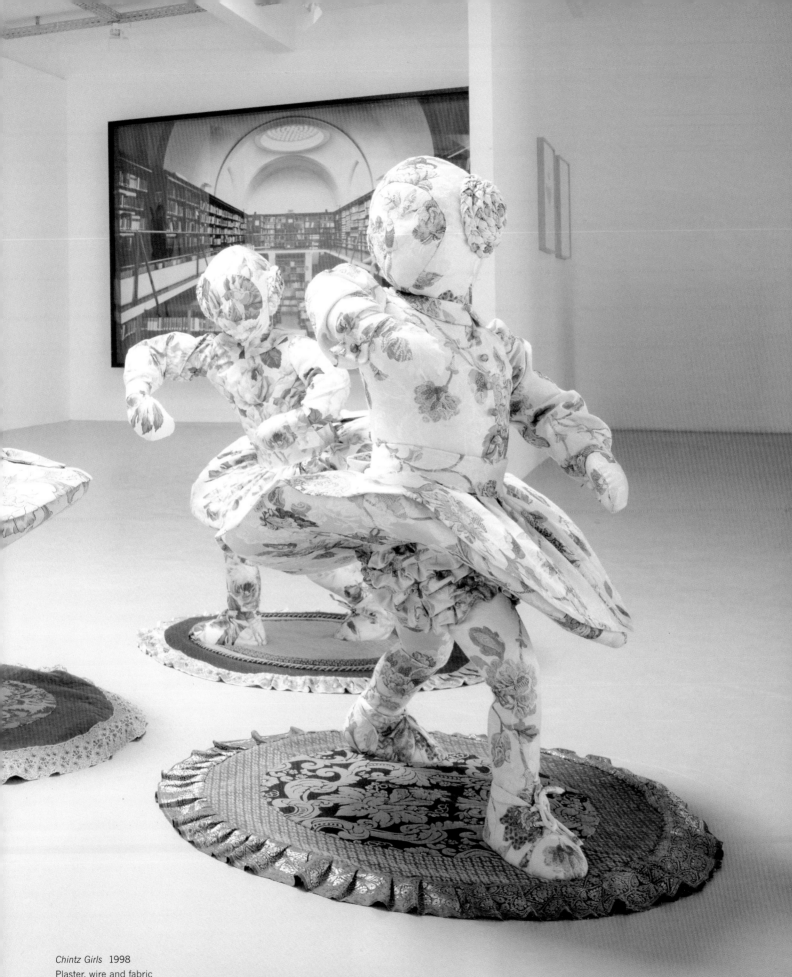

Chintz Girls 1998
Plaster, wire and fabric
7 figures, each 122 x 79 x 106.7 cm
Courtesy the artist
Installation view, *New Art from Britain*, Kunstraum Innsbruck, 1998
Photograph courtesy Kunstraum Innsbruck

Liam Gillick

Liam Gillick was born in Aylesbury, Buckinghamshire, in 1964. He studied at Hertfordshire College of Art, and Goldsmiths College, London. Gillick's work investigates the relationships of power found within the world of politics and decision-making. The artist constructs spaces where the viewer can consider the elements of a system which, although often invisible, is in control of our lives. Using a combination of text and installations, Gillick provides documentation of the way social and economic realities are shaped and manipulated. Recent exhibitions include *Documenta X*, Kassel (1997), *Liam Gillick*, Hamburg Kunstverein (1998), *David*, Frankfurter Kunstverein (1999), and *Turnaround: Inside Out at the Hayward – Who Controls the Near Future? Recent Work by Liam Gillick*, Hayward Gallery, London (2000). Liam Gillick lives and works in London and New York.

work not illustrated

Post Discussion Legislation Platform 1998
Anodized aluminium and plexiglass
240 x 240 cm
Courtesy Corvi-Mora, London

illustrated (not in exhibition)

Installation view, *Resignation Platform*, *Documenta X*, 1997
Courtesy Sammlung FER, Laupheim
Photograph: Werner Maschmann

illustrated (not in exhibition)

Untitled 1998
From the series *End of an Age*
Colour photograph
175 x 134 cm
Courtesy Anthony Reynolds Gallery,
London

Paul Graham

Paul Graham was born in Stafford in 1956. He is self-taught as a photographic artist. Graham's photographic portraits made across Western Europe in the late 1990s combine super sharp images with blurred available light imagery, hard flash against shaky saturated colour, full-on reality against escape. A refusal to manipulate images results in a flawless authority which allows us to engage with the work with a trust and intimacy which can, at times, be almost uncomfortable. His recent exhibitions include *End of an Age*, Anthony Reynolds Gallery, London (1997) and Galerie Bob van Orsouw, Zurich (1998), Anthony Reynolds Gallery, London (1998), *Art Life 21*, Spiral/Wacoal Art, Tokyo (1999), and *Common People*, Fondazione Sandretto Re Rebaudengo, Guarene (1999). Paul Graham is based in London.

illustrated (not in exhibition)

Untitled 1998
From the series *End of an Age*
Colour photograph
175 x 134 cm
Courtesy Anthony Reynolds Gallery, London

not illustrated

Further works from the series *End of an Age* 1998
Colour photographs
each, 175 x 134 cm
Courtesy Anthony Reynolds Gallery, London

Lucy Gunning

Lucy Gunning was born in Newcastle upon Tyne in 1964. She studied at Falmouth School of Art, Cornwall, and Goldsmiths College, London. Gunning works with film, video, text and sculpture, focusing on the peculiarities of everyday objects and human behaviour. Engaging directly with the subject / object, her work disrupts and undermines social conventions and expected behaviour through play and humour. The understated simplicity of Gunning's scenarios gradually reveals subtle psychological insights, tensions between fantasy and reality, and levels of complexity within her chosen subject. Recent exhibitions include *Lucy Gunning*, Chapter Arts Centre, Cardiff (1998), *Do All Oceans Have Walls?*, Bremen (1998), *horsePLAY*, Real Art Ways, Hartford, Connecticut (1999), *Lucy Gunning / Juan Cruz*, Künstlerwerkstatt Lothringerstrasse, Munich (1999), and *Lucy Gunning*, Matt's Gallery, London (1999). Lucy Gunning lives and works in London.

 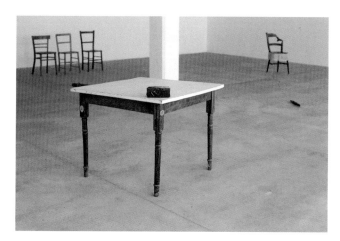

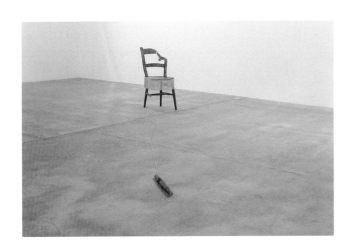

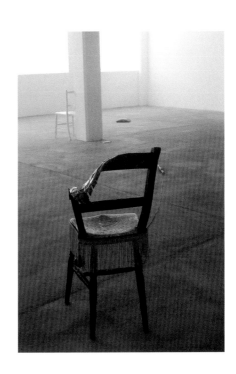

Untitled 1999
Found objects
Dimensions variable
Courtesy the artist and Matt's Gallery, London
Photographs courtesy Matt's Gallery, London

Graham Gussin

Graham Gussin was born in London in 1960. He studied at Middlesex University, and Chelsea College of Art & Design, London. Using a wide range of media including text, film and drawing, Gussin's work is concerned with our notions of time, space and scale. Through his use of science fiction titles, film scenes or pieces of dialogue, Gussin explores or fuses together ideas about landscape, translation and movement. The viewer often plays a vital role when encountering the work as, to complete the picture, we project our own experiences and information on to what we see and hear. Recent exhibitions include *Any Object In The Universe,* Art Now, Tate Gallery. London (1998), *Signs of Life*, Melbourne Biennale (1999), and Spill, Aarhus Kunst-museum, Denmark (1999). Graham Gussin lives and works in London.

SUDDENLY
NEW YORK, 1970
8.30 pm
10 YEARS LATER
DAY ONE
Nightfall
TWO DAYS LATER
ACROSS TOWN
24 HRS LATER
THE NEXT DAY
IDLEWILD AIRPORT, 1963
SEVEN YEARS LATER
The Aftermath
TWO DAYS EARLIER
CALIFORNIA-SUNDAY-10.04. AM.
DAY TWO

Susan Hiller

Susan Hiller was born in Tallahassee, Florida, in 1942. She studied at Smith College, Massachusetts, and Tulane University, New Orleans and has lived in London since 1973. Hiller's work is an investigation into the unconscious of culture. Cultural artefacts are the starting point for her works in various media including painting, sculpture, installation, video and photography. Using unconscious processes such as dreaming, automatic writing or improvised vocalizations, Hiller reveals significant aspects of our shared experience which are usually concealed or overlooked. Recent solo exhibitions include Tate Gallery, Liverpool (1996), Galeria Foksal, Warsaw (1997), and Delfina Gallery, London (1999). Recent group exhibitions include *The Object of Performance*, MOCA, Los Angeles (1998) and *The Muse in the Museum*, MOMA, New York (1999). Susan Hiller was awarded a Guggenheim Fellowship in art in 1998. She has recently curated *Dream Machines*, an international group exhibition for National Touring Exhibitions from the Hayward Gallery, London.

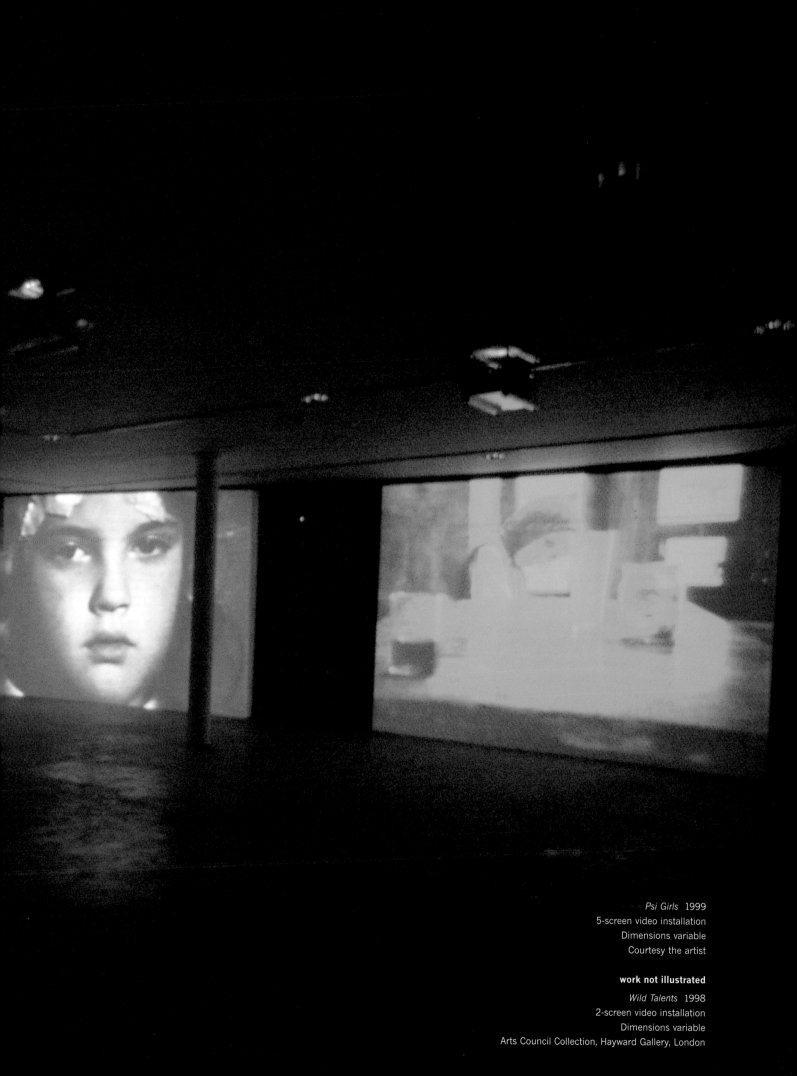

Psi Girls 1999
5-screen video installation
Dimensions variable
Courtesy the artist

work not illustrated

Wild Talents 1998
2-screen video installation
Dimensions variable
Arts Council Collection, Hayward Gallery, London

David Hockney

David Hockney was born in Bradford, Yorkshire, in 1937, and studied at the Royal College of Art, London. He achieved early recognition in the 1960s, and since 1978 has lived and worked in California. Hockney's new series of drawings has been produced using a camera lucida, an intricate nineteenth-century device used to capture an image to be portrayed. Hockney has always been interested in issues of representation and, in previous works, has made use of photography, fax machines, painting and set design to explore the possibilities of rendering the visual world. While using a device designed to provide faithful representations, Hockney, a master draughtsman, depicts his subjects with an empathy and fluidity characteristic of his freehand drawings. Recent exhibitions include *David Hockney: Space & Line*, Annely Juda Fine Art, London, and Centre Georges Pompidou, Paris (1999), *Recent Etchings* by David Hockney, Pace Gallery, New York (1999), and *The Royal Academy of Arts Summer Exhibition* (1999), where his Grand Canyon paintings were awarded the Wollaston Award (William Hyde Wollaston invented the camera lucida in 1806)

Jacob Rothschild. London. 20th June 1999
Pencil on grey paper using a camera lucida
56.5 x 38.1 cm
Photograph: Steve Oliver

Brian Young. London. 15th June 1999
Pencil on grey paper using a camera lucida
32.4 x 38.7 cm
Photograph: Steve Oliver

Geordie Greig. London. 16th June 1999
Pencil and crayon on grey paper using a camera lucida
38.4 x 44.8 cm
Photograph: Steve Oliver

Lindy, Marchioness of Dufferin & Ava. London. 17th June 1999
Pencil on grey paper using a camera lucida
38.1 x 42.9 cm
Photograph: Prudence Cuming

Damien Hirst. London. 18th June 1999
Pencil on grey paper using a camera lucida
38.2 x 43.5 cm
Photograph: Prudence Cuming

*Stephen Stuart-Smith.
London. 30th May
1999*
Pencil and white
crayon on grey paper
using a camera lucida
38.1 x 35.6 cm
Photograph:
Steve Oliver

*Alan Bennett.
London. 25th
May 1999*
Pencil on grey
paper using a
camera lucida
38.1 x 23.5 cm
Photograph:
Steve Oliver

Katharine Jones. London. 24th June 1999
Pencil and white crayon on grey paper
using a camera lucida. 45.7 x 38.1 cm
Photograph: Steve Oliver

Martin Kemp. London. 22nd June 1999
Pencil and white crayon on grey paper
using a camera lucida. 38.1 x 36.8 cm
Photograph: Steve Oliver

Gregory Evans I. London. 13th June 1999
Pencil on grey paper using a camera lucida
45 x 38.1 cm
Photograph: Prudence Cuming

Colin St. John Wilson. London 3rd June 1999
Pencil and crayon on grey paper using a camera lucida
38.1 x 48.6 cm
Photograph: Steve Oliver

Jaqui Staerk. London. 26th June 1999
Pencil and white crayon on grey paper using a camera lucida
38.1 x 44.1 cm
Photograph: Steve Oliver. All works courtesy the artist

Dean Hughes

Dean Hughes was born in Manchester in 1974, and studied at Chelsea College of Art & Design, London. Hughes works with a range of ordinary, familiar objects, such as paper, rolls of masking tape and bus tickets. Through small interventions, the artist transforms the objects into records of everyday life, through which daily rituals become charged with meaning. Recent exhibitions include *Contemporary British Drawings*, Sandra Gering Gallery, New York (1997), *A to Z*, The Approach, London (1998), and *Go Away*, Royal College of Art, London (1999). Dean Hughes lives and works in Manchester.

*Thread on and
Through Paper* 1996
Thread on paper
44.3 x 44.3 cm (framed)

*Thread on and
Through Paper* 1996
Thread on paper
44.3 x 44.3 cm (framed)

Hole Punch Piece, Series of VIII, No. 4 1998
A4 sheet of paper
35.2 x 26.6 cm (framed)

works not illustrated

Hole Punch Piece, Series of VIII, No. 2 1998
A4 sheet of paper
35.2 x 26.6 cm (framed)

Lots of Nicks and a Couple of Holes 1999
A4 sheet of paper on wooden plinth
36 x 36 x 13 cm

All works and photographs courtesy Laure Genillard Gallery, London

Anna Hunt

Anna Hunt was born in Newcastle upon Tyne in 1946, and studied at the University of Newcastle. Hunt's thread on canvas works recreate architectural constructions taken from photographs. Her work allows us to examine the forms and aesthetic ideologies of the transformed images beyond the supposedly functional characteristics of architectural design. Recent exhibitions include *Loose Threads*, Serpentine Gallery, London (1998), *What Difference does it Make?*, Cambridge Darkroom Gallery (1998), and *EAST International*, Norwich (1999). Anna Hunt lives and works in Brighton.

Jewish Museum, Berlin 2000
Thread on canvas
17 x 27.5 cm

Glass House 1999
Thread on canvas
15 x 25 cm
Monte Clark

Guggenheim, Bilbao 1998
Thread on canvas
18 x 33 cm
Courtesy P. Prinster and W. Yuen

Paimio Sanatorium
1999
Thread on canvas
23.5 x 19 cm

Sketch for Newspaper Office, (Vesnins)
1999
Thread on canvas
22 x 13.5 cm

works not illustrated

Einstein Tower 1996
Thread on canvas
18 x 13 cm

TWA Terminal 1998
Thread on canvas
17 x 28 cm

Fire Station, (Vitra) 1999
Thread on canvas
17.5 x 24 cm

*Monument to Karl Liebknecht
& Rosa Luxemburg* 1999
Thread on canvas
15 x 26.5 cm

Olympia Tent, Munich 1999
Thread on canvas
20 x 19 cm

Villa Dall Ava 1999
Thread on canvas
19.5 x 14.5 cm

Sketch for de la Warr Pavilion 2000
Thread on canvas
17 x 23 cm

Unless stated otherwise, all works:
Collection of the artist
Photographs: Mike Fear

Runa Islam

Runa Islam was born in Dhaka, Bangladesh, in 1970. She was a participant at the Rijksakademie van Beeldende Kunsten, Amsterdam. Although Islam works with a variety of media, film has a significant place in her practice as she particularly engages with its language, constructing analytical and reflexive installations which locate the viewer in a critical position. Evoking and exposing the mental processes of sensual experience, her work produces a shifting of perception as our gaze is returned by the image. Recent exhibitions include *000zero-zero-zero*, Whitechapel Art Gallery, London (1999), *EAST International*, Norwich (1999), *Dis-locations*, hARTware, Projekte, Dortmund (1999), *Stimuli*, Witte de With, Rotterdam (1999– 2000), *and if there were no stories*, Stephen Friedman Gallery, London (2000), and *50 projects, 50 weeks*, fig-1 project, Soho, London (2000). Runa Islam lives and works in London.

illustrated above (not in exhibition)

Turn (Gaze of Orpheus) 1998
Video projection
Courtesy the artist
Photograph courtesy the artist

(Stare Out) Blink 1998
16mm film installation
Courtesy the artist
Photograph courtesy the artist

74

And GOD created the Earth and the seven seas in seven days, and on the seventh day he rested, and was pleased with what he had done.

The Earth was created to hang between Heaven and Hell, where before there was only a terrible blackness. GOD gave the Earth land and water so that living things could flourish and then he created a man and called him Adam. (One of his reasons for doing this was to prove to the Devil that goodness would always triumph over evil).

Heaven was populated by angels, and those angels that were not good enough in GOD's eyes were banished to hell forever. These were known as 'Fallen Angels'. When the Devil noticed what GOD was trying to do, he saw to it that humans who failed to be good ended up in hell. These lost souls were condemned to Eternal Damnation in Purgatory, which was a horrible place burning with hellfire.

Adam was placed in a beautiful and verdant garden that GOD had made especially for him, called Eden. Eden was like paradise, in fact it was an Earthly Paradise (although most of the Earth was like this at the time). It was also known as the Garden of Earthly Delights. Adam ran around naked, eating fruit and vegetables, and playing with the animals, in a state of innocence. But because Adam was not an animal and had the power of speech, he became bored and wanted someone to talk to. So GOD removed one of Adam's ribs while he was asleep and from it he fashioned Eve, a woman. Eve was just like Adam except for some particular physical features. Their sexual (or reproductive) organs were what differentiated them, in fact made them opposites, although Adam and Eve didn't realise this because they didn't know what these organs were for.

For a while Adam and Eve were very happy and spent most of their time discovering what was around them, eating fruit and stroking the other creatures who were their friends. But they soon began to weary of their perpetual state of innocence and bliss. They became dissatisfied with their lot, and wondered why they should always do GOD's will.

There was a tree in the garden that GOD had told them not to touch. It was called the Tree of Knowledge, and on no account were they to pluck its fruit. Eve

from GOD.

The story of Ruth would be one of these. Ruth used to glean corn (picking up what is left in the fields after the harvest). She attracted the attention of a rich man called Boaz, and there is a whole book in her name. Certainly she was the daughter of a prophet or some similarly well known man. Cain and Abel were the sons of Isaac. They had an argument which resulted in the accidental murder of Abel by Cain, who threw a rock at his head. Cain was forever scarred by this event, and the Mark of Cain, whether real or metaphorical, came to be symbolic.

The Prodigal Son left the family home because his father divided up his land between his three sons, and he wasn't happy with his lot. He went off to seek his fortune in the world, which nearly broke his father's heart. In his absence, the other stay-at-home brothers squabbled over the third share of land, and became greedy, idle and lazy. Although they had at first seemed to care more about their father, because they had stayed at home, the farm went to rack and ruin. Meanwhile the Prodigal Son didn't fare any better than he would have done if he had stayed at home and worked his plot of land. So he returned to claim it back. His father forgave him for leaving. This is known as the 'Return of the Prodigal Son'.

There was also a king who was asked to adjudicate over a maternity dispute. Two mother's were claiming the same baby. He declared that the only way to settle the problem was to cut the baby in half, wisely realising that the real mother would rather give the baby up, than let it die. When she did so, he restored her child to her, since her care for the child's had been proved to be greater than her desire to keep it for herself.

Daniel was an important leader, who was unfortunately thrown into a lion's den. He managed to avoid being eaten by talking to the lion calmly. Jonah was also persuasive – he ended up in the belly of a whale after being swallowed, but persuaded the whale to open its mouth and let him walk free.

Moses is the most famous person in the Old Testament, followed by Abraham, Noah, Elijah (who was once fed by ravens when he was starving). Solomon

were introduced. Prophets m[...]
these things were all signals[...]
approval, and that the only w[...]
wrath of their LORD was to[...]

When some tribes were[...]
desert, GOD showed[...]
providing them with food. [...]
flakes fell from the sky, w[...]
bread when eaten in quant[...]
heavy dew was deposited and[...]
to taste like honey. Flocks of[...]
around. The people ate the [...]
eydew and the flakes, whic[...]
manna – this is known as t[...]
Manna and Quails.

A great famine was preve[...]
the son of Jacob, a Cana[...]
the son of Esau) and the h[...]
(Jacob had an eventful life –[...]
ing in a field one night, resti[...]
a stone, and dreamt he saw[...]
ing up to a cloud. In additio[...]
in his life he had to wres[...]
angels). Joseph was one of[...]
whom the youngest was ca[...]
But Joseph was the favourite.[...]
given him a beautiful 'C[...]
Colours', which made his bro[...]
ous. They were also irritated[...]
tic dreams he had. So they[...]
rid of him, and somehow th[...]
ended up working as a baker[...]
of a rich man called Potip[...]
around that he could interpr[...]
eventually he became Potiph[...]
man. All Joseph's dream[...]
proved correct, and by payi[...]
them Potiphar managed to a[...]
able wealth. Unfortunately,[...]
Potiphar's wife's eye and she[...]
him. Potiphar found out an[...]
Joseph had been the seduce[...]
thrown into a dungeon.

Even from prison Josep[...]
tive talents stood him in g[...]
interpreted his fellow pris[...]
and when Pharaoh got word[...]
he summoned him to his pa[...]
dream which really worried[...]
seven thin cows ate seven fa[...]
n't derive any nourishmen[...]
Joseph predicted seven yea[...]
harvest followed by seven ye[...]
He advised the king to stock[...]
good years and then ration[...]
Sure enough, the prediction[...]

work not illustrated

Worldview 1999
Inkjet on paper
180 x 280 cm
The artist, courtesy The Approach,
London

Emma Kay

Emma Kay was born in London in 1961, and studied at Goldsmiths College, London. Her work involves the reconstruction of epic historical, geographical or fictional stories entirely from memory. Half-remembered fragments are pulled together, written down or drawn, and presented in their new form as authoritatively as possible. Fiction and reality are blurred to produce an image which contains elements of both. Kay's work is governed by the self-imposed rule that no access to sources of reference is permitted. Recent exhibitions include *Shakespeare from Memory*, The Approach, London (1998), *The Istanbul Biennial* (1999), and *Abracadabra*, Tate Gallery, London (1999). Emma Kay lives and works in London.

illustrated above and opposite (detail)

The Bible from Memory 1997
Ink on paper (offset print on paper)
43 x 31 cm (framed)
The artist, courtesy The Approach, London
Photographs courtesy The Approach, London

Joan Key

Joan Key was born in St Helen's, Lancashire, in 1948. She studied at Maidstone College of Art and the Royal College of Art, London. Although Key's paintings are not text-based, her interest in the structure of language is clearly evident. Language can be both arbitrary and precise and, through the emphasis on the visual qualities of language, Key's work concerns itself with the complexities of systems we employ in our attempts to make sense of the world. Recent exhibitions include *Pictura Britannica*, Museum of Contemporary Art, Sydney (1997), *Joan Key*, Richard Salmon Gallery, London (1999), and *Sublime: The Darkness and the Light*, National Touring Exhibitions from the Hayward Gallery, London (1999). Joan Key lives and works in London.

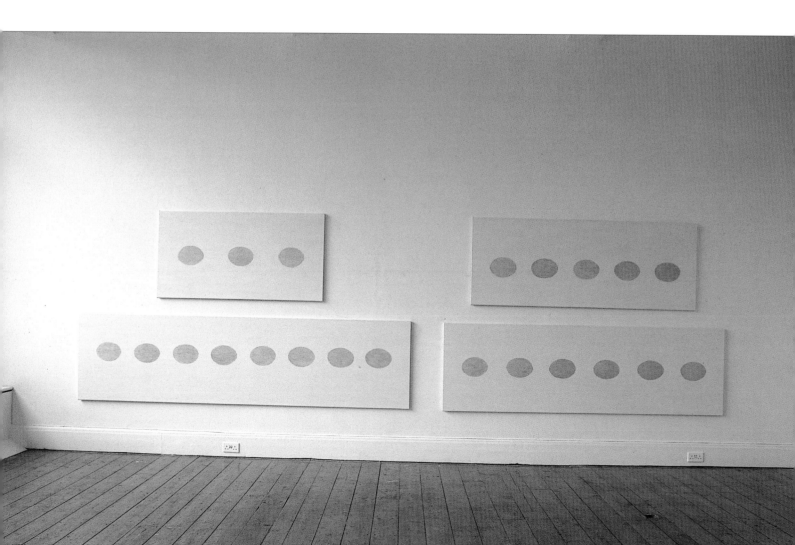

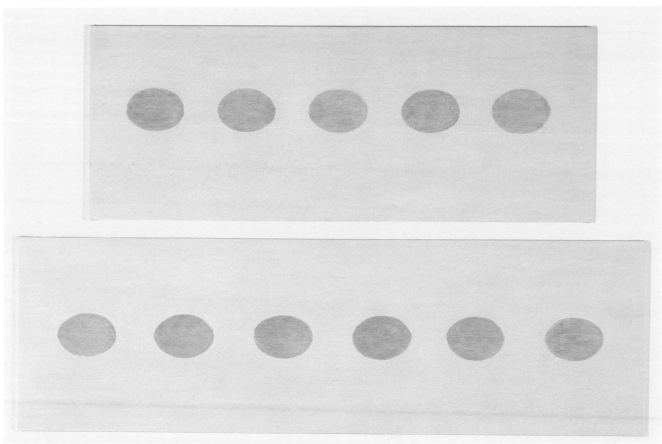

illustrated opposite and above (detail)

3+8=11, 6+5=11, (diptych) 1999
Oil on canvas
4 paintings:
76 x 152.2 cm; 76 x 305 cm;
76 x 203 cm; 76 x 257.5 cm
Courtesy Richard Salmon Gallery, London
Photograph: Mike Fear

Jim Lambie

Jim Lambie was born in Glasgow in 1964, and studied at Glasgow School of Art. Lambie's involvement in the Glasgow music scene has considerable influence on his work. Like music, visual art can fill a space and change the way we perceive our surroundings as well as ourselves. It can produce altered states of mind. Using vibrantly coloured tapes that follow the contours of a room, Lambie's installation transforms and energizes the gallery space. Recent exhibitions include *Jim Lambie*, Sadie Coles HQ, London (1999), *The Queen is Dead*, Stills Gallery, Edinburgh (1999), *Voidoid*, Transmission Gallery, Glasgow (1999), and *ZOBOP*, The Showroom Gallery, London (1999). Jim Lambie lives and works in Glasgow.

illustrated below and opposite

Zobop 1999
In situ installation with coloured vinyl
Dimensions variable
The artist, courtesy The Modern Institute
Installation view, Transmission Gallery, Glasgow, 1999
Photographs: Alan Dimmick

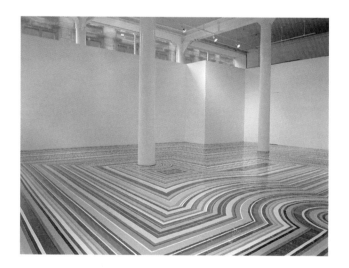

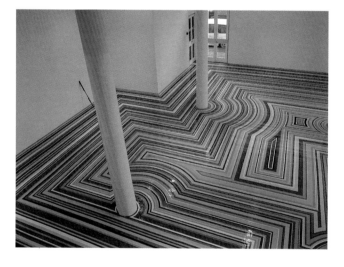

works not illustrated

Plaza 2000
Plastic bags, paint
Dimensions variable, in situ installation
The artist, courtesy The Modern Institute

Psychedelic Soul Stick 2000
Cane, wire, thread
130 cm high
The artist, courtesy The Modern Institute

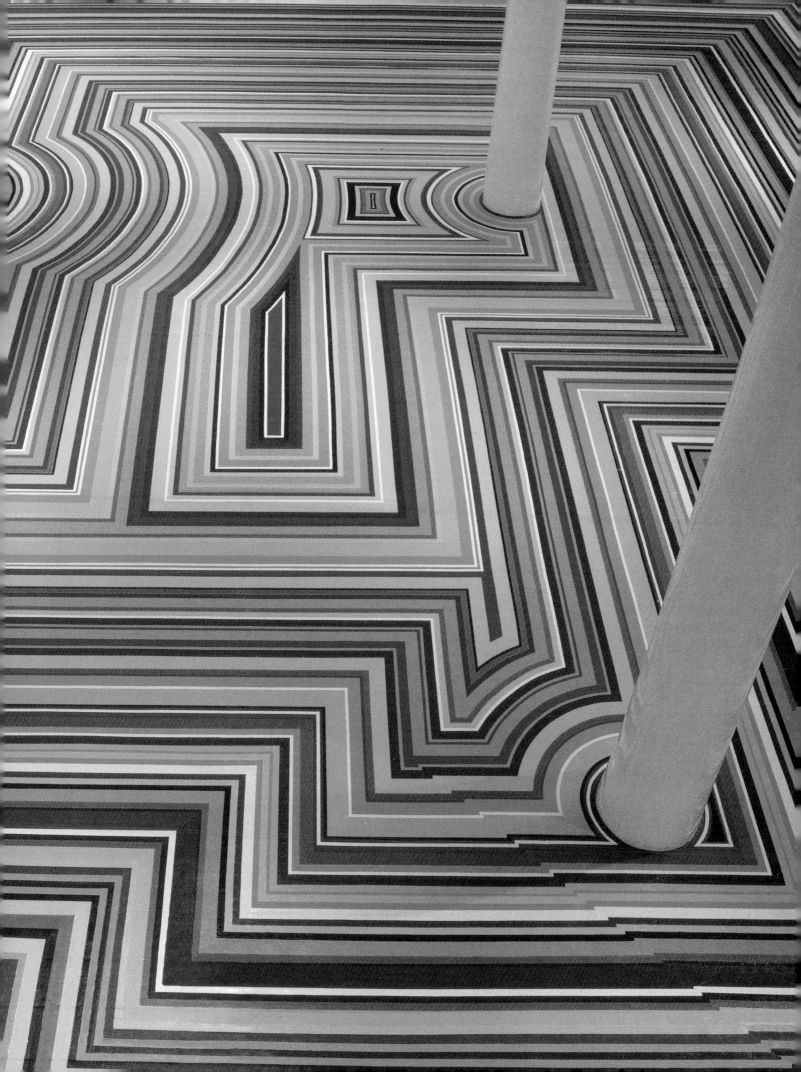

Michael Landy

Michael Landy was born in London in 1963. He studied at Loughborough College of Art, and Goldsmiths College, London. Landy's installations, videos and drawings create an artificial world which reminds us of some of the more sinister aspects of the society in which we live and our complicity in sustaining its dehumanizing values. *Scrapheap Services*, his best-known large-scale installation, first introduced us to the fictitious cleaning company which offered its services to a 'prosperous society [which] depends upon a minority of people being discarded'. Recent exhibitions include *Scrapheap Services*, Chisenhale Gallery, London (1996), *Michael Landy at Home,* 7 Fashion Street, London (1999), and *Diary*, Cornerhouse, Manchester and touring (2000). Michael Landy lives and works in London.

illustrated opposite

The Consuming Paradox (collage) 1999
Mixed media
182 x 244 cm

The Consuming Paradox 1999
Plastic milk crates, framed pen and
ink drawings, collage, perspex
1230 x 1537 cm
Photograph courtesy the artist

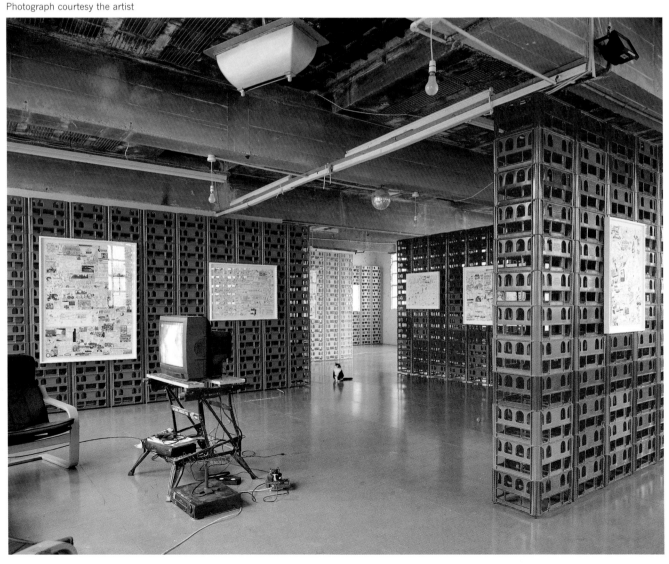

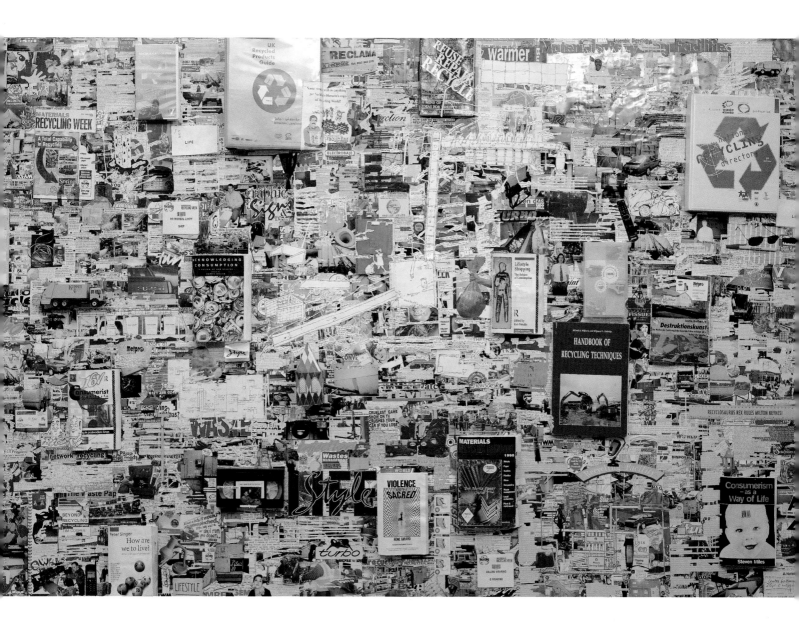

Hilary Lloyd

Hilary Lloyd was born in Yorkshire in 1964. She studied at Newcastle upon Tyne Polytechnic. Lloyd's videos document apparently banal human activities which are presented through the use of high-tech equipment, creating elaborate visual spectacles out of deceptively simple scenarios. The repetitive flow of each work creates a rhythm which seems to give order to the chaos of everyday life. Recent exhibitions include *SuperNova*, Stedelijk Museum Bureau, Amsterdam (1998), *Lovecraft*, CCA, Glasgow and South London Gallery (1998), *Accelerator*, Southampton City Art Gallery and Arnolfini, Bristol (1998), and *Hilary Lloyd*, Chisenhale Gallery, London (1999).

Landscape 1999
Sony PVM-14M4E video monitor
Sony VO-5630 U-matic videocassette recorder
Installation view, Chisenhale Gallery, London
Photograph: Hugo Glendinning

Rachel Lowe

Rachel Lowe was born in Newcastle upon Tyne in 1968. She studied in London, at Camberwell School of Art and Chelsea College of Art & Design. Lowe's work addresses our fundamental need to record or 'capture' a particular moment in time, the impossibility of ever adequately doing so, and the resultant sense of loss. Recent exhibitions include *Enough*, The Tannery, London (1998), *Speed*, Whitechapel Art Gallery and Photographers' Gallery, London (1998), a solo show at Southampton City Art Gallery (1999), *Vegas, 1999 Olay Vision Award for Women Artists*, Lux Gallery, London (1999), *Diary*, Cornerhouse, Manchester and touring (2000), and *Landscape*, ACC Galerie, Weimar and touring (2000). Rachel Lowe lives and works in London.

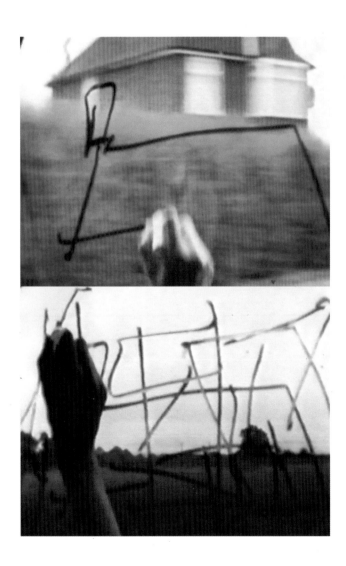

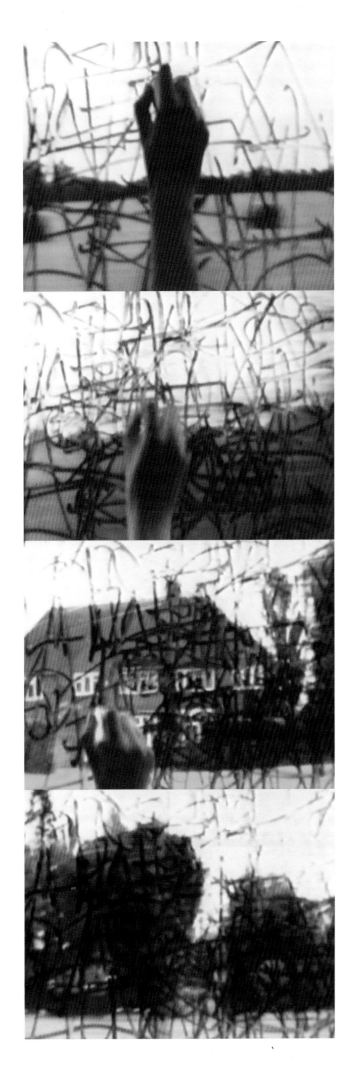

A Letter to an Unknown Person,
No. 6 1998
Video installation
Dimensions variable

Sarah Lucas

Sarah Lucas was born in London in 1962. She studied at the London College of Printing, and Goldsmiths College, London. Lucas works with a variety of materials and media, including photographs, sculpture and installations. Her work often features images of herself in a confrontational stance. Challenging sexual stereotypes, her representations of women and men use humour and a colloquial vocabulary to challenge accepted notions of morality. Recent exhibitions include *The Old In Out*, Barbara Gladstone, New York (1998), *Real Life: New British Art*, Tochigi Prefectural Museum of Fine Arts, Japan and tour (1999), and *The Fag Show*, Sadie Coles HQ, London (2000).

Fighting Fire with Fire 1996

Self Portrait with Fried Eggs 1996

Self portraits 1990–1998 1999
Iris prints on watercolour paper
12 prints, each 85 x 68 cm (framed)
Sarah Lucas, courtesy Sadie Coles HQ, London
Photographs: Mike Fear

Smoking 1998

Human Toilet II 1996

Summer 1998

Self Portrait with Knickers 1994

Got a Salmon On #3 1997

Self Portrait with Skull 1997

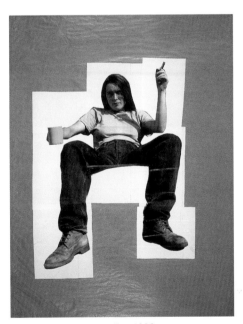

Self Portrait with Mug of Tea 1993

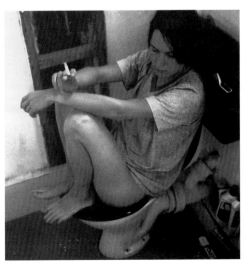

Eating a Banana 1990

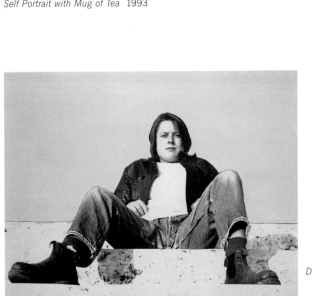

Divine 1991

Human Toilet Revisited 1998

Kenny Macleod

Kenny Macleod was born in Aberdeen in 1967. He studied at Goldsmiths College, London, and is currently at the Rijksakademie van Beeldende Kunsten, Amsterdam. Macleod's videos create disorientation and confusion by refusing to provide linear narratives which the viewer can engage in and follow through. Having to provide their own interpretations of the situations proposed by the artist, the viewers become a vital part of the work as they reassemble and complete each piece. Recent exhibitions include *New Contemporaries 1999*, Liverpool, and *SYZYGY O(rphan)d (rift>)*, Beaconsfield Gallery, London (1999). Kenny Macleod lives and works in London.

illustrated on front cover

Twin Sisters 1999
Video installation
Dimensions variable
The artist, courtesy Arts Council
Collection, Hayward Gallery, London
Photograph: Richard Haughton

Robbie Fraser 1999
Video installation. Dimensions variable
The artist, courtesy Arts Council Collection, Hayward Gallery, London

Money is Destroyed 1999
Gouache on paper
75.5 x 151.9 cm
JPC Collection, Geneva

Obedience Doesn't Relieve Pain
1999
Gouache on paper
78 x 135 cm
Collection MAMCO, Geneva

People Have Relaxing Orgasms
1999
Gouache on paper
78 x 135 cm
Collection J.-P. Jungo, Geneva

Chad McCail

Chad McCail was born Manchester in 1961. He studied at the University of Kent and Goldsmiths College, London. His detailed drawings remind us of illustrations in school books. The fictional environments present a harmonious picture of human interaction which defies our knowledge of the chaotic world we inhabit. The narratives contained within each picture are didactically spelt out by captions, suggesting the artist as an agent for social change. Recent exhibitions include *Chad McCail*, Laurent Delaye, London (1998), *Surfacing – Contemporary Drawing*, ICA, London (1998), and *Attitudes*, Geneva (1999). Chad McCail lives and works in Edinburgh.

Soldiers Leave the Armed Forces
1999
Gouache on paper
78 x 153 cm
Collection du Fonds d'art
contemporain de la ville de Genève

People Stop Using Things 1999
Gouache on paper
78 x 135 cm
Private collection (Switzerland)

Armour Dissolves 1999
Gouache on paper
78 x 135 cm
Collection MAMCO, Geneva

works not illustrated

Land is Shared 1999
Gouache on paper
78 x 135 cm
Collection J.-P. Jungo, Geneva

Mercy is Shown 1999
Gouache on paper
78 x 135 cm
Collection MAMCO, Geneva

People Build Homes and Grow Food 1999
Gouache on paper
78 x 153 cm
Collection du Fonds d'art contemporain
de la ville de Genève

Roads are Dug Up 1999
Gouache on paper
78 x 153 cm
Collection du Fonds d'art contemporain
de la ville de Genève

Wounds are Healed 1999
Gouache on paper
78 x 153 cm
Collection du Fonds d'art contemporain
de la ville de Genève

All works and photographs courtesy
Laurent Delaye Gallery, London

Conor McFeely

Conor McFeely was born in Derry in 1958. He studied at Kingston Polytechnic. McFeely's installation *Disclaimer* addresses the dynamics of responsibility in relation to certain forms of habitual behaviour – their social background and consequences – which remained unclaimed. Recent exhibitions include *Disclaimer*, Orchard Gallery, Derry (1997), *Perspective '98*, Ormeau Baths Gallery, Belfast (1998), *Popular Mechanics*, The Old Museum, Belfast and Context Gallery, Derry (1998–99), *The Horsehead International Project*, Belfast (1999), and *Small Steps*, The Ellipse Gallery, Washington DC (2000). Conor McFeely lives and works in Derry.

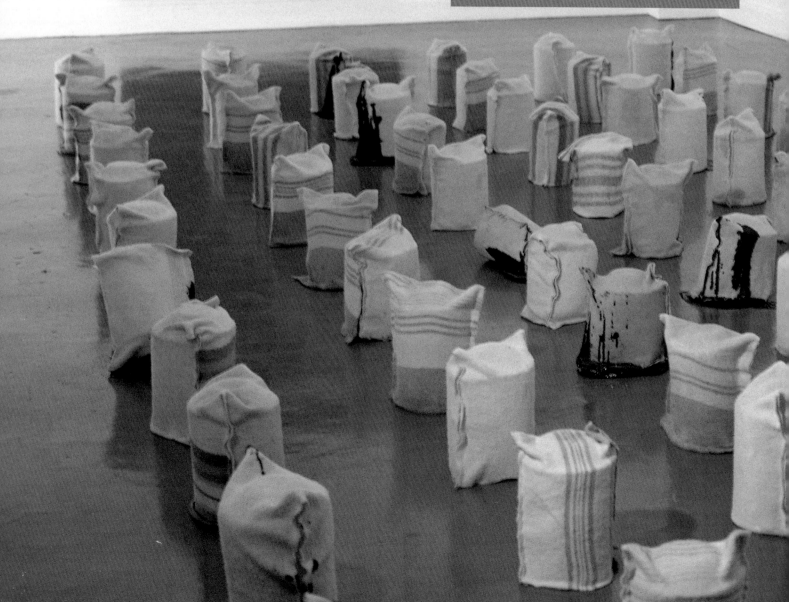

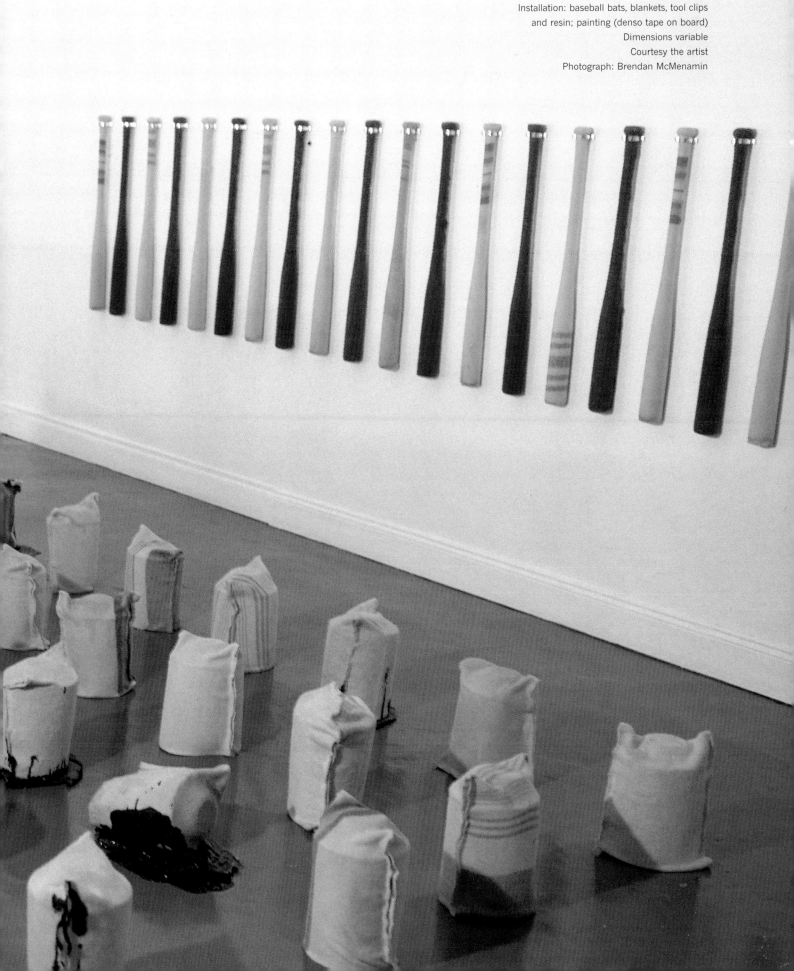

Disclaimer 1997
Installation: baseball bats, blankets, tool clips
and resin; painting (denso tape on board)
Dimensions variable
Courtesy the artist
Photograph: Brendan McMenamin

Lucy McKenzie

Lucy McKenzie was born in Glasgow in 1977. She studied at Duncan of Jordanstone College of Art & Design, Dundee, and Karlsruhe Kunst Akademie, Germany. McKenzie appropriates images from a variety of sources, including Olympic Games ephemera, pornography and alternative culture, to explore the artificial construction and categorization of identity. Her use of the symbolic within the realms of hegemony, both political and popular, is an intuitive attempt to make transparent the genesis of those cultural faith systems that are manipulated by visual desire; employed both personally and culturally, a basic seductiveness is at their root. Recent exhibitions include *EAST International*, Norwich (1999), *Dream of a Provincial Girl*, Gdansk (2000), and *Die Gefahr I'm Jazz*, Deutsch Britische Freundschaft, Berlin (2000). Lucy McKenzie lives and works in Glasgow.

works not illustrated

Festival 1998
Oil on canvas
123 x 93 cm
Courtesy the artist

Olga Korbut 1998
Oil on canvas
106 x 400 cm
Courtesy the artist

Curious 1998
Oil on canvas
79 x 48 cm
Courtesy Cabinet
Gallery, London
Photograph courtesy the artist

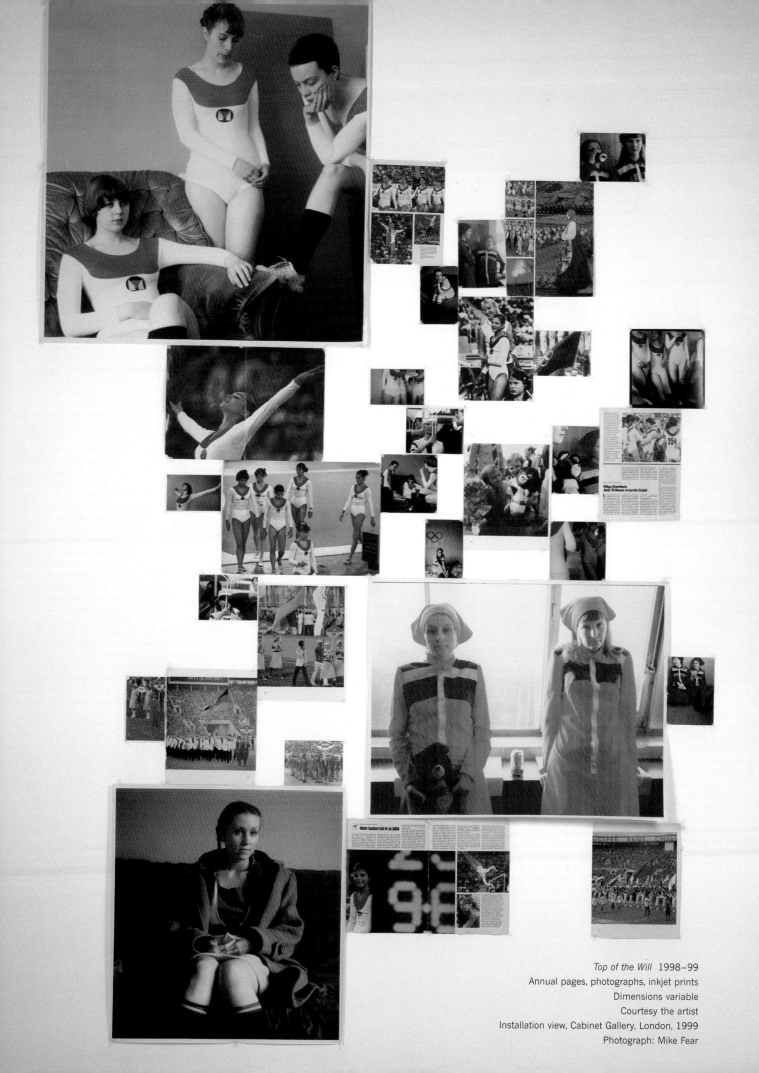

Top of the Will 1998–99
Annual pages, photographs, inkjet prints
Dimensions variable
Courtesy the artist
Installation view, Cabinet Gallery, London, 1999
Photograph: Mike Fear

David Musgrave

David Musgrave was born in Stockton-on-Tees, in 1973. He studied at Chelsea College of Art & Design, London. Musgrave's works experiment with different forms of representation and the way we have learned to read them as referencing something in the 'real' world. Using markings and signs as symbols that carry meaningful associations, his work suggests our interpretations of the visual world are dependent on a vocabulary which is both shared and specific to our own individual contexts. Recent exhibitions include *David Musgrave*, Duncan Cargill Gallery, London (1998), *Limit Less*, Galerie Krinzinger, Vienna (1999), and *David Musgrave and Mark Titchner*, Grey Matter, Sydney (2000). David Musgrave lives and works in Surrey and London.

Animal 1998
Polyurethane resin, enamel paint
21 x 13.7 x 4 cm
Courtesy the artist
Photograph courtesy the artist

Mike Nelson

Mike Nelson was born in Loughborough in 1967. He studied at Reading University, and Chelsea College of Art & Design, London. During the past seven years, Nelson has built a series of site-specific environments. References to the site are sometimes cultural or actual, sometimes fictional or reflecting the circumstances of the show. These mix with other information from film and literature, personal experience and real political situations to construct an idiosyncratic language, often attributed to a fictional 'other': a dog with a human mind (*Tracing Station AlphaCMa*, Matt's Gallery, London, 1996), a motorcycle gang called the Amnesiacs (*Master of Reality*, Berwick Gymnasium Gallery, Berwick-upon-Tweed, 1997), or a renegade bank of refugees (*Tourist Hotel*, Douglas Hyde Gallery, Dublin, 1999). Recently, these fictions of alienation and otherness have been pursued utilizing faked architectural spaces such as *To The Memory of H.P. Lovecraft*, Collective Gallery, Edinburgh (1999), and *The Coral Reef*, Matt's Gallery, London (2000). Mike Nelson lives and works in London and Edinburgh.

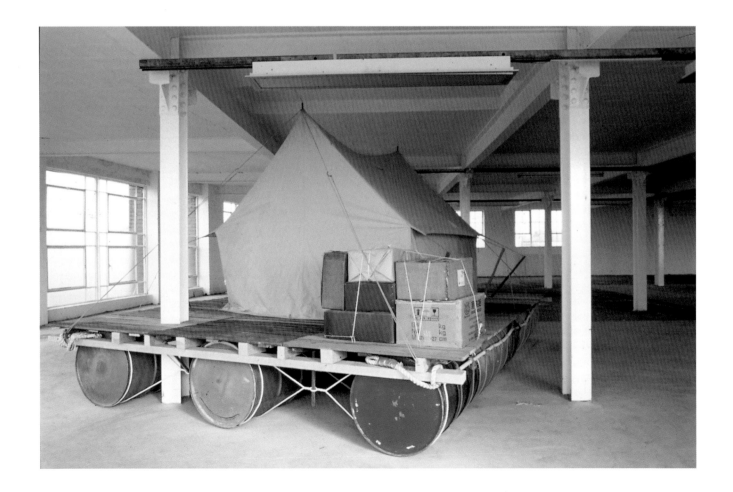

Taylor 1994
Mixed media, 250 x 336 x 456 cm
Installation view, *Turning Up*, The View, Liverpool
Photograph courtesy the artist and Matt's Gallery, London

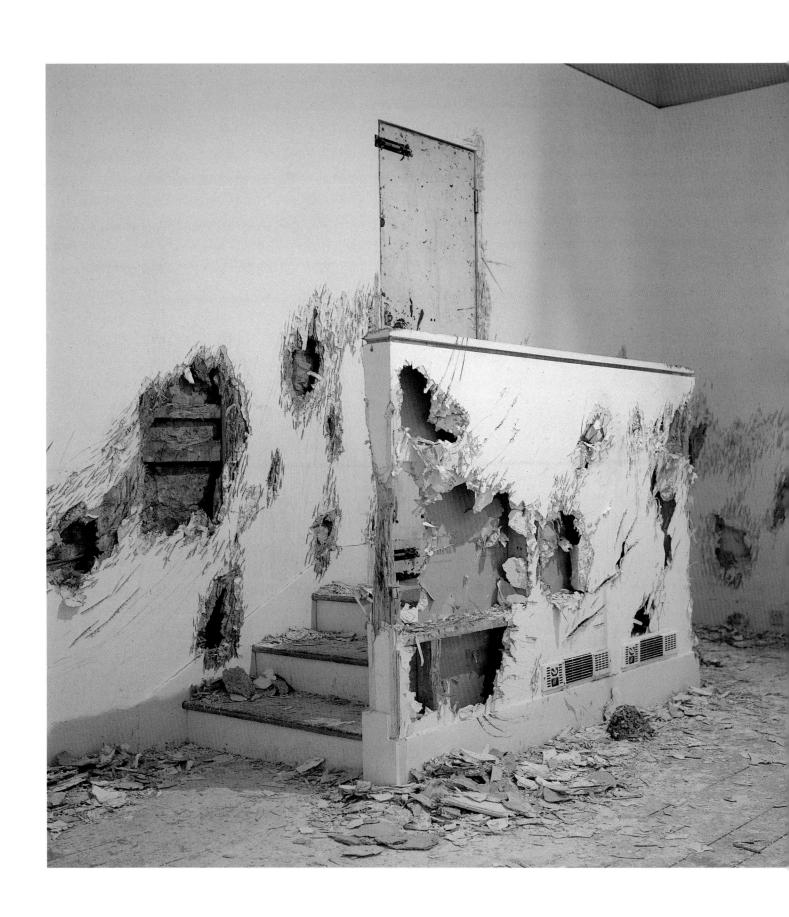

illustrated above (not in exhibition)

To The Memory of H. P. Lovecraft 1999
Installation view, Collective Gallery, Edinburgh
Photograph courtesy the artist and Matt's Gallery, London

Paul Noble

Paul Noble was born in Dilston, Northumberland, in 1963, and studied at Humberside College of Higher Education. Noble's large-scale pencil drawings are part of the artist's ongoing project, begun in 1998, *NOBSON*. A fictitious town where buildings are designed according to an alphabet created by the artist to represent various social functions or activities within this urban environment. His drawings resemble architectural plans while suggesting a fantasy landscape which has been faithfully recreated from the imaginary. Recent exhibitions include *NOBSON*, Chisenhale Gallery, London (1998), *Welcome to Nobpark*, Maureen Paley, Interim Art, London (1998–99), *Abracadabra*, Tate Gallery, London (1999), a solo exhibition at Gorney Bravin + Lee Fine, New York (2000), and *Landscape*, ACC Galerie, Weimar, Germany and touring (2000). Paul Noble lives and works in London.

'O' Tent, Nobwood 1998
Bubblejet print from CD
Dimensions variable
Courtesy the artist and Maureen Paley, Interim Art

'O' Tent, Nobwood 1998
Tent with tent bag
182.8 x 182.8 x 228.6 cm
Courtesy the artist and Maureen Paley, Interim Art

C.L.I.P.O.N. – Chemical Waste 1997
Pencil on paper
150 x 250 cm
Private collection, courtesy Maureen Paley, Interim Art

Jonathan Parsons

Jonathan Parsons was born in Redhill, Surrey, in 1970, and studied at Goldsmiths College, London. Parsons recreates found marks and explores the three-dimensional, illusory quality of the flat surface. His renderings of lines and markings lend them a significance which relies on our familiarity with visual language. What we see is informed by what we know, and painting can draw from this infinite possibility to go beyond its own surface. Recent exhibitions include *Sensation*, Royal Academy of Arts, London (1997), *Anthem*, Milch Gallery, London (1998), and *Furniture*, John Hansard Gallery, Southampton (1999). Jonathan Parsons lives and works in Farnham, Surrey.

Achrome 1994
Sewn polyster flag with rope and toggle
228 x 457 cm
Arts Council Collection, Hayward Gallery, London
Photograph (above) courtesy The Saatchi Collection, London

No! 1999
Ceramic 51 x 18 x 18 cm
Courtesy the artist

I Dunno 1999
Ceramic 48 x 25 x 25 cm
Courtesy the artist, Laurent Delaye Gallery, London

Boring Cool People 1999
Ceramic 63.2 x 26 x 26 cm
Courtesy the artist, Laurent Delaye Gallery, London

works not illustrated

Peasants with Fridge Freezer 1995
Ceramic 30 cm high
Courtesy the artist

Gimiks 1996
Ceramic 29.2 x 22.8 cm
Courtesy Jay Jopling (London)

Vase using my Family 1998
Ceramic 70 cm high
Courtesy Jay Jopling (London)

Video Installation 1999
Ceramic 28 x 14 x 14 cm
Courtesy the artist

All photographs courtesy
Laurent Delaye Gallery, London

Mr Shit Sex 1999
Ceramic 71 x 30 x 30 cm
Courtesy the artist, Laurent Delaye Gallery, London

Grayson Perry

Grayson Perry was born in Chelmsford, Essex, in 1960. He studied Fine Art at Portsmouth Polytechnic and learnt pottery at evening classes. Perry's use of craft in his work comments on issues of taste in art as well as other cultural and moral values. The explicitly sexual or Fascistic imagery in his work subverts the benign domesticity usually associated with craft. The contemporary art world's claim to be the ultimate arbiters of good taste is also ridiculed in Perry's work. He exhibited recently at the Anthony d'Offay Gallery, London (1997). Grayson Perry lives and works in London.

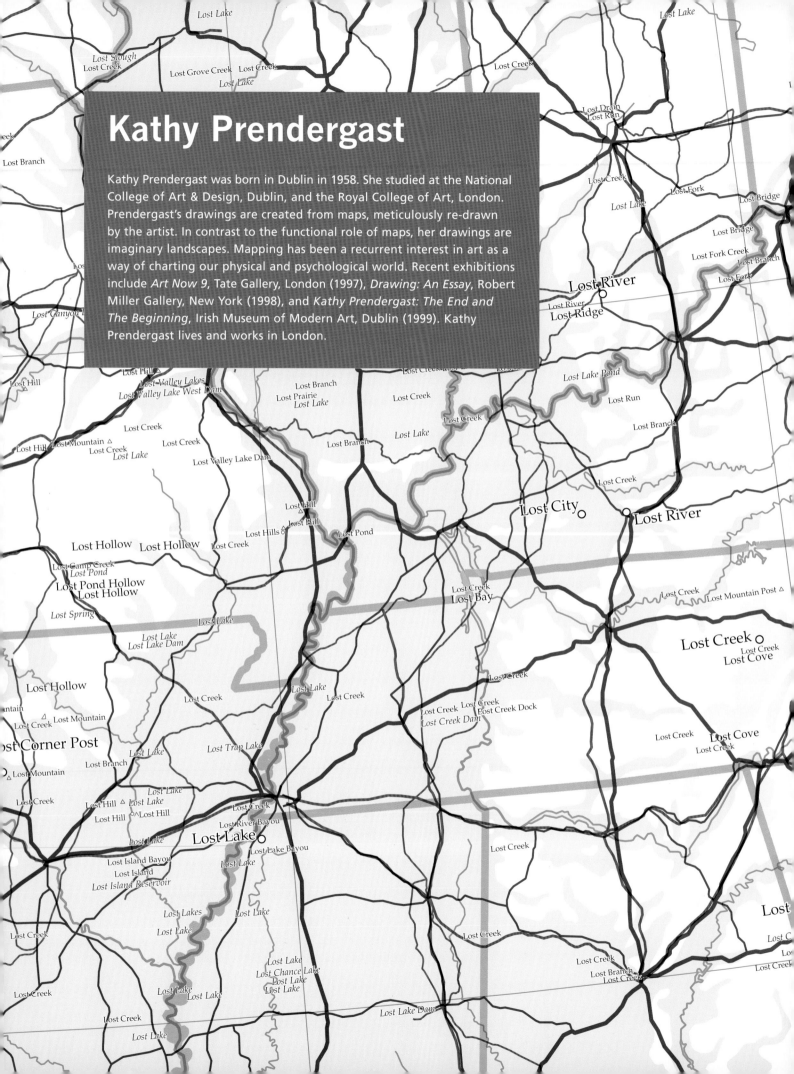

Kathy Prendergast

Kathy Prendergast was born in Dublin in 1958. She studied at the National College of Art & Design, Dublin, and the Royal College of Art, London. Prendergast's drawings are created from maps, meticulously re-drawn by the artist. In contrast to the functional role of maps, her drawings are imaginary landscapes. Mapping has been a recurrent interest in art as a way of charting our physical and psychological world. Recent exhibitions include *Art Now 9*, Tate Gallery, London (1997), *Drawing: An Essay*, Robert Miller Gallery, New York (1998), and *Kathy Prendergast: The End and The Beginning*, Irish Museum of Modern Art, Dublin (1999). Kathy Prendergast lives and works in London.

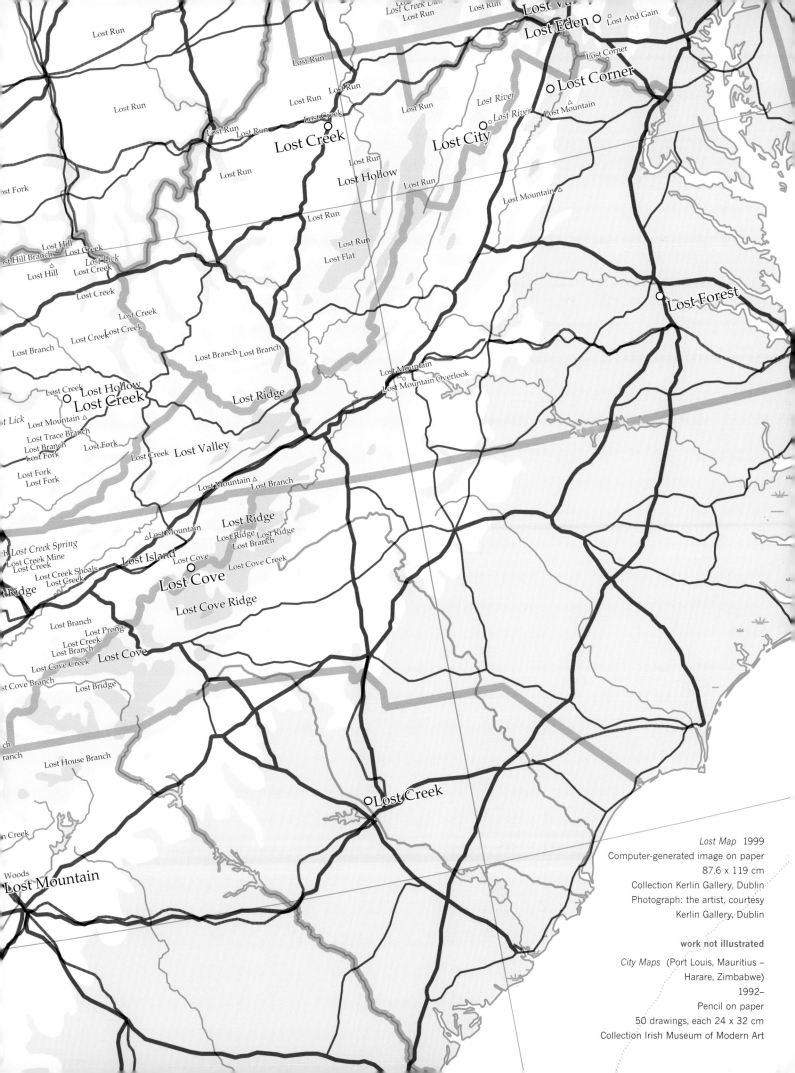

Lost Run
Lost Creek Dam
Lost Run
Lost Run
Lost Valley
○ Lost Eden ○
Lost And Gain
Lost Corner
Lost Run
Lost Run
Lost Run
Lost Run
○ Lost Corner
Lost River
Lost Run
Lost River
Lost Run
Lost Mountain
Lost Run ○ Lost Creek
Lost Creek
Lost City ○ ○ Lost River
Lost Run
Lost Creek
Lost Run
Lost Hollow
Lost Run
Lost Mountain △
Lost Run
Lost Run
Lost Flat
Lost Mountain △
Lost Fork
Lost Hill △
Lost Hill Branch △ Lost Creek
Lost Lick
Lost Hill Lost Creek
Lost Forest ○ Lost Forest
Lost Creek
Lost Creek
Lost Creek Lost Creek
Lost Branch
Lost Branch Lost Branch
Lost Creek Lost Creek
Lost Mountain
Lost Ridge
Lost Mountain Overlook
Lost Creek
Lost Hollow
Lost Creek
Lost Lick
Lost Mountain △
Lost Trace Branch
Lost Branch
Lost Fork
Lost Creek Lost Valley
Lost Fork
Lost Mountain △
Lost Branch
Lost Fork
Lost Fork
Lost Ridge
Lost Creek Spring
△ Lost Mountain
Lost Ridge Lost Ridge
Lost Creek Mine
Lost Ridge
Lost Branch
Lost Creek
Lost Island
Lost Cove
Lost Cove Creek
Lost Creek Shoals ○ Lost Cove
Lost Creek
Ridge
Lost Cove Ridge
Lost Branch
Lost Prong
Lost Creek
Lost Branch
Lost Cove Creek Lost Cove
Lost Cove Branch
Lost Bridge
Lost House Branch
Lost Creek ○
Creek
Woods
Lost Mountain

Lost Map 1999
Computer-generated image on paper
87.6 x 119 cm
Collection Kerlin Gallery, Dublin
Photograph: the artist, courtesy
Kerlin Gallery, Dublin

work not illustrated
City Maps (Port Louis, Mauritius –
Harare, Zimbabwe)
1992–
Pencil on paper
50 drawings, each 24 x 32 cm
Collection Irish Museum of Modern Art

Michael Raedecker

Michael Raedecker was born in Amsterdam in 1964. He studied at the Rijksakademie van Beeldende Kunsten, Amsterdam, and Goldsmiths College, London. Raedecker's use of thread – possibly inspired by his earlier work as a fashion student – seems to emphasize the unusual compositions and atmospheric landscapes of his paintings. Different textures and surfaces mimic domestic or organic materials and create the effect of empty film sets, full of dream-like, dramatic expectations. Recent exhibitions include *Examining Pictures*, Whitechapel Art Gallery, London/MOCA, Chicago (1999), *John Moores 21* (1st prize winner), Liverpool (1999), and solo exhibitions at The Van Abbemuseum, Eindhoven (1999 – 2000) and The Approach, London (2000). Michael Raedecker lives and works in London.

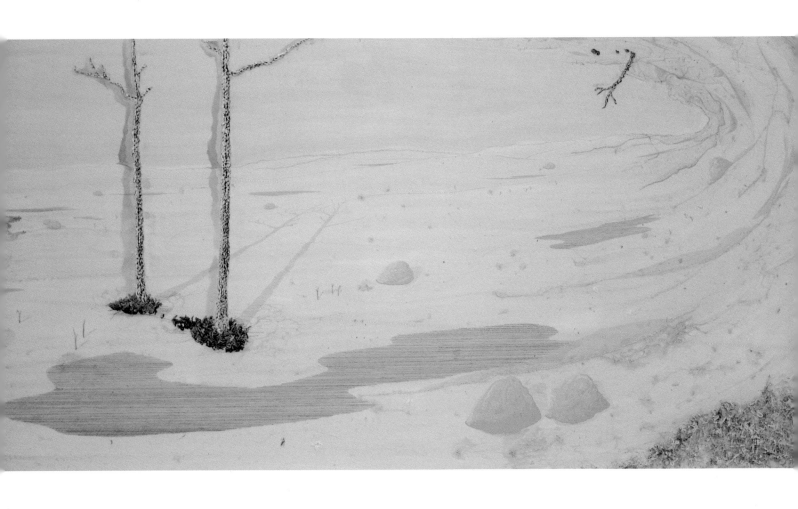

Mirage 1999
Acrylic thread and sequins on linen canvas
70 x 190 cm
Courtesy Board of Trustees of the National Museums
and Galleries on Merseyside (Walker Art Gallery)
Photograph courtesy The Approach, London

Triptych 1998
Pastel on paper mounted on aluminium
3 parts, each 110 x 100 cm
Courtesy Marlborough Fine Art, London
Photograph: Prudence Cuming, courtesy Malborough Fine Art, London

Paula Rego

Paula Rego was born in Lisbon in 1935. She studied at the Slade School of Fine Art, London. Rego's large paintings use a form of visual narrative structure to tell us stories which we may recognize as our own. Emotional conflicts, such as those we encounter through love, hate, lust or fear, are acted out by characters who populate our collective unconscious. The use of fables as vehicles for symbolic representation is a powerful means of conveying the thoughts and experiences we may not be able to articulate through consciousness or words. Recent exhibitions include *The Children's Crusade*, Marlborough Graphics, London, *Paula Rego: Recent Work*, Marlborough Galeria, Madrid, and *Paula Rego*, Fundação Calouste Gulbenkian, Lisbon (all 1999). Paula Rego lives and works in London.

Forest 1999
Oil on board
35 x 60 cm
Private collection
Photograph: Mike Fear

Carol Rhodes

Carol Rhodes was born in Edinburgh in 1959. She studied at Glasgow School of Art. Rhodes' paintings depict aerial views of fictional landscapes. Apparently desolate, the man-made and functional characteristics of the spaces do not suggest human presence. The precision and delicacy of the artist's technique are in contrast with the remoteness of the subject she chooses to portray – there is no evidence of anything of significance taking place anywhere. Recent exhibitions include *Carol Rhodes*, Andrew Mummery Gallery, London (1998), *Intelligible Lies*, Talbot Rice Gallery, Edinburgh (1998), *Jerwood Painting Prize* (1999), *Picture of Pictures*, Arnolfini, Bristol and Norwich Gallery (1999), and *The Constructed Landscape*, Brent Sikkema, New York and Lawrence Rubin Greenberg Van Doren Fine Art, New York (1999). Carol Rhodes lives and works in Glasgow.

Sea and Motorway 1998
Oil on board
42 x 48 cm
Collection of Leszek Dobrovolsky, Johannesburg;
courtesy Andrew Mummery Gallery, London
Photograph: Mike Fear

Container Depot 1998
Oil on board
51.5 x 46 cm
Collection of Leszek Dobrovolsky, Johannesburg;
courtesy Andrew Mummery Gallery, London
Photograph: Mike Fear

Donald Rodney

Donald Rodney was born in Birmingham, in 1961. He studied at Trent Polytechnic, Nottingham and the Slade School of Fine Art, London. Rodney's work, through the use of different media and materials, attempted to create a new language to articulate his experience. His very personal, autobiographical approach to his work is illustrated by the artist's use of his own skin (removed during an operation) to produce a small model house. Suffering from sickle cell anaemia from infancy, Rodney developed sophisticated, intricate ways of weaving together different aspects of his own life – including his disease – to explore questions of identity which went beyond his individual self. His last solo exhibition was *9 Night in Eldorado*, South London Gallery (1997). Donald Rodney died on 4 March 1998 in London.

In the House of My Father 1997
Photographic print on aluminium
153 x 122 cm
Arts Council Collection, Hayward Gallery, London
© The Estate of Donald Rodney
Photograph: Andra Nelkie

Paul Seawright

Paul Seawright was born in Belfast in 1965. He studied at the University of Ulster, and the West Surrey College of Art & Design. Seawright's photographs document the dehumanizing process of political control and violence and its effects on Northern Ireland's society. Men's fetishistic relationship with authority and its paraphernalia takes the foreground in the artist's observations of a community living in the grip of political struggle. Recent exhibitions include *The Glen Dimplex Artists' Award*, Irish Museum of Modern Art, Dublin (1997), and *Paul Seawright*, Kerlin Gallery, Dublin (1999). Paul Seawright is Head of the Photographic Research Centre at the University of Wales College, Newport, and lives and works in Gwent, South Wales.

Cage I 1997
Colour type C-print
on aluminium
188 x 150 cm

illustrated opposite

Fires (Black Spike) 1997
Colour type C-print on aluminium
150 x 150 cm

Fires (Cubes) 1997
Colour type C-print on aluminum
150 x 150 cm

Fires (Wheel with Flame) 1997
Colour type C-print on aluminium
150 x 150 cm

Cage II 1997
Colour type C-print on aluminium
188 x 150 cm

All works and photographs courtesy
Kerlin Gallery, Dublin

119

David Shrigley

David Shrigley was born in Macclesfield in 1968, and studied at Glasgow School of Art. Shrigley's drawings, sculptures and photographs use humour and the absurd to comment on the nonsensical aspects of the human condition. In his work, daily life often appears as a sequence of tragic events punctuated by comic insights into our fears and aspirations. Recent exhibitions include a solo show at Stephen Friedman Gallery, London (1997), *Surfacing – Contemporary Drawing*, ICA, London (1998), and Yvon Lambert Gallery, Paris (1999). David Shrigley lives and works in Glasgow.

Sculpture of a Nail 1999
Aluminium and polyester
11.5 x 4.5 cm

Pumpkin 1998
C-print
25.2 x 24 cm
(framed)

Red Kermit 1998
C-print
25 x 24 cm (framed)

Knees and Elbows 1999
Wood
4, each 24.5 x 58.5 x 12.5 cm

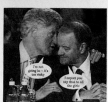

$$H_2C - CH - \underset{|}{\overset{H}{C}}.COOCH_3$$
$$| \quad NCH_3 \quad CH.OCOC_6H_5$$
$$H_2C - CH - CH_2$$

Structural formation of the Devil's dandruff

COKE

Cocaine or coke is a central nervous system (CNS) stimulant that heightens alertness, inhibits appetite and the need for sleep, and provides intense feelings of pleasure. It is prepared from the leaf of the Erythroxylon coca bush, which grows primarily in Peru and Bolivia. Pure cocaine was first extracted and identified by the German chemist Albert Niemann in the mid-19th century, and was introduced as a tonic/elixir in patent medicines to treat a wide variety of real or imagined illnesses, later, it was used as a local anaesthetic for eye, ear, and throat. Because of its potent euphoric and energising effects, many people in the late 19th century took cocaine and in the 1880's the psychiatrist Sigmund Freud created a sensation with a series of papers praising cocaine's potential to cure depression, alcoholism, and morphine addiction. The soft drink company Coca-Cola were stopped from using (Erythroxylon) coca as an ingredient in 1904 but were permitted to retain use of the word coca, that has also transposed into the word coke.

BLOCKING UP

In the south-western states of America during the early C20 tablets of cocaine were sold openly in boxes as a cheap substitute for drink. Since it's criminalization, and huge increase in price, cocaine has been favoured by the affluent and those involved with popular entertainments, film, sport, music, etc., In the early 1960s modernists (later mods) took amphetamines, usually Purple Hearts, as an alternative to alcohol, with the important difference that for the first time people in the mass were experiencing a cerebral sensation, not a physical one. It wasn't escape these teenagers were looking for but heightened awareness and the ability to experience it for longer periods.

PEACE MAN

When mods transformed into hippies in the mid 1960's so use of cannabis became the popular choice for the young. Easily available in the large cities through the West Indian community, cannabis with its pronounced ideological overtones was more suitable to the laid-back attitudes of the hippies. It soon established itself as a more useable drug for all daily periods and situations and consequently has steadily grown in use. By the early 1970s the whole hippie culture had become something of a joke for the new disillusioned generation who could see nothing in what was to them just another commercial enterprise. The wheel had turned full circle and it was back to a stimulant with a heightened cerebral sensation, this time it was the more sophisticated white powder, cocaine.

GLAMOUR GIRL

Cocaine is sold as a hydrochloride salt, a fine white crystalline powder known as coke. Dealers usually dilute it with inert (non-psychoactive) but similar-looking substances such as talcum powder, or with active drugs such as procaine or other (CNS) stimulants like amphetamines. Cocaine has actually become purer over the years averaging 75% purity at the end of the C20th. It is taken into the nostrils by 'snorting', traditionally through a tube (usually made from a rolled bank note) or just lifted under the nostril on a key or swipe card and sniffed up. Much of the illicit drug culture has its own language. Cocaine and its use has had many names and terms, like; coke, snow, girl, Charlie, sniff, bugle, smidging, shelving. Some names date back to before the second world war, Charlie can be heard in many fine blues songs, like, Glamour Girl, recorded by the American blues singer T-Bone Walker in 1950. Although not as widely used as cannabis, use of cocaine as a recreation drug continues to increase as an alternative to Britain's most common psychotropic drug; alcohol.

Johnny Spencer

Johnny Spencer was born in Tonbridge, Kent, in 1954. He studied at Camberwell School of Art, London, and Goldsmiths College, London. Spencer's work is concerned with the gathering of information on different subjects, from a wide range of sources, which the artist organizes and re-presents in different formats. His investigations on historical and cultural knowledge examine the ways in which we understand and attribute significance to the wealth of information we are constantly receiving and processing. Recent exhibitions include *Johnny Spencer*, Anthony Wilkinson Gallery, London (1998), *Real Life*, Galeria S.A.L.E.S., Rome (1998), and *The Golden Age*, ICA, London (1999). Johnny Spencer lives and works in London.

Student Isaac Reynolds, photo by Richard Avedon C1954

Released in 1965 minus the verse: *"I go to the movies and I go downtown/ But someone's always telling me/Don't hang around . . ."*

Mayfield formed the Impressions with singer Jerry Butler and two other vocalists Fred Cash and Sam Gooden in 1957. When Butler left after an early hit, *For your precious love*, the group disbanded, but reformed as a trio in 1961.

It's All Right, by Curtis Mayfield, a talented songwriter, he wrote *Gypsy woman* at the age of twelve!

RCA wanted to mould Sam Cooke into an 'all round entertainer', until the 1960s this was the fate of most rock & roll and pop stars if they survived beyond a handful of hits.

A CHANGE IS GONNA COME

The National Association for the Advancement of Coloured People (NAACP) was founded in 1910. Forty five years later in December 1955 Rosa Parks, a seamstress from Montgomery Alabama, defied the law by refusing to give up her seat on a public bus, she helped set in motion a series of events that would for ever change the human rights policies in the USA. One of these was the formation of the Montgomery Improvement Association, whose purpose would be to improve race relations and uplift the 'general tenor of the community', to be headed by a young pastor Dr. Martin Luther King, Jr. Although Rosa Park's brave and historic action revealed incredible unity and strength of purpose in virtually every black citizen of Montgomery (70 percent of bus passengers stayed off the buses) there was no significant reflection of this and other similar events in the black music of the period.

KEEP ON PUSHING

Almost the entire history of blues and jazz tells of the Afro Americans' condition either directly or indirectly, yet black musicians did not always utilise the possibilities of their art as a vehicle for the verbal transmission of attitudes and ideas. It wasn't until Curtis Mayfield's radical song, *Keep on Pushing*, that a mass audience heard a strong moral and political message that embodied the spirit and determination of the civil rights movement. Due in part to Mayfield's song writing abilities the Impressions established themselves as one of the nation's leading soul groups of the mid 60s. *Keep On Pushing* was released in 1964, the previous year Dr. Martin Luther King had delivered his "I have a dream" speech at the great march to freedom rally in Washington, DC, which sparked off nation-wide unrest and turmoil. It was against this background that Curtis Mayfield's positive and encouraging songs were heard.

SOUL STIRRINGS

It is said that Sam Cooke was so taken aback by the message in the song after hearing Bob Dylan's *Blowing in the Wind* that he wrote *A Change Is Gonna Come*. First released on the *Good News* album in 1964 then in an edited version the following year as the B-side of *Shake*. The song is a poignant, haunting description of a black American, his ambitions, struggles and needs. Cooke began singing gospel, with the Soul Stirrers, followed by a solo career with songs aimed at a teen audience. After joining RCA he was groomed to become an 'all round entertainer'. During this period Sam Cooke managed to turn the most abysmal slush into half-decent records. Then in the early sixties when soul music (and the civil rights movement) was in its infancy Cooke found within himself empathy for this new age and shook off the institutional pressure to make him, in their image, old before his time. *A Change is Gonna Come* is not only a fine soul record but also an expression of the new black consciousness; a civil rights song.

SAY IT LOUD, I'M BLACK AND I'M PROUD

Dr. Martin Luther King was assassinated in April 1968, four months later James Brown sung; *Say it loud, I'm black and I'm proud*, a potent message which rapidly became a black power anthem. When this moderately aggressive record was released it shocked and troubled a complacent public, consider; the CIA thought Martha and the Vandellas' *Dancing in the Street*, was a coded call to riot! It became a point from which there was no going back, and instigated the way for a black consciousness that has appeared in soul music ever since. By far the most important aspect of the white culture with which blacks were forced to come to terms, in the process of becoming Americans, was *language*. It could be said that in the field of black music, amongst the most worthwhile and enduring contributions to western life in the C20th, 60s soul represents the defining moment at which this was achieved.

James Brown had made the ultimate statement and black music had changed irrevocably

Simon Starling

Simon Starling was born in Epsom, Surrey, in 1967. He studied at Trent Polytechnic, Nottingham, and Glasgow School of Art. Starling reproduces culturally significant objects through a process which includes research and a form of historical reconstruction. Unlike the artistic appropriation of objects (known as 'readymades'), Starling appropriates authorship and design in order to create new works. Ultimately, the artist's source is the history in which we are all located. Recent exhibitions include *Family*, Inverleith House, Edinburgh (1998), Moderna Museet Project Room, Stockholm (1998), and *Micropolitiques*, Magasin, Grenobles (2000). Simon Starling lives and works in Glasgow.

*Le Jardin Suspendu (A 1:6:5 scale model of a 1920's 'Farman Mosquito', built
using the wood from a balsa tree cut on the 13th May 1998 at Rodeo Grande,
Baba, Ecuador, to fly in the grounds of Heide II designed in 1965 by David
McGlashan and Neil Everest)* 1998
Model airplane, glass, steel, balsa, vinyl text, assorted tools
Dimensions variable
Courtesy the artist and The Modern Institute, 2000
Photographs courtesy the artist and The Modern Institute
Photographed at MOMA at Heide, Melbourne, 1998

John Stezaker

John Stezaker was born in Worcester in 1949. He studied at the Slade School of Fine Art, London, and made a significant contribution to the Conceptual art movement of the 1970s. His current photographic work examines how representation, as a reflection of reality, informs and is defined by the way in which we perceive the world. Photography, like painting, is a tool of the imaginary with which the artist can give shape to our fantasies of the real. Recent exhibitions include *Angels*, Portfolio Gallery, Edinburgh International Festival (1999), *River Deep, Mountain High*, Westland Place Gallery, London (1999), and Ljubljana International Biennial of Graphic Art n° 23, Slovenia (1999). John Stezaker lives and works in London.

Overworld I 1998
Computer print
222.5 x 105 cm
Collection the artist

Overworld II 1998
Computer print
222.5 x 88 cm
Collection the artist

illustrated above and opposite

Soldiers – The Nineties 1999
Colour photocopies and inkjet prints
Dimensions variable
Courtesy the artist, Maureen Paley,
Interim Art

work not illustrated

*British Art Show Installation
1986–2000*, 2000
C-prints and inkjet prints
Dimensions variable
Courtesy the artist, Maureen Paley,
Interim Art

Wolfgang Tillmans

Wolfgang Tillmans was born in Remscheid, Germany, in 1968, and studied at Bournemouth & Poole College of Art & Design. The way Tillmans chooses to display his photographs plays an important part in the viewer's experience of his work. As we follow the sequences laid out by his installation of images, narratives unfold to which we bring our own individual interpretations. Recent solo exhibitions include Andrea Rosen Gallery, New York (1998), *Fruiciones*, Museo Reina Sofia, Madrid (1998), *Wako Works of Art*, Tokyo (1999), *Soldiers – The Nineties* (1999) and *Space Between Two Buildings*, Maureen Paley, Interim Art, London (1999). Wolfgang Tillmans lives and works in London.

Padraig Timoney

Padraig Timoney was born in Derry, Northern Ireland, in 1968. He studied at St Martin's School of Art, London, and Goldsmiths College, London. Timoney uses a variety of media and materials in his work, including photographs, painting and installation. Timoney's work, informed by the way meaning is constructed in and through art, juxtaposes concepts and languages to create layers of signification which viewers are invited to disentangle. Looking at his work is, therefore, not a passive act but an examination of our own linguistic and visual skills. Recent exhibitions include *The Hunter Became The Hunted*, Laure Genillard Gallery, London (1997), *Mille neuf cent*, Analix Gallery, Geneva (1998), and *London Calling*, The British School at Rome (1998). Padraig Timoney lives and works in Liverpool.

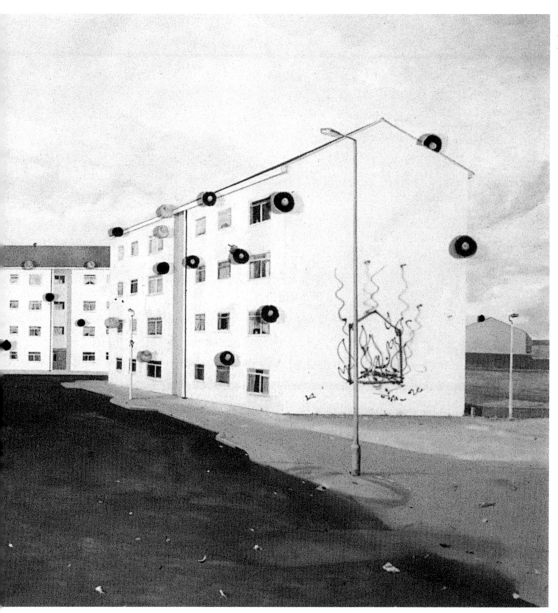

Fungus Rules the Brazen Cars 1995
Acrylic on canvas with plaster mushrooms
400 x 200 x 8 cm
Private collection
Photograph: Mike Fear

Armchair Painting – Untitled (Choose Death) 1995
Oil on canvas
50 x 61 cm

Armchair Painting – Untitled (When the Chips are Down) 1999
Oil on canvas
50 x 61 cm

Amikam Toren

Amikam Toren was born in Jerusalem, Israel, in 1945 and had no formal art training. Toren has been producing his 'Armchair Paintings' since the late 1980s. The artist's use of cheaply bought, street-market paintings – and the resulting significant increase in the paintings' selling price – questions the issues of authorship and value in art. The words cut out from the canvas are idiomatic expressions which have almost lost their original, literal meaning through constant use, just as they obscure the original image on the painting. Recent exhibitions include *L'Empreinte*, Centre Georges Pompidou, Paris (1997), *Hand in Glove*, Galerie Gabrielle Maubrie, Paris (1997), and *Armchair Paintings 1989–1998*, Minerva Bar Gallery, Tel Aviv (1998). Amikam Toren lives and works in London.

Armchair Painting – Untitled (Cathartic Knowledge), 1994
Oil on canvas
40.5 x 50.5 cm

Armchair Painting – Untitled (Sea Cow) 1999
Oil on canvas
35 x 46 cm

work not illustrated

Armchair Painting – Untitled (The Pleasure of Aesthetic Life) 1994
Oil on canvas
43 x 35 cm

All works courtesy Anthony Reynolds Gallery, London
All photographs: Mike Fear

Keith Tyson

Keith Tyson was born in Ulverston, Cumbria, in 1969. He studied at Carlisle College of Art and the University of Brighton. Tyson's work may be seen as the shaping of infinite possibilities into discernible fragments. This shaping is determined by, amongst other things, his *Artmachine*, a device which, through its access to many sources of information provides the artist with instructions for new works. Apparently disparate, arbitrary thoughts and ideas are combined to create an art work using a highly logical, precise structure and process to include that which escapes the terms of rational thought and investigation. Recent exhibitions include *Keith Tyson*, Anthony Reynolds Gallery, London (1997), *Seeing Time: Selection from the Pamela and Richard Kramlich Collection of Media Art*, San Francisco Museum of Modern Art (1998), *Molecular Compund 4*, Kleinesheimhaus, Zurich (1999), *Keith Tyson*, Delfina Gallery, London (1999), *Dream Machines*, National Touring Exhibitions from the Hayward Gallery, London (2000), and *Over the Edge*, Stedelijk Museum voor Actuele Kunst, Ghent (2000). Keith Tyson lives and works in London.

12 Magic Items (1976–2000)

The Wine of Life Swapping, 1976–2000
Magically activated item
Dimensions variable
(MGI.1.wine)

Doorway to a Parallel Universe, 1976–2000
Magically activated item
Dimensions variable
(MGI.2.doorway)

Dustbin of World Travel, 1976–2000
Magically activated item
Dimensions variable
(MGI.3.dustbin)

Line of Universal Expansion and Contraction, 1976–2000
Magically activated item
Dimensions variable
(MGI.4.telephone)

A Supermicroscopic Windowpane, 1976–2000
Magically activated item
Dimensions variable
(MGI.5.window)

The Apocalyptic Switch, 1976–2000
Magically activated item
Dimensions variable
(MGI.6.switch)

The Housebrick of Mind Control, 1976–2000
Magically activated item
Dimensions variable
(MGI.7.housebrick)

The Can of Chains, 1976–2000
Magically activated item
Dimensions variable
(MGI.8.tin can)

The Artwork of Altered Interest, 1976–2000
Magically activated item
Dimensions variable
(MGI.9.artwork)

The Paving Stone of Trailing Desire, 1976–2000
Magically activated item
Dimensions variable
(MGI.10.paving stone)

The Light of Awareness, 1976–2000
Magically activated item
Dimensions variable
(MGI.11.lightbulb)

The Chair of Global Itch Transfer, 1976–2000
Magically activated item
Dimensions variable
(MGI.1.wine)

Magic Item
Number One

The Wine of Life Swapping

Casting
This spell transforms any normal bottle of wine into
Magic Item Number One 'The wine of life swapping'.
An Initiate casts the spell by thinking it so (while in the
vicinity of a bottle of wine.)

Activation
The Magic Item is activated by the first human being
who's lips touch the wine inside the bottle.

Effects
As soon as the Magic Item is activated then the entire
population of the world are destroyed and reborn in a
new body, in a new place, with a completely new set of
memories.

Warnings and restrictions
This is a powerful item with unpredictable results.
Although most of the population will remain oblivious to
any change, there may be some people who come across
the spellbook and are not happy with the life they are
leading. They may even hold the caster personally
responsible.
Of course, revenge would be pointless, the caster would
also be somebody else.

For further information please phone this number: 020 7921 0896

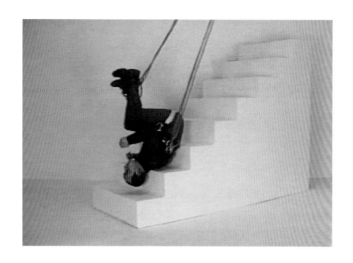

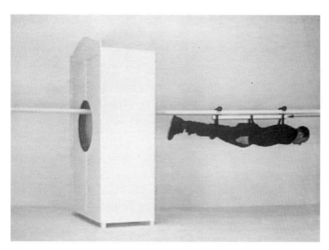

Volunteer 1998
Video installation
Dimensions variable
The artists funded by South West Media Development Agency

John Wood & Paul Harrison

John Wood was born in Hong Kong in 1969 and Paul Harrison in Wolverhampton in 1966. Both trained at Bath College and they have been working together since 1993. Their videos present intricate visual scenarios which refer to a range of human processes. The artists use the body's sculptural elements as a way to construct a vocabulary of shared, physical and emotional experiences. Recent exhibitions include *New British Video*, MOMA, New York (1997), *this other world of ours*, TV Gallery, Moscow (1999), *Physical Evidence*, Kettle's Yard, Cambridge (1999), and *Obstacle Course* and other works, John Hansard Gallery, Southampton and tour (1999). Their work has been widely shown in Europe, South America and the USA, and at screenings at the National Theatre, Tate Modern and Lux Centre, in London, as well as being broadcast on Channel 4, BBC2, ARTE in France, and German and Spanish TV. Wood lives and works in Bristol. Harrison lives and works in Shropshire.

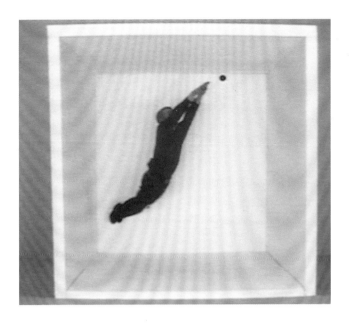

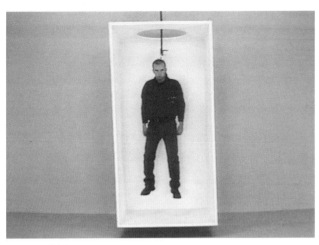

6 *Boxes* 1997
Video installation
Dimensions variable
The artists funded by West Midlands Arts / Film and Video Umbrella

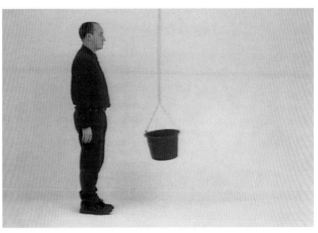

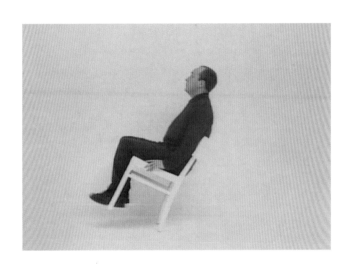

October 97 1997
Video installation
Dimensions variable
The artists commissioned by Werkleitz Gesellscharft

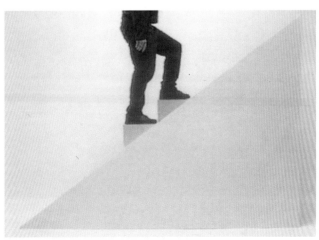

Device 1996
Video installation
Dimensions variable
The artists funded by BBC2 /
Arts Council of England

Richard Wright

Richard Wright was born in England in 1960. He studied at Edinburgh College of Art and Glasgow School of Art. Wright's wall paintings are developed on the spot, emerging from a meeting of memory and the architectural space. These mental and physical determinants are appropriated and re-conceived from within the individual paintings. The work concerns the boundaries of the intimate surface, the impossibility of control (grace versus entropy) and a desire to speak about reality beyond the inadequacy of the symbolic order of painting. Recent exhibitions include *Manifesta 2*, Luxembourg (1998), *Richard Wright*, BQ, Cologne (1999), *Creeping Revolution*, Foksal Gallery, Warsaw (1999), and *Intelligence: New British Art*, Tate Britain, London (2000). Richard Wright lives and works in Glasgow.

work not illustrated
Work for The British Art Show 2000
Gouache and enamel paint

illustrated above (not in exhibition)

Work from Salon 3 1998
Silver enamel on vinyl
Courtesy the Modern Institute, Glasgow

illustrated opposite (not in exhibition)
Work from Inverleith House, Edinburgh 1999
Gouache
Courtesy the Modern Institute, Glasgow

Cerith Wyn Evans

Cerith Wyn Evans was born in Llanelli, Wales, in 1958. He studied in London, at St Martin's School of Art, and the Royal College of Art. Wyn Evans has used neon lighting, mirrors and photography among other materials. The artist's earlier training in film seems to inform much of his work, which explores possibilities of representation, perception and our role as viewers and interpreters of visual language. Wyn Evans has exhibited extensively, including *Life/Live*, Musée d'art moderne de la ville de Paris and Centro de Exposições do Centro Cultural de Belém, Lisbon (1996), *Material Culture*, Hayward Gallery, London (1997), and *Sensation*, Royal Academy of Arts, London and tour (1997). Solo exhibitions include Centre for Contemporary Art, Kitakyushu, Japan (1998) and The British School at Rome (1999). Cerith Wyn Evans lives and works in London.

Untitled (gold-plated crowd control barrier)
1998
Plated steel
122 x 259 cm
Courtesy Jay Jopling (London)
Photograph: Stephen White, courtesy Jay
Jopling (London)

work not illustrated

So to Speak 1998
Neon light
Dimensions variable: approximately
5.6 cm high
Courtesy Jay Jopling (London)

Chronology: British Art and Society 1975 – 2000

Helen Luckett

This chronology traces the history of five *British Art Shows*, placing them in the context and climate of contemporary art in Britain and alongside world events. A necessarily partial account, it begins some four years before the first *British Art Show* and points to some of the factors that led to the initial decision to mount a major survey of contemporary art in Britain. Artists whose names are highlighted in blue are included in *The British Art Show 5*.

Art

1975

- 500th anniversary of Michelangelo's birth.
- **Eight Good Reasons to Visit the Serpentine Gallery** (festival of Performance Art) and **The Video Show** (festival of Independent Video) at the Arts Council-run Serpentine Gallery, London (opened in 1970).
- Founding of the ACME Gallery, London, which later becomes an important venue for video installation and performance work.
- **The Condition of Sculpture** at the Hayward Gallery, London; recent sculpture by younger British and foreign artists, selected by William Tucker. Includes work by 36 men and 4 women, and prompts a feminist protest.
- Liliane Lijn approaches the Tate Gallery with a proposal for a women's art exhibition, which is deemed 'not feasible'.
- Barbara Hepworth dies in a fire at her studio in St Ives.

1976

- **The Human Clay**; figurative works – mainly paintings and drawings – by 50 artists, selected by R.B. Kitaj, who prefaces his introductory essay by saying 'I have felt very out of sorts with my time …' (Hayward Gallery, London, and tour).
- Milan: **Arte Inglese Oggi**, organized by The British Council, includes about 340 works by 55 artists (among them Art & Language David Hockney and John Stezaker), plus films and performances.
- After the suspension of the traditional Biennale in 1974, the **Venice Biennale** – the leading show-place for the established international avant-garde – is revived, with an emphasis on 'social reality' and a priority for the theme of

Society

1975

- World population c.4 billion, or less.
- Communist victory in Vietnam.
- Civil war breaks out in Lebanon.
- Indira Gandhi declares a state of emergency in India.
- Britain suffers an economic crisis; though its potential saviour, British North Sea oil, begins to come ashore it is not yet available in substantial quantities.
- Personal computers go on sale in the USA.
- Bill Gates and Paul Allen found Microsoft computer company.
- Death of General Franco.
- Films released include Steven Spielberg's *Jaws* and Ken Russell's *Tommy* and *Lisztomania*.
- The first series of *Fawlty Towers* begins on British television.

1976

- Pol Pot becomes Cambodian Premier.
- Death of Chairman Mao.
- Jimmy Carter elected US President.
- The Anglo-French supersonic airliner Concorde makes its first commercial flight to America, crossing the Atlantic in less than three hours.
- The most destructive earthquake of the century obliterates the Chinese city of Tangshan; tremors had occurred earlier in Guatemala, Italy and Turkey.
- Abnormally hot summer leads to drought in Britain.
- Rioting at Notting Hill Carnival.
- The National Theatre, designed by Denys Lasdun,

'the environment'; Richard Long represents Britain.
• Christo builds *Running Fence*, a white nylon fence 18′
high and 24 miles long, running over the hills of northern
California and into the Pacific, designed to stand for only
two weeks before being dismantled.
• *Daily Mirror* provokes heated public controversy by
expressing outrage at the Tate Gallery's acquisition (4 years
previously) of Carl Andre's *Equivalent VIII* (1966) – the 'bricks'.
• *Art Monthly*, Britain's longest-running contemporary art
magazine, is founded.

opens in London.
• Apple computer company is founded by Steve Jobs and
Stephen Wozniak.
• Marshall McLuhan declares that advertising is the great
art form of the twentieth century.
• Books published include Shere Hite's *The Hite Report on
Female Sexuality* and Alex Hayley's *Roots*.
• Films released include Martin Scorcese's *Taxi Driver* and
Derek Jarman's *Sebastiane*.
• Pop group Abba becomes Sweden's biggest export earner
after Volvo.
• The Sex Pistols' record *Anarchy in the UK* marks the birth
of punk rock.
• Queen releases the song *Bohemian Rhapsody*.

1977

• First **Hayward Annual**, Hayward Gallery, London, selected
by Michael Compton, Howard Hodgkin and William Turnbull,
includes work by 30 artists (among them David Hockney) and
is greeted by critics as an 'art-political event'. As a series, the
Hayward Annuals are intended to present a cumulative picture
of British art as it develops.
• **Art into Landscape**, an exhibition of schemes to enliven
public spaces, selected from 1,000 submissions from the
second competition organized by the Arts Council of Great
Britain in collaboration with the RIBA, the Landscape Institute
and *The Sunday Times*, opens at the Serpentine Gallery.
• Extra **Venice Biennale** held, devoted to art of dissent and
dissidents, especially in Eastern Europe and USSR.
• Walter De Maria's *Lightning Field* – 400 stainless-steel poles
in grid-formation – is installed in New Mexico on top of a
remote mountain plateau famous for its frequent and violent
thunderstorms; in order to experience it properly, visitors
are advised to spend 24 hours in and around the work.
• **Documenta 6**, Kassel, Germany: 'Art and Media'.
• **The Henry Moore Foundation** is established 'to
advance the education of the public by the promotion
of their appreciation of the fine arts and in particular the
works of Henry Moore'.

1977

• Czechoslovak dissidents publish Charter 77 manifesto;
Czech government begins harassing the signatories.
• First elections for 41 years held in Spain.
• Steve Biko, South African political activist and founder of
the Black Consciousness movement, dies in police custody.
• First AIDS deaths in New York.
• Thousands of 'Boat People' – economic refugees – flee
from Vietnam every month, hoping to escape across the Gulf
of Thailand or the South China Sea; almost a quarter die in
the attempt.
• Centre Georges Pompidou, designed by Renzo Piano,
Richard Rogers and Gio Franco Franchini, opens in Paris.
• Foundation of publishing house Virago.
• Books published include J.K. Galbraith's *The Age of
Anxiety*.
• Mike Leigh's TV play, *Abigail's Party*, revolutionizes British
television drama.
• Films released include *Star Wars*, *Annie Hall*, *Close
Encounters of the Third Kind*, *Saturday Night Fever* and
Andrzej Wajda's *Man of Marble*.
• 'Punk' rock music prevalent; the Sex Pistols' *God Save
the Queen* charts at number two in the week of Queen
Elizabeth's Silver Jubilee.
• Death of Elvis Presley.
• UK-based charity Amnesty International awarded Nobel
Peace Prize.

1978

• **Art for Whom?**, selected for the Serpentine Gallery
by Richard Cork, editor of *Studio International*, attempts
to redress the 'failure of so much contemporary art to

1978

• Red Brigade kidnap and murder Aldo Moro, former
Italian Prime Minister and leader of the ruling Christian
Democrat party.

communicate with anyone outside a small circle of initiates'.
- **Art for Society: Contemporary British Art with a Social or Political Purpose**, selected for the Whitechapel Art Gallery by a committee including Richard Cork and the gallery's director, Nicholas Serota.
- **Hayward Annual '78**, selected by Rita Donagh, Tess Jaray, Liliane Lijn, Kim Lim and Gillian Wise Ciobotaru, includes work by 23 artists – 16 women (among them Susan Hiller) and 7 men – and aims to 'bring to the attention of the public the quality of the work of women artists in Britain in the context of a mixed show'.
- Mark Boyle represents Britain at the **XXXVIII Venice Biennale**.
- Giorgio de Chirico dies.

1979

- **Matt's Gallery**, one of the first spaces designed specifically for artists to exhibit installation works, opens in an East End studio.
- **Hayward Annual 1979: Current British Art**, selected by Helen Chadwick, Paul Gopal Chowdhury, James Faure Walker, John Hilliard and Nicholas Pope, includes work by 24 artists (among them John Stezaker), plus an ancilliary programme of performance art.
- **The British Art Show [1]** 1 December – 24 May 1980 Selected by the art critic William Packer (who says, 'this is, above all else, my exhibition…'), contains work by 112 artists (among them David Hockney); mainly painting, with some sculpture. Tours to Sheffield, Newcastle upon Tyne and Bristol; total attendance: 77,000.
- Jennifer Durrant is the first woman artist-in-residence at Oxford University.
- Bruce McLean performs *The Masterwork Award Winning Fishknife* at London's Riverside Studios, followed by four other major performances there over the next five years.

1980

- **Hayward Annual 1980: contemporary painting and sculpture**, selected by John Hoyland, includes work by 18 artists whose average age is about 45.
- Tim Head and Nicholas Pope represent Britain at the **XXIX Venice Biennale**.
- **British Art Now: An American Perspective** – the 1980 Exxon International Exhibition at the Solomon R. Guggenheim Museum, New York – includes paintings, sculpture and installations by John Edwards, Alan Green, Tim Head, Keith

- World's first 'test-tube' baby born in Manchester.
- Deaths of Pope Paul VI and his successor John Paul I; John Paul II becomes first non-Italian pope since 1522.
- Bulgarian defector, Georgi Markov, dies after being stabbed with a poison-tipped umbrella in central London.
- 914 members of the People's Temple die in a mass suicide at a commune in the Guyana jungle.
- Armistead Maupin's *Tales of the City* is published.
- The soap opera *Dallas* debuts on US television.
- *The South Bank Show* begins on UK television.
- Films released include *Grease*, *Midnight Express*, *The Deer Hunter* and *Superman*.
- Disco culture is at its height.

1979

- Khmer Rouge atrocities in Cambodia are exposed.
- General Idi Amin, one of Africa's most brutal dictators, is overthrown in Uganda.
- Revolution in Iran.
- 'Winter of discontent' in Britain.
- Conservatives win general election with 43.9 per cent of votes cast. Margaret Thatcher becomes Britain's first woman Prime Minister.
- Referendums in Scotland and Wales reject devolution from Britain.
- USSR invades Afghanistan.
- Earl Mountbatten and 3 others are killed by an IRA bomb in County Sligo.
- 'Dirty Protest' by 350 IRA prisoners at Maze Prison, Belfast.
- Books published include Italo Calvino's *If on a Winter's Night a Traveller*, Milan Kundera's *The Book of Laughter and Forgetting* and Jean-François Lyotard's *The Post-modern Condition* (later recognized as raising 'bafflement to a high point of principle').
- First £1 million transfer deal completed in British football.

1980

- Start of Iran-Iraq war.
- Emergence of 'Solidarity' in Poland.
- Unemployment in Britain exceeds 2 million.
- Death of President Tito of Yugoslavia causes a power vacuum in the Balkans.
- Ronald Reagan elected 40th President of the United States.
- Launch of the Sony 'Walkman'.
- The Intelsat-V communications satellite is launched. It is able to handle 12,000 telephone calls and 2 colour TV

Milow, David Nash, Hugh O'Donnell, Nicholas Pope and Simon Read.
• Opening of the Barbara Hepworth Museum and Sculpture Garden, St Ives, given to the nation and placed in the care of the Tate Gallery.
• Maggi Hambling is the first artist-in-residence at the National Gallery, London.

1981

• **British Sculpture in the Twentieth Century**, at the Whitechapel Art Gallery, London, contains more than 300 works, covering 80 years and 'the whole culture' of modern sculpture.
• **A New Spirit in Painting**, Royal Academy of Arts, London, curated by Christos M. Joachimides, Norman Rosenthal and Nicholas Serota, includes work by 38 painters of all generations, chosen from Britain, Europe and the USA.
• No Hayward Annual, due to the showing of *Picasso's Picassos* at the Hayward Gallery during the time usually reserved for the Annual. Instead, British art and photography is represented at the Hayward Gallery in exhibitions of Michael Andrews, William Johnstone, Phillip King and Raymond Moore.

1982

• **Hayward Annual: British Drawing**, the first Hayward Annual to be devoted to work in one medium, selected by Kenneth Armitage, Gillian Ayres, Frances Carey, Mark Francis and Euan Uglow from an open submission of over 6,000 works by 2,200 artists; the 262 exhibiting artists include Paula Rego and John Stezaker.
• Young British sculptors Tony Cragg, Richard Deacon, Bill Woodrow and Barry Flanagan gain widespread recognition; Flanagan represents Britain at the **XL Venice Biennale**.
• **Documenta 7**, Kassel, Germany, curated by Rudi Fuchs, with the participation of 178 artists.
• **First Carnegie International**, Pittsburgh, USA, at the Carnegie Museum of Art.

1983

• **The Sculpture Show: Fifty Sculptors at the Serpentine and the South Bank**, at the Hayward Gallery and Serpentine Gallery, selected by Paul de Monchaux, Fenella Crichton and Kate Blacker; admission free, thanks to sponsorship;

channels at the same time. Messages and documents can now be sent by 'fax'. The first public facsimile service is introduced by Intelpost.
• Television series *Yes, Minister* begins.
• John Lennon is shot dead in New York.
• Deaths of Roland Barthes, Jean-Paul Sartre, Alfred Hitchcock, Mae West and Marshall McLuhan.

1981

• Inner-city youth/race riots in Brixton, London, and Toxteth, Merseyside.
• Martial law in Poland.
• China limits families to one child.
• Peter Sutcliffe, the 'Yorkshire Ripper', is found guilty of the murder of 13 women.
• Marriage of Prince Charles and Lady Diana Spencer.
• Opening of bridge over the River Humber in north-east England – the world's longest suspension bridge.
• Books published include Salman Rushdie's *Midnight's Children* and D.M. Thomas's *The White Hotel*.
• *Postman Pat* first broadcast on television.
• Death of Bob Marley.

1982

• Argentine troops invade the Falkland Islands; Britain sends Task Force; Argentine forces surrender after 2 months' conflict.
• Conservatives make large gains in local elections.
• Israel invades Lebanon.
• 'Solidarity' is banned in Poland.
• 20,000 women encircle Greenham Common air base in protest against proposed siting of US cruise missiles there.
• A gene controlling growth is transferred from a rat to a mouse; the mouse grows to double size.
• Compact Disc (CD) audio system is launched.
• Start of broadcasts by Channel 4 television station.
• Films released include Ridley Scott's *Blade Runner*, Steven Spielberg's *ET*, Werner Herzog's *Fitzcarraldo* and Richard Attenborough's *Gandhi*.

1983

• First cruise missiles arrive at Greenham Common.
• President Reagan announces his 'Star Wars' defence strategy; huge research funds are allocated to it but prominent scientists argue that it is not technically feasible.

attendances reach record figures: 125,000 at Hayward and Serpentine Galleries; outdoors, on the South Bank and in Kensington Gardens, there are uncounted thousands more; the commissioning of outdoor works on a large scale is made possible by the support of the Greater London Council and The Henry Moore Foundation. Laura Ford is the youngest artist in the exhibition.

- **Public Art Development Trust** – the first organization for public art in the UK – is established.
- Artist-run **Transmission Gallery** is founded in Glasgow.

- Government White Paper proposes abolition of Greater London Council and metropolitan counties.
- Start of craze for Cabbage Patch dolls in USA.
- The 'Hitler Diaries' are exposed as fakes.
- Books published include Alice Walker's *The Color Purple*, Philip Roth's *The Anatomy Lesson* and J.M. Coetzee's *The Life and Times of Michael K*.
- Solidarity leader Lech Walesa is awarded the Nobel Peace Prize.
- Deaths of Kenneth Clark, Nikolaus Pevsner, Bill Brandt and Joan Miró.

1984

- **The British Art Show: Old Allegiances and New Directions 1979–1984 [2]** 2 November – 30 June 1985 Selected by Marjorie Allthorpe-Guyton (curator), Alexander Moffat (painter), and Jon Thompson (artist and teacher), contains work by 81 artists (among them Art & Language, Susan Hiller and Paula Rego), and includes film, video and performance as well as painting and sculpture. Tours to Birmingham, Edinburgh, Sheffield and Southampton; total attendance: 160,000.
- Howard Hodgkin represents Britain at the **XLI Venice Biennale**.
- 'The Glory of the Garden', the Arts Council of Great Britain's Arts Development Strategy, creates new posts and spaces, particularly for contemporary art and exhibitions, in regional galleries.
- Annual **Turner Prize** inaugurated by the Tate Gallery to stimulate public debate and interest in contemporary British art; the first winner is the expatriate painter Malcolm Morley; also shortlisted are Richard Deacon, Gilbert & George, Howard Hodgkin and Richard Long.
- The Australian **Sydney Biennial: 'Private Symbol: Social Metaphor'**, includes the work of 63 international contemporary artists, among them Art & Language
- Scottish Gallery of Modern Art moves to larger premises in a former school in Belford Road, Edinburgh.

1984

- Miners' strike in protest against proposed pit closures lasts for almost one year and also precipitates a national dock strike; British Coal Board Chairman Ian MacGregor – described by the Bishop of Durham as an 'imported, elderly American' – arrives for talks with NUM leader Arthur Scargill with a carrier bag over his head.
- IRA bombs Conservative Party Conference in Brighton, killing 5 and injuring 30; Margaret Thatcher escapes injury.
- Indira Gandhi is shot dead by two Sikh bodyguards at her home in Delhi.
- 45 tons of poisonous methyl isocyanate gas escape from the Union Carbide pesticide plant in Bhopal, central India; the worst industrial accident in history.
- Major famine in Ethiopia.
- In Britain, publication of *The Yuppie Handbook* draws attention to the 'young upwardly mobile professional', one of the defining icons of the mid-1980s.
- The satirical series *Spitting Image* begins on British television.
- *Teenage Mutant Ninja Turtles*, featuring Donatello, Leonardo, Michaelangelo [sic] and Raphael – launched as a black and white comic – soon becomes a children's craze.
- End of capital allowances on films in Britain; producers announce that they will leave the country.
- In the USA, the 50th anniversary of Donald Duck is celebrated.
- Death of Michel Foucault.

1985

- **The Saatchi Collection** opens to the public in premises in St John's Wood, London, with an exhibition of work by Donald Judd, Brice Marden, Cy Twombly and Andy Warhol.
- Turner Prize awarded to Howard Hodgkin (also shortlisted: Terry Atkinson, Tony Cragg, Ian Hamilton Finlay, John Walker

1985

- Sinking of the Greenpeace ship *Rainbow Warrior*.
- Anglo-Irish Agreement.
- Hole discovered in ozone layer.
- Norman Foster's Hong Kong and Shanghai Bank Headquarters opens in Hong Kong.

and the curator Milena Kalinovska).
- **The British Show**, Art Gallery of New South Wales in association with The British Council, includes work by 35 artists, among them Susan Hiller
- The **Contemporary Art Society** celebrates the 75th anniversary of its founding; since 1910 it has been purchasing contemporary painting and sculpture and presenting it to public galleries in Britain and the Commonwealth; up to now it had given away over 4,000 works of art. Beneficiaries include the Tate Gallery in particular, but also most regional galleries, many of which would otherwise be unable to represent contemporary art in their collections.
- **Artangel Trust**, an organization specializing in the commission of 'unfamiliar art in unfamiliar places', founded.

1986

- The first international Hayward Annual (and the last in the series), **Falls the Shadow: Recent British and European Art**, selected by Barry Barker and Jon Thompson, includes work by 32 artists.
- Frank Auerbach represents Britain at the **XLII Venice Biennale**. He shares the *Leone d'Oro* prize for the best artist with Sigmar Polke.
- Turner Prize awarded to Gilbert & George (also shortlisted: Art & Language, Victor Burgin, Derek Jarman, Stephen McKenna and Bill Woodrow).
- Camberwell College of Arts, Central St Martin's College of Art and Design and Chelsea College of Art and Design merge to become part of the newly-founded London Institute; Camberwell loses its Fine Art department (later reinstated) and St Martin's loses its status as the centre for British sculpture.
- **Chisenhale Gallery** founded.
- **TSWA-3D** (Television South West Arts) exhibition tours work of 14 artists to 9 British cities.
- Deaths of Henry Moore and Joseph Beuys.

1987

- Christie's sells Van Gogh's *Irises* for £30 million, a world record sale price for art of any kind.
- Hayward Gallery, National Touring Exhibitions and Arts Council Collection transferred from Arts Council of Great Britain to newly formed South Bank Centre (SBC) as result of GLC demise.
- Turner Prize awarded to Richard Deacon (also shortlisted: Patrick Caulfield, Helen Chadwick, Richard Long, Thérèse Oulton and the curator Declan McGonagle).
- **British Art of the Twentieth Century**, Royal Academy

- Richard Rogers's Lloyd's Building opens in the City of London.
- Live-Aid, the most ambitious live music festival ever attempted, raises more than £50 million for famine relief through televised concerts in the USA and Britain which are broadcast worldwide.
- Ted Hughes is appointed Poet Laureate.
- Peter Brook's *Mahabharata* is performed in Glasgow.
- The television soap *EastEnders* is first broadcast.
- Samplers begin to transform pop music production.
- Football fans riot in Britain; football-related violence becomes known as an 'English Disease'.

1986

- Explosion at nuclear power station in Chernobyl.
- State of Emergency in South Africa.
- Space shuttle Challenger explodes seconds after take-off at Cape Canaveral.
- President Reagan, with the support of Margaret Thatcher, launches a series of bombing raids against terrorists in Libya; there is little support for the action outside the US and the British Prime Minister is accused of having 'blood on her hands'.
- Abolition of Greater London Council.
- Overthrow of President Marcos in the Philippines.
- Insider dealing exposed on Wall Street.
- New newspaper, the *Independent*, first published in Britain.
- Last volume of the *Oxford English Dictionary* published (the first volume was published in 1884).
- Death of Argentine poet and author Jorge Luis Borges.

1987

- Iran-Contra hearings in USA.
- Development of Canary Wharf in London's Docklands.
- The first fibre-optic telephone cable is laid across the Atlantic.
- Massacre in Hungerford, Berkshire: Michael Ryan kills 16 people before shooting himself.
- The Great Gale: hurricane-force winds hit south-east England causing widespread devastation and millions of pounds' worth of damage.
- Black Monday: £50 billion is wiped off the value of shares

of Arts, London.

• *Modern Painters*, art journal edited by Peter Fuller (died 1990), launched; Prince Charles is a contributor to the first issue and Sister Wendy Beckett becomes its special protégée.

• Richard Wilson's *20/50*, a room filled with used sump oil across which the viewer walks on a steel plank, exhibited at Matt's Gallery; it is later bought by Charles Saatchi.

• **Documenta 8**, Kassel, Germany.

• **A Quiet Revolution: British Sculpture Since 1965** at the Museum of Contemporary Art, Chicago, includes work by Tony Cragg, Richard Deacon, Barry Flanagan, Richard Long, David Nash and Bill Woodrow.

• **Current Affairs: British Painting and Sculpture in the 1980s** at the Museum of Modern Art, Oxford, includes work by 26 artists, among them Art & Language, Susan Hiller and Paula Rego.

• **State of the Art**, a six-part series about art in the 1980s, is broadcast on Channel 4.

• Death of Andy Warhol.

in a single day's trading on the London Stock Exchange.

• IRA bomb Remembrance Day parade at Enniskillen.

• USA and USSR sign Intermediate Nuclear Forces treaty for reducing nuclear weapons.

• US dollar reaches record low.

• Books published include Tom Wolfe's *The Bonfire of the Vanities* and Simon Schama's *The Embarrassment of Riches*.

• KLF (Kopyright Liberation Front) release their first album, *1987 – What the Fuck is Going On?*, which makes controversial use of the newly-accessible 'sampling' technology and leads to a lawsuit with the pop group Abba.

1988

• **Tate Gallery Liverpool** opens; its inaugural exhibition, **Starlit Waters**, includes work by 15 contemporary British sculptors, among them Michael Craig-Martin, Tony Cragg, Richard Deacon, Antony Gormley, Anish Kapoor, Richard Long and Alison Wilding.

• Major **Hockney** retrospective travels from Los Angeles and New York to the Tate Gallery, London.

• Damien Hirst organizes **Freeze**, an exhibition of work by fellow students at Goldsmiths College, in an empty building in London's Docklands; the first of the 'warehouse shows', the 17 artists represented include Michael Landy and Sarah Lucas.

• Tony Cragg represents Britain at the **XLIII Venice Biennale** and is awarded a special mention.

• Turner Prize awarded to Tony Cragg (there was no published shortlist, but several other artists were considered: Lucian Freud, Richard Hamilton, Richard Long, David Mach, Boyd Webb, Alison Wilding and Richard Wilson).

• **Delfina Trust** founded to provide free studio space for British and foreign artists.

1988

• USSR withdraws from Afghanistan.

• Cease-fire ends the Iran-Iraq war after several years of military deadlock.

• Three IRA terrorists are gunned down in Gibraltar.

• Prominent American 'televangelist' Jimmy Swaggert admits on air to 'a sin of the flesh'.

• George Bush elected US President.

• General Augusto Pinochet is forced to stand down as President of Chile after losing plebiscite.

• The Boeing 747 jet Pan-Am Flight 103 explodes over Lockerbie in the Scottish borders as the result of a terrorist bomb.

• Concert held at Wembley Stadium to celebrate the 70th birthday of Nelson Mandela.

• British government bans Sinn Fein politicians' voices from being heard on TV and radio.

• GCSE school exams introduced in Britain.

• Books published include Stephen Hawking's *A Brief History of Time* and Salman Rushdie's *The Satanic Verses*. The following February, Salman Rushdie is accused of blasphemy by Islamic fundamentalists; Ayatollah Kohmeini announces a fatwa calling for his execution and Rushdie is forced into hiding.

1989

• The **New Contemporaries**, Britain's most important touring exhibition of work by students and recent graduates

1989

• Students massacred in pro-democracy demonstration in Tiananmen Square, Beijing.

from UK art schools – established under the title of Young Contemporaries in 1949, and renamed in 1974 – is relaunched, coinciding with the emergence of young British artists such as Glenn Brown, Damien Hirst, Alex Landrum, Abigail Lane, Maud Sulter and Marcus Taylor (who are all included in this year's exhibition, which opens at the ICA in London and tours to Manchester, Bracknell, Halifax and Kendal).

• Artist-run gallery **City Racing** is established in a former betting shop at the Oval, south London; one of the founders is Paul Noble.

• **Four Cities Project**, TSWA exhibition at Derry, Glasgow, Newcastle upon Tyne and Plymouth, includes 28 works by international artists, among them Donald Rodney.

• Turner Prize awarded to Richard Long (commended: Gillian Ayres, Lucian Freud, Giuseppe Penone, Paula Rego, Sean Scully and Richard Wilson).

• Burmese opposition leader Aung San Suu Kyi is placed under house arrest.

• Berlin Wall demolished.

• Disaster at Hillsborough Football Stadium in Sheffield; 95 fans are crushed to death.

• 'Velvet Revolution' ends Communist control of Czechoslovakia; the playwright Václav Havel becomes President.

• Collapse of Communism in Eastern Europe; in Romania, President Ceauçescu is overthrown and executed.

• In the USA, President Bush expresses his distaste for broccoli, and his power as world leader never to have to eat the vegetable again.

• Supertanker *Exxon Valdez* runs aground in Alaska, causing one of the worst man-made ecological disasters in history.

• Bastille Opera and I.M. Pei's pyramid, surmounting an extension to the Musée du Louvre in Paris, open.

• *A Vision of Britain, A Personal View of Architecture*, by HRH The Prince of Wales, is published.

• Launch of satellite station Sky TV.

• *The Simpsons* is first shown on American television.

• Acid-house rave parties attract tens of thousands of young people.

• First recorded UK ecstasy-related death.

1990

• **The British Art Show 1990 [3]** 24 January – 12 August Selected by Caroline Collier (curator), Andrew Nairne (curator) and David Ward (artist), contains work by 42 artists, most of whom are aged 35 or under (among them Lea Andrews); includes painting, sculpture, installations, film and video and performance. Tours to Glasgow, Leeds and Hayward Gallery, London; total attendance: 76,723.

• **Glasgow's Great British Art Show**, organized by Glasgow Art Galleries and Museums as a critical riposte to *The British Art Show 1990*, at the McLellan Galleries, Glasgow, includes 50 artists, among them Art & Language, Susan Hiller, David Hockney and Paula Rego.

• Paula Rego becomes the National Gallery's first Associate Artist.

• Anish Kapoor represents Britain at the **XLIV Venice Biennale**, and wins the *Premio Duemila* for the work of a young artist; the American artist Jeff Koons shows the life-size sculpture *Made in Heaven*, of himself having sex with his wife, the Italian porn-star La Cicciolina.

• **A New Necessity: First Tyne International Exhibition of Contemporary Art** at Newcastle upon Tyne.

• The **Museum of Installation** is opened in Deptford,

1990

• Nelson Mandela is released after 27 years in prison in South Africa.

• 'Mad Cow Disease' threatens British farming.

• Huge anti-poll tax demonstration in Trafalgar Square ends in rioting.

• 'Supergun' parts are intercepted on their way to Iraq; 4 months later Iraqi forces seize control of Kuwait.

• Boris Yeltsin becomes President of the Russian Federation, the largest of the 15 republics comprising the Soviet Union.

• Failure of air-conditioning at Mecca leads to one of the world's worst-ever crowd disasters, with some 1,400 people suffocated or trampled to death.

• Re-unification of Germany; 327 days after the opening of the Berlin Wall, East and West Germany are united in a single state of over 77 million people and the new government plans a return to its traditional seat in Berlin.

• Resignation of Margaret Thatcher as Prime Minister; John Major succeeds.

• Mary Robinson becomes first woman President of the Irish Republic.

• Lech Walesa becomes Poland's first post-Communist President.

south-east London.
- **Tramway** opens in Glasgow.
- Turner Prize is cancelled due to withdrawal of sponsorship.

- In Yugoslavia, democratic elections bring nationalists to power in the 6 republics: Slobodan Miloševic becomes President of Serbia with the aim of creating a 'Greater Serbia', while nationalists in Croatia and Slovenia want self-rule.
- Films released include *The Silence of the Lambs*.

1991

- *frieze* magazine is launched.
- **Broken English**, Serpentine Gallery, London, includes work by Angela Bulloch, Ian Davenport, Anya Gallaccio, Damien Hirst, Gary Hume, Michael Landy, Sarah Staton and Rachel Whiteread.
- First **EAST** exhibition, selected by Andrew Brighton and Sandy (Alexander) Moffat at Norwich Gallery, Norfolk Insititute of Art and Design; this annual open exhibition is later described as 'frugal but ambitious' and 'a product of the 1990s'.
- Paula Rego's mural, *Crivelli's Garden*, is completed for the brasserie in the new extension to the National Gallery, London.
- **Irish Museum of Modern Art** opens at the Royal Hospital, Kilmainham, Dublin.
- **BANK**, an artists' co-operative, is formed to curate and collaborate on exhibitions (later based at Gallerie Poo Poo); they institute 'THE BANK FAX-BAK SERVICE – Helping You Help Yourselves' which comments on other galleries' press releases and gives marks out of ten for pompousness.
- The reinstated Turner Prize, sponsored by Channel 4, is awarded to Anish Kapoor (also nominated: Ian Davenport, Fiona Rae and Rachel Whiteread).

1991

- Operation 'Desert Storm' launches the Gulf War. Correspondents covering the war are able to send their copy and pictures from Baghdad in real time from laptop computers by way of satellites; people sit in their living rooms thousands of miles away and watch the war.
- Former Indian Prime Minister, Rajiv Gandhi, is assassinated by a suicide bomber.
- In the aftermath of a failed coup against him, President Gorbachev – publicly humiliated by Yeltsin – resigns as First Secretary of the discredited Communist Party, leading to the demise of the USSR.
- Disintegration of Yugoslavia; civil war escalates between Serbia and Croatia.
- Repeal of South Africa's apartheid legislation.
- Discovery in the Austrian Alps of the preserved body of a man from c.3,300 BC.
- Sir Norman Foster's Stansted Airport opens.
- The Sainsbury Wing, Robert Venturi and Denise Scott Brown's extension to London's National Gallery, opens.
- Magazine *Dazed and Confused* launched.
- The Ministry of Sound opens in London.
- Freddie Mercury, star of the rock band Queen, dies of AIDS; the American basketball player 'Magic' Johnson is HIV-positive and announces his retirement from the sport to concentrate on raising AIDS awareness.

1992

- *Artscribe* magazine, founded in 1976, folds.
- **Doubletake: Collective Memory and Current Art**, Hayward Gallery.
- **Documenta 9**, Kassel, Germany: includes work by 190 artists from 30 countries.
- The Australian **Sydney Biennial: The Boundary Rider**, includes work by Helen Chadwick, Rachel Whiteread and Richard Wilson.
- **Young British Artists I**, The Saatchi Collection, London, includes Damien Hirst's *The Physical Impossibility of Death in the Mind of Someone Living* (the 'Shark').
- **Nigel Greenwood Gallery** closes.
- Turner Prize awarded to Grenville Davey (also nominated:

1992

- A 'Jiffy' condom advertisement released during the run-up to the general election shows the Prime Minister's parents with the caption 'if only they had used a "Jiffy"'; in spite of this, John Major wins.
- Betty Boothroyd becomes the first woman Speaker of the House of Commons.
- Andrew Morton's hagiography *Diana: Her True Story* goes on sale; Prince Charles and Princess Diana announce that they are to separate.
- Polytechnics become universities.
- Windsor Castle is damaged by fire.
- *Absolutely Fabulous* begins on BBC2.
- At the Brit Awards, the best-selling KLF announce that

Damien Hirst, David Tremlett, Alison Wilding).
• **Rear Window** begins to show site-specific works in temporary venues across London.
• *Sister Wendy's Odyssey*, a series of 10-minute art appreciation programmes by Sister Wendy Beckett (a contemplative nun), begins on BBC2.
• Death of Francis Bacon.

they have 'left the music business' and present the post-awards party with a freshly-slaughtered sheep with a tag reading, 'I died for ewe. Bon appetit.'
• Bill Clinton is elected President of USA.
• John Cage dies.

1993

• **The Henry Moore Institute** opens in Leeds.
• **Tate St Ives** opens.
• Tracey Emin and Sarah Lucas open a shop selling their work in Bethnal Green Road, London (and close it 7 months later).
• **Young British Artists II**, The Saatchi Collection, London.
• Jay Jopling opens **White Cube**, 'a temporary project space for contemporary art' in St James's, London.
• Richard Hamilton represents Britain at the **XLV Venice Biennale**, and shares the *Leone d'Oro* prize for the best artist with Antoni Tàpies. David Sylvester is awarded a *Leone d'Oro* (Giulio Carlo Argan prize) for art criticism. Damien Hirst exhibits *Mother and Child Divided*, the carcasses of a cow and calf preserved in formaldehyde.
• Joshua Compston organizes *A Fête Worse than Death* in Hoxton Square, London.
• **Wonderful Life** at the Lisson Gallery, London, includes 40 contemporary British artists, among them Martin Creed Graham Fagen Liam Gillick and Graham Gussin
• The artist-run commissioning agency **Locus+** begins operating from Newcastle upon Tyne.
• Turner Prize awarded to Rachel Whiteread for *House* (also nominated: Hannah Collins, Vong Phaophanit and Sean Scully); Whiteread is simultaneously awarded £40,000 as the 'worst artist in Britain' by the K Foundation (a reincarnation of the pop group KLF); she donates £10,000 to the charity Shelter and makes 11 grants of £2,400 to young artists. In December, Whiteread's *House* (completed the previous month) is demolished by the local council, in spite of many protests.
• Tracey Emin's *My Major Retrospective* is shown at White Cube.
• Princess Diana becomes Patron of the Serpentine Gallery.

1993

• Government announces privatization plans for British Rail
• Unemployment reaches 3 million for the first time in six years.
• Czechoslovakia splits, without violence or joy, to form two independent states – the Czech Republic and Slovakia; Václav Havel is elected first President of the Czech Republic.
• Siege of the Branch Davidian headquarters at Waco, Texas, by federal authorities ends in an inferno with over 80 dead.
• Sarajevo holds the first Bosnian 'War Crimes' trial.
• IRA bombs Harrods and, later, the City of London (for a second time).
• A record 5.6 million crimes per year are recorded in England and Wales.
• A car bomb severely damages the Uffizi Gallery in Florence.
• The Queen celebrates the 40th anniversary of her coronation. The Royal Family renounce many of their financial privileges and the Queen is to pay tax on income and capital gains.
• Boris Yeltsin sends tanks into Moscow to quell a rebellion by hardliners; dozens are killed.
• Two eleven-year-old boys are found guilty of murdering two-year-old James Bulger on Merseyside.
• Books published include Irving Walsh's *Trainspotting*, Vikram Seth's *A Suitable Boy* and Roddy Doyle's *Paddy Clarke Ha Ha Ha*.
• MTV's *Beavis and Butt-Head* is shown on Channel 4.
• ANC leader Nelson Mandela and South African President F.W. de Klerk share the Nobel Peace Prize.

1994

• Arts Council of Great Britain becomes Arts Council of England.
• **Some Went Mad, Some Ran Away...**, Serpentine

1994

• Democracy proclaimed in South Africa.
• Rwandan civil war; during April and May at least half a million people are killed in one of the worst genocidal

Gallery, London, curated by Damien Hirst.
- **Young British Artists III**, The Saatchi Collection, London.
- Tate Gallery selects Bankside Power Station as the future home for London's first museum of modern art.
- Turner Prize awarded to Antony Gormley (also nominated, Willie Doherty, Peter Doig and Shirazeh Houshiary).
- **The Institute of Cultural Anxiety: Works from the Collection**, ICA, London, curated by Jeremy Millar, includes 61 artists, among them Martin Boyce, Liam Gillick, Graham Gussin, Simon Starling, Keith Tyson (and Jeff Koons).
- **The Laboratory** founded at the Ruskin School of Drawing and Fine Art, Oxford, to support the production of new work in the visual arts.
- Institute of International Visual Arts (**inIVA**) founded 'to reflect a culturally diverse spectrum of artistic practices, curatorial voices and critical perspectives in contemporary art through collaborations and commissions'.
- Deaths of Derek Jarman and Leigh Bowery.

massacres of recent times.
- Cease-fire in Northern Ireland.
- 9 bodies are found in the Gloucester home of Fred and Rosemary West.
- Inauguration of Channel Tunnel, people can travel from the centre of London to the centre of Paris in little over three hours.
- President Clinton denies charges of sexual harassment.
- Tony Blair becomes leader of the Labour party.
- Guerrilla war against Russian forces begins in Chechnya, which had declared its independence from the Russian Federation three years earlier; brutal warfare costing an estimated 30,000 lives is followed by a peace deal (which is short-lived).
- Criminal Justice Act targets travellers, festivals and raves in Britain.
- Kurt Cobain of Nirvana commits suicide.
- Media interest in the internet explodes.
- The trial of O.J. Simpson opens in California.
- The National Lottery is launched in Britain; 25 million people buy tickets.
- The two members of the pop group KLF ritually burn £1 million – in notes – before an invited audience on the Isle of Jura.

1995

- **The British Art Show** [4] [4] 12 November – 21 July 1996 Selected by Richard Cork (critic), Rose Finn-Kelcey (artist) and Thomas Lawson (artist/writer), contains work by 25 artists; includes painting, sculpture, installation, film and video. Tours to Manchester (7 venues), Edinburgh (7 venues), Cardiff (6 venues/sites); total attendance: 258,151.
- Leon Kossoff represents Britain at the **XLVI Venice Biennale;** Kathy Prendergast wins the *Premio Duemila* prize for the best young artist.
- **Young British Artists IV**, The Saatchi Collection, London.
- **Art Now** space opens at the Tate Gallery, London, with an exhibition by Matthew Barney.
- **Brilliant! New Art from London**, at the Walker Art Center, Minneapolis, includes work by 22 young British artists; among them Glenn Brown, Tracey Emin, Liam Gillick, Michael Landy and Sarah Lucas.
- Turner Prize awarded to Damien Hirst (artists also nominated: Mona Hatoum, Callum Innes and Mark Wallinger).
- **Rites of Passage: Art for the End of the Century** at the Tate Gallery, London, includes work by 11 international contemporary artists working in video, sculpture, photography and site-specific installation, and celebrates the 'diversity

1995

- Heavy fighting in Chechnya; Russian forces capture the capital, Grozny, but resistance continues. A peace agreement is signed in July.
- The 50th anniversary of the liberation of Auschwitz is commemorated.
- Huge earthquake devastates Kobe, in western Japan.
- Nick Leeson's speculative and fraudulent trading brings down Britain's oldest merchant bank, Barings, which faces losses of £860 million.
- Gas attack on underground system in Tokyo, perpetrated by members of the Aum Shinrikyo (Supreme Truth) doomsday cult, injures over 5,000 people.
- Bomb attack in Oklahoma City on the second anniversary of the Waco siege kills 168 and is identified as an extreme right-wing revenge attack on the federal offices.
- In Afghanistan, Islamic fundamentalist Taliban forces capture the capital, Kabul.
- Assassination of Israeli Prime Minister Itzhak Rabin.
- Peace treaty for Bosnia-Herzegovina is negotiated at Dayton, Ohio.
- A Levi's jeans advertisement featuring a transsexual is launched in Britain.
- Dyson Dual Cyclone DC02 vacuum cleaner is launched.

and fragmentation [which] have characterized the art of the last decade'.

1996

- Turner Prize awarded to Douglas Gordon (also nominated: Craigie Horsfield, Gary Hume and Simon Patterson).
- **New Contemporaries**, now with the support of the Nigel Moores Family Charitable Foundation, opens at the Tate Gallery, Liverpool and tours to Camden Arts Centre, London.
- Paul Graham's *Hypermetropia* is shown in Art Now at the Tate Gallery, London.
- **Gasworks**, an artist-studio complex with an attached gallery, opens with *DAD*; this is followed in 1997 with *SAD*, which includes John Stezaker and Tracey Emin.
- Bill Viola's *The Messenger*, one section of a three-part video installation, is projected onto the ceiling of Durham Cathedral.

1997

- Anthony-Noel Kelly, a tutor at the Prince of Wales's Institute of Architecture, is convicted for stealing human body parts for use in his sculptures.
- Rachel Whiteread represents Britain at the **XLVII Venice Biennale**.
- **Sensation: Young British Artists from the Saatchi Collection**, at the Royal Academy of Arts, London, includes work by over 40 artists (among them Glenn Brown, Tracey Emin, Michael Landy, Sarah Lucas, Jonathan Parsons and Cerith Wyn Evans) and is one of its most successful shows ever, visited by 284,734 people – 2,800 per day – and, as predicted, causes outrage, but officers from the Metropolitan Police's Clubs and Vice Unit decide that the exhibition is not likely to infringe the 1959 Obscene Publications Act; Marcus Harvey's portrait of Myra Hindley is called an 'artrage' by the *Sun*, with the headline 'toddler's handprints used in portrait of evil Myra at posh gallery' and is defaced by ink and eggs in two separate attacks.
- Turner Prize awarded to Gillian Wearing (also nominated: Christine Borland, Angela Bulloch and Cornelia Parker); Tracey Emin gives a memorable performance on live television during a post-prize giving discussion on Channel 4.
- **Pictura Britannica**, organized by The British Council, tours Australia; it includes work by 48 contemporary British artists, among them Paul Graham, Joan Key, Jonathan Parsons, John Stezaker and Richard Wright

- Seamus Heaney is awarded Nobel Prize for Literature.
- AIDS affects over 1 million people worldwide.

1996

- London's Canary Wharf is severely damaged in an IRA bomb attack. This signals the end of the 1994 cease-fire; the new IRA campaign on the mainland continues, culminating in an attack on Manchester in which the city centre is devastated.
- 16 primary school children and a teacher are shot dead at Dunblane, Scotland.
- Prince Charles and Princess Diana divorce.
- International paedophile ring is brought to light in Belgium following the arrest of Marc Dutroux amid scandalous official incompetence.
- The USA attacks Iraq; Britain is the only one of America's Nato allies fully to support the missile strikes.
- President Clinton is re-elected for a second term, with a comfortable majority.

1997

- 'Eco-warriors' dig a network of tunnels under the proposed route of a new link road in Devon.
- Hale-Bopp comet is clearly visible in the night sky. Members of the Heaven's Gate announce their impending mass suicide on their website, saying they are going to rendezvous with a spaceship in the wake of the Hale-Bopp comet.
- Madeleine Albright becomes the first woman in the post of American Secretary of State.
- Birth of Dolly the Sheep, the world's first cloned animal.
- Tony Blair leads Labour to election victory and becomes Prime Minister.
- Verdict delivered in the case of McDonald's versus Morris and Steel (two ecology campaigners) – the longest libel trial in British legal history; the judge finds in favour of the fast food chain, but the action costs McDonald's an estimated £10 million.
- Gianni Versace is shot dead in Miami.
- The Princess of Wales dies in a car accident in Paris.
- Alexander McQueen, chief designer to Givenchy, launches his *Bellmer La Poupée* collection.
- Hong Kong is handed back to China.
- Earthquake in Italy causes very severe damage to the basilica of St Francis in Assisi.
- A British au pair, Louise Woodward, is tried for the alleged murder of a nine-month-old baby in Boston, Massachusetts.
- *Teletubbies*, a 'major pre-school initiative, drawing on

• Damien Hirst opens Pharmacy, his restaurant in Notting Hill Gate.
• **Dimensions Variable: New Works for The British Council Collection** includes 16 artists, among them Martin Creed Graham Gussin and Michael Landy
• The multimedia **Lux Centre** opens in Hoxton Square, London.

months of research with its target audience of two – five year olds', is first broadcast on British television; Tinky Winky, Dipsy, Laa-Laa and Po are later recognized as an example of 'design brilliance' and are to be shown in the Millennium Dome as one of our 'greatest modern industrial achievements'.

1998

• Antony Gormley's monumental sculpture, *The Angel of the North*, is erected near the A1 in Gateshead, north-east England.
• Turner Prize awarded to Chris Ofili (also nominated: Tacita Dean, Cathy de Monchaux and Sam Taylor-Wood).
• Frank Gehry's **Guggenheim** opens in Bilbao, Spain.
• Michael Craig-Martin represents Britain at the **São Paulo Bienale**.
• The **Jerwood Gallery** opens with an exhibition of the **Jerwood Painting Prize**; this annual event now has a permanent home for the first time in its five-year life; the prize itself is worth £30,000.
• **Milch Gallery**, originally opened in 1990, relaunches its programme with *Anthem*, which includes commissioned works by Jonathan Parsons
• **Art Transpennine**, a multi-site exhibition of international contemporary art and a 'dialogue between art, people and place', is shown in venues across the north of England.

1998

• Belfast accord endorsed by referendum; months later the Good Friday Peace Agreement is rocked by Protestant intransigence, leading to the death of 3 young boys in a petrol-bomb attack at Drumcree and a massacre perpetrated by the Real IRA in a car-bomb attack at Omagh.
• India and Pakistan carry out nuclear tests.
• At the request of two Spanish judges, former Chilean dictator General Pinochet is arrested in a private London hospital.
• 'Zippergate' scandal leads, 13 months later, to President Clinton's impeachment on counts of perjury and obstruction of justice, but he is to be allowed to stay at the White House until the end of his presidency in January 2001.
• Financial crisis in East Asia; fears of a 'global financial meltdown' are proved wrong.
• New British Library, designed by Colin St John Wilson in 1982, opens to readers, in considerably reduced form.
• David Trimble and John Hume awarded the Nobel Peace Prize.

1999

• Opening of Scottish National Gallery of Modern Art's **Dean Centre**.
• Opening of Centre for Visual Arts – **CVA** – in Cardiff.
• First 'Neurotic Realism' exhibition at Saatchi Gallery.
• Charles Saatchi gives 100 works from his collection to the Arts Council Collection, managed by the Hayward Gallery.
• Gary Hume represents Britain at the **XLVIII Venice Biennale**.
• **Sensation: Young British Artists from the Saatchi Collection**, having previously toured to Berlin in 1998, is shown at the Brooklyn Museum of Art, New York, attracting 170,000 visitors and incurring the wrath of New York's mayor, Rudolph Giuliani, who attempts to withdraw city funding; Chris Ofili's *The Holy Virgin Mary* is attacked by a pensioner.
• Michael Raedecker wins first prize at the **John Moores Liverpool Exhibition of Contemporary Painting**; the purpose of this biennale, established in 1957, is 'to encourage

1999

• After accidentally bombing a refugee convoy in Kosovo and the Chinese embassy in Belgrade, Nato troops enter Kosovo to halt ethnic cleansing of Kosovo Albanians.
• Scotland and Wales elect new, devolved assemblies.
• Glasgow is City of Architecture & Design 1999.
• Two students carry out a gun attack at Columbine High School in Colorado, USA, leaving 15 dead and many injured; this follows on from similar attacks in Oregon, Mississippi, Pennsylvania, Kentucky and Arkansas.
• A wave of bomb attacks rocks Brixton, Brick Lane and Soho.
• Total solar eclipse visible from Cornwall.
• Astronomers working with the Hubble telescope discover the oldest galaxy in the universe (14.25 billion years).
• Nelson Mandela retires as South African President.
• Jeffrey Archer is discredited and debarred from standing for election as Mayor of London.

contemporary artists, especially the young and progressive'.
- **Abracadabra: International Contemporary Art** at the Tate Gallery, London, includes 15 artists, among them Emma Kay and Paul Noble
- Turner Prize awarded to Steve McQueen (also nominated: Tracey Emin, Steven Pippin, Jane and Louise Wilson); the Turner Prize exhibition is visited by 140,687 people, many of whom go specifically to see Tracey Emin's *My Bed*.
- The Royal Society of Arts commissions Mark Wallinger, Rachel Whiteread and Bill Woodrow to make works for the empty plinth in London's Trafalgar Square.

- Boris Yeltsin resigns as President of Russia.
- Guerrilla warfare escalates in Chechnya.
- The internet rules communications, linking almost every country in the world and allowing the unlimited exchange of information and entertainment, and providing a means of electronic commerce and publishing. One of the fastest growing uses is for the transmission of e-mail.
- Pokémon craze hits children in UK.

2000

2000

- New Millennium Experience opens at the Dome (designed by Richard Rogers Partnership) with works by David Begbie, Tony Cragg, Bill Culbert, Richard Deacon, Tacita Dean, Antony Gormley, Anish Kapoor, Ron Mueck, Gerald Scarfe, Gavin Turk, James Turrell and Richard Wilson.
- The biggest programme of new and refurbished museums and galleries in British history – costing over £400 million – begins with the opening of Walsall's **New Art Gallery**, followed by Manchester's Lowry Centre and, in London, the new wing of the National Portrait Gallery, the Dulwich Picture Gallery extension, the Somerset House refurbishment, the re-launch of the Tate Gallery on Millbank as Tate Britain and the new **Tate Modern** at Bankside.
- **The British Art Show 5** 8 April 2000 – 28 January 2001 Curated by Pippa Coles (freelance curator), Matthew Higgs (artist/writer) and Jacqui Poncelet (artist), contains works by fifty-seven artists. Tours to Edinburgh (8 venues), Southampton (3 venues), Cardiff (4 venues), Birmingham (2 venues).

- World population exceeds 6 billion.
- During January and February: massive demonstrations take place in Austria against the new coalition government which includes five ministers from Jörg Haider's far-right Freedom Party; the Northern Ireland power-sharing agreement collapses and the Sinn Fein president Gerry Adams says that the Good Friday Agreement is 'in tatters'; hijacked Afghan airliner lands at Stansted Airport – the victims seek asylum and despite the wishes of the Home Secretary are not deported; crises at the under-visited Millennium Dome result in a radical administrative restructure; Tony Blair admits that 'there is potential for harm, both in terms of human safety and in the diversity of our environment, from GM foods and crops'…

29 February 2000

John Abbott
Ivor Abrahams
Norman Adams
Michael Andrews
Martin Ball
John Bellany
Adrian Berg
Stephenie Bergman
Elizabeth Blackadder
Frank Bowling
Stephen Buckley
Jeffery Camp
Anthony Caro
John Carter
Tony Carter
Prunella Clough
John Cobb
Doug Cocker
Barrie Cook
Jack Crabtree
Dennis Creffield
Michael Crowther
Francis Davison
Kenneth Draper
John Edwards
Anthony Eyton
Brian Fielding
Lucian Freud
Terry Frost
Hamish Fulton
Lloyd Gibson
Michael Ginsborg
Derrick Greaves
Alan Green
Anthony Green
Jon Groom
Nigel Hall
Maggi Hambling
John Hilliard
David Hockney
Howard Hodgkin
Carole Hodgson
Harry Holland
John Hoyland
Patrick Hughes
Paul Huxley
Henry Inlander
Albert Irvin
Allen Jones
Wynn Jones
Jake Kempsall

Michael Kenny
Dave King
Phillip King
Leon Kossoff
Edwina Leapman
Terry Lee
John Loker
Richard Long
Michael Lyons
Leonard McComb
John Macfarlane
John McLean
John Maine
Barry Martin
Michael Mason
Robert Mason
Michael Mayer
Keith Milow
Jack Milroy
Nick Monro
Andrew Mylius
Janet Nathan
Martin Naylor
Paul Neagu
Victor Newsome
Ken Oliver
Brian Peacock
Michael Peel
Heinz-Dieter Pietsch
Nick Pope
Lawrence Preece
William Pye
Simon Read
Keith Reeves
Bridget Riley
Peter Rippon
Will Rogers
Kate Rose
Bruce Russell
Michael Sandle
Gavin Scobie
Bill Scott
Sean Scully
John Selway
Harry Snook
Norman Stevens
Brian Thompson
David Tindle
Euan Uglow
Michael Upton
John Walker

The British Art Show

1

Margaret Walker
David Walker Barker
Karl Weschke
Anthony Whishaw
Caroline White
David Willetts
Victor Willing
Gerard Wilson
Laetitia Yhap
Ainslie Yule

The British Art Show

2

Art & Language
Kevin Atherton
Terry Atkinson
Frank Auerbach
Gillian Ayres
Jo Baer & Bruce Robbins
Peter Bailey
Basil Beattie
John Bellany
Tony Bevan
Stuart Brisley
Victor Burgin
Paul Bush
Steven Campbell
Anthony Caro
John Carter
Tony Carter
Helen Chadwick
Marc Chaimowicz
Alan Charlton
Tony Cragg
Michael Craig-Martin
John Davies
Richard Deacon
Graham Durward
Ian Hamilton Finlay
Rose Finn-Kelcey
Gareth Fisher
Joel Fisher
Barry Flanagan
Gilbert & George
Sandra Goldbacher
Antony Gormley
Mick Hartney
Tim Head
Gerard Hemsworth
Susan Hiller
John Hilliard
Howard Hodgkin
Shirazeh Houshiary
Anthony Howell
John Hoyland
John Hyatt
Stephen Johnson
Peter Joseph
Anish Kapoor
Mary Kelly
Ken Kiff
R.B. Kitaj
Leon Kossoff
Bob Law

Richard Long
Leonard McComb
Jock McFadyen
Ian McKeever
Stephen McKenna
Bruce McLean
Alastair MacLennan
Kenneth Martin
John Murphy
Avis Newman
Gerald Newman
Philip Nicol
Thérèse Oulton
Jayne Parker
Paula Rego
Michael Sandle
Terry Setch
John Smith
Ray Smith
Station House Opera
Andrew Walker
John Walker
Boyd Webb
Richard Wentworth
Alison Wilding
Victor Willing
Adrian Wiszniewski
Bill Woodrow
Stephen Taylor Woodrow
John Yeadon

Lea Andrews
Eric Bainbridge
Black Audio Film Collective
Sonia Boyce
Jyll Bradley
Kate Bright
Melanie Counsell
Matthew Dalziel
Ian Davenport
Grenville Davey
Cathy de Monchaux
Jeffrey Dennis
Willie Doherty
Mona Hatoum
Kevin Henderson
Gary Hume
Kabir Hussain
Bethan Huws
Callum Innes
Brian Jenkins
Patrick Keiller
Joanna Kirk
Elizabeth Magill
Lisa Milroy
John Mitchell
Locky Morris
Julian Opie
Cornelia Parker
Vongphrachanh Phaophanit
Fiona Rae
David Robilliard
Caroline Russell
Veronica Ryan
Lesley Sanderson
Louise Scullion
Yolande Snaith
Gary Stevens
Linda Taylor
Peter Turley
Shafique Uddin
Rachel Whiteread
Caroline Wilkinson

The British Art Show

3

The British Art Show

4

Jordan Baseman
Christine Borland
Mat Collishaw
Tacita Dean
Ceal Floyer
John Frankland
Anya Gallaccio
Douglas Gordon
Damien Hirst
Gary Hume
Permindar Kaur
Steve McQueen
Lucia Nogueira
Chris Ofili
Julie Roberts
Bridget Smith
Georgina Starr
Kerry Stewart
Marcus Taylor
Sam Taylor-Wood
Mark Wallinger
Gillian Wearing
Hermione Wiltshire
Jane & Louise Wilson
Catherine Yass

Lea Andrews
Art & Language
Phyllida Barlow
David Batchelor
Martin Boyce
Glenn Brown
Billy Childish
Martin Creed
Jeremy Deller & Karl Holmqvist
Tracey Emin
Graham Fagen
Laura Ford
Liam Gillick
Paul Graham
Lucy Gunning
Graham Gussin
Susan Hiller
David Hockney
Dean Hughes
Anna Hunt
Runa Islam
Emma Kay
Joan Key
Jim Lambie
Michael Landy
Hilary Lloyd
Rachel Lowe
Sarah Lucas
Kenny Macleod
Chad McCail
Conor McFeely
Lucy McKenzie
David Musgrave
Mike Nelson
Paul Noble
Jonathan Parsons
Grayson Perry
Kathy Prendergast
Michael Raedecker
Paula Rego
Carol Rhodes
Donald Rodney
Paul Seawright
David Shrigley
Johnny Spencer
Simon Starling
John Stezaker
Wolfgang Tillmans
Padraig Timoney
Amikam Toren
Keith Tyson
John Wood & Paul Harrison
Richard Wright
Cerith Wyn Evans

The British Art Show

5